REVISED EDITION

HOW TO SHOOT STOCK PHOTOS THAT SELL

Michal Heron

ALLWORTH PRESS, NEW YORK

Published by Allworth Press, an imprint of Allworth Communications, Inc., 10 East 23rd Street, New York, New York 10010

Distributor to the trade in the United States and Canada: Writer's Digest Books, an imprint of F&W Publications, Inc., 1507 Dana Avenue, Cincinnati, OH 45107. To order additional copies of this book, call toll-free 1-800-289-0963.

Cover and book design by Douglas Design Associates, New York, New York

Artwork © 1990 Minoru Saito, Ladleton Studio, Claryville, New York

Library of Congress Catalog Number: 95-83302

ISBN: 0-927629-12-7

Identification of Photographs

Cover, from top left:

1) Navajo infant in cradleboard, Chinle, Arizona;
2) Paramedics transport patient, Phoenix, Arizona;
3) Kisofukushima, Japan;
4) Fieldcrest textile mill, Eden, North Carolina;
5) Santa Barbara Mission, Santa Barbara, California.

Black and White Photographs

Page 6	17th Century Architecture, Old Salem, North Carolina
Page 36	Colonial Kitchen, historical restoration, Old Salem, North Carolina
Page 84	Ettie Banks, Big Cowan Creek, Kentucky
Page 116	Pavilions of the Emperor, Chengde, China
Page 148	Appalachian girl, Letcher County, Kentucky
Page 158	Robots on body assembly line, Nissan factory, Zama, Kanagawa Prefecture, Japan
Page 172	Architecture, Research Triangle Park, North Carolina, (Digitized)

Acknowledgments

For Theo, Bob, Reyna, Edith, and Fran

I wish to acknowledge the many people, ASMP friends, photographic colleagues, stock agents, and legal experts, who have shared with me their insights, experience, and enthusiasm for photography.

For help in the preparation of this book my gratitude goes to Ted Gachot for his skilled editing; to David Milne for a clean, elegant design; to publisher Tad Crawford for his patience, keen perceptions, and valuable direction; and to my family on Red Hill for their support and understanding.

Contents

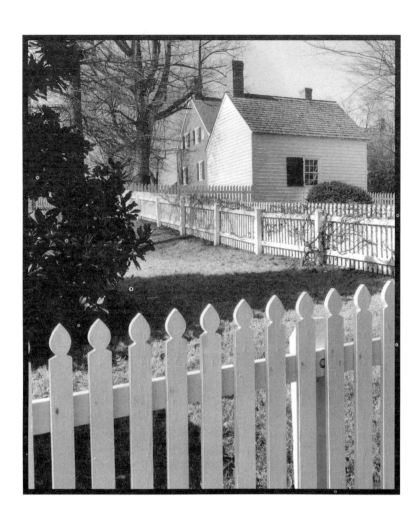

New Trends in Stock

The world of stock may not change quite as fast as bits race — at the speed of light — along optic fibers, but it certainly feels that way. Currently, each year brings the same degree of change that previously occurred over a decade.

The primary cause? A technology that is developing at dizzying speeds. We face exciting, sometimes daunting new prospects: filmless cameras, magazines without paper, an insatiable appetite for photographs from the Internet, and multimedia products poised to swallow vast numbers of visuals. We have the ability to deliver images at warp speed and to market in exciting but unsettling new ways. We must contend with the copyright and protection issues of these new technologies. Whew.

Meanwhile, back in the non-digital world, there have been dramatic shifts in societal and corporate values which affect the look of our photographs.

The successful stock photographer today will have to be vigilant, alert and ready for new developments. The most creative will anticipate and be responsive to change. Clinging to what once worked won't bring successful results.

But through all these changes there are certain constants: quality and imagination.

In practical terms, the major areas of change in stock are in style, markets, and, of course, the digital technology.

Style

Until recently successful stock was characterized as being "generic" in style. This meant showing idealized models and situations and avoiding the specific, sometimes homely details that make people individual and real. To some degree we were dishing out fantasy. All things to all people, the photos showed what marketing experts thought people wanted to identify with, wanted to believe they looked like.

At it's worst, that approach was plastic, stiff, and artificial, portraying unreal scenes and unbelievable people.

However, the generic style at it's very best yielded clean, crisp, well-styled, and well-executed professional photography. The models were good-looking, confident, and healthy. Their clothes may have been in artful disarray as they interacted with charming partners and children, but there was no doubt about the harmony of their lives. All was well in their world. If it looked a little too good to be true, until the mid-nineties that's what the public (and advertisers) wanted.

In a reaction against slick production pho-

tos, there has been a move toward establishing credibility with the viewer by giving a down-to-earth feeling, more authentic and humanized photos. Buyers are looking for a greater sense of the casual, of the way people really behave and relate to each other, in the kind of clothing they really wear.

Translation: this means use more realistic looking people. If you use a professional model try a for a pleasant character-actor type.

Warning: *less generic* doesn't mean sloppy: It doesn't mean to let down your standards. It doesn't mean allowing photos to show brand names, messy backgrounds, or to use models with cracked toenail polish, "just because it's real".

Also, if you never mastered generic then you can't leap away from it without looking back. Consider that you still need to control all the elements — props, location, models — then create an environment in which they can behave "real."

Continue to follow the guidelines in chapter 2 for style and content, but get looser -- loose in feeling. Remember, in a good drama what appears to be an authentic outburst is actually tightly controlled acting. Bring that quality to your photos. Work with your models to be more spontaneous and authentic in feeling, more evocative, more convincing. Provide the willing suspension of disbelief.

Topics

What interests Americans? What do they care about, do with their time, spend their money on? A stock photographer must be in touch with these trends. Read the *Wall Street Journal* for early warnings of what's to come in business. To see the extraordinary range of interests of Americans, go to a large book or magazine store. You'll find 200-300 magazines, on every imaginable topic, Consider this: there are enough people out there to support each of these magazines that survives for any length of time.

Study the titles: *Hispanic Woman, Walls & Windows, Indian Artist, Teen Machine,* *Remedy, Byte, Black Belt, Golf Tips, Birders' World, Veggie Life, Snowboarding, Country Accents, Quilt Almanac, Canoe & Kayak, AguaGeographica, Futurist, Online Access, Weathernoise, True West* ...and that's a mere sampling.

But the common question persists for photographers new to stock — what subjects do I shoot? As you'll see in chapter 2, the subject matter is only the surface, a superficial aspect of a strong stock photograph. The underlying power is the concept in that photograph, which communicates to the viewer an idea, an emotion, a life view.

The subject matter and the details surrounding the choice of subject — clothes, look of the models, props, location setting -- all play a part in reinforcing (or undermining) the concept. Here's where the research you've done at the magazine shelf comes in. The interests and trends you've observed help you select the props, style, and locales as a setting for your concept. Just as in a film, the concept is embodied in the screenwriter's words, and a set decorator through design and propping creates a mood which heightens the concept of the movie.

Your photograph is more believable, and the concept has a stronger impact (which translates into salability) if it resonates as current, current because the styles and interests of Americans are seen or felt as part of the fabric of the photograph.

The same approach holds true for photographs directed to an international market. Research European magazines. Compare details in order to remove the uniquely American elements that would destroy a photograph's usefulness in foreign markets.

Diversity

For a number of years we have known that it was useful to create stock which included a representation of a variety of ethnic backgrounds (See chapter xx). This was recognized as important by editorial clients early on. Now, shined up with a slick new name,

multiculturalism has hit the big time. Advertisers have finally realized that cultural and ethnic diversity and the subtleties of expressing not just the color of a face, but the foods, flavors, and textures of a culture must resonate in a photo.

Some agencies are creating catalogs devoted primarily to photographs with a multicultural or cross-disciplinary emphasis.

On the international market, The EEC (European Economic Community) has upped the ante for photographs that are useful anywhere in the Common Market — as saleable and appealing to the Dutch as to the Spanish. A single European currency is not far off. As products are marketed across national lines, photographs must be equally adaptable.

Digital Environment

The most exciting and dazzling element of change in stock will continue to be the magical, mysterious, and intriguing world of digital technology. See chapter 13 for a discussion of digital imaging capabilities and the equipment and software choices for a stock photographer in the digital world.

Until the moment when digital technology phases out all else, every discussion of stock will compare current digital methods with traditional or conventional handling of every aspect of the business.

What's important to understand is that every aspect of stock — except the original idea which still begins in our imagination — can and is being done in a digital format. That includes the marketplace of photo buyers, marketing methods for licensing pictures, delivery systems, and, of course, the creation of images.

To stay current on the trends in digital stock you must read the trade press, especially *Photo District News* and as often as possible attend local seminars or Viscomm, the major photo expo held annually on the East and West Coast.

Markets for Photography

Who are the users of photography today? Will the traditional buyers for print use be significant? Where will the growth occur?

It is a time of flux in the marketing of stock. In the recent past there was a huge growth in stock usage as a new generation of buyers discovered stock. That extraordinary expansion has leveled off, and the market for traditional photography through traditional sources is relatively stable. The new game is digital marketing for new media.

The new media (multimedia, desktop publishing, and consumer use) has the potential to provide markets for an extraordinary volume of pictures and is a potentially challenging new area to explore.

The downside is pricing. These markets, in spite of their voracious appetite, haven't exhibited a pricing structure that has any relation to the cost of producing the kind of photography they need.

Marketing

The traditional marketing method of stock has been through a number of stock photo agencies of varying sizes and specialties, as well as via individual photographers, often working through specialty stock catalogs. The indication is that mega agencies are the best positioned to survive in the next decade, with some specialty or well-managed boutique agencies holding their own.

Digital Marketing

In place of reliance on conventional agencies, we now have a range of digital marketing vehicles on the scene with new ones emerging monthly.

Among the existing digital marketing and distribution services are the Kodak Picture Exchange, KPZ and Picture Network International, PNI. ASMP's MPCA In View licenses member's images to new media. Among other "filmless" photo agen-

cies who market images in digital form only are Corbis (part of the vast Continuum/Microsoft domain), the Corel Corporation in Ottawa and Digital Stock in San Diego. Jim Pickerell's Digital Stock Connection markets via CD catalog to traditional markets.

So far so good, digital technology provides a new way of marketing and a new delivery system with less wear and tear on the valuable original film. Great. But concerns about copyright safety ride the berm of this information superhighway. Once the digitized image is available, even in a low-resolution form on a CD catalog, what prevents theft? Honor is one answer. We've always had some skullduggery, but ethical clients will continue to pay their usage price. However, the technology makes it so much easier to lift a decent quality image, that the temptation becomes stronger, especially in the hands of the uninformed new breed of graphic designers who believe any visual is grist for their mill.

The debate continues over whether watermark symbols will provide protection or offer only a simplistic solution that a skilled technician can easily overcome. This problem will not be solved tomorrow, but it should not cause photographers to shy away from the digital area. Proceed with some caution.

Enter the onerous CD-ROM clip art disc. When discussing the technology of CD-ROM it's critical to distinguish the CD ROM when it's used as a catalog or delivery system from the CD ROM clip art disc. One is merely a form of catalog showing available images, which must be licensed and paid for prior to receiving high-resolution scans or actual film for reproduction. What is commonly called the "clip art disc" is a CD-ROM disc as product. This type of disc offers purchasers, for a one-time purchase price of often only a few hundred dollars, scans of hundreds of photographs, which they can reproduce in any way, for any use, for any period of time. The purchaser (usually a photo buyer) receives unlimited, non-exclusive rights to hundreds of photos and all for a pittance compared to traditional stock prices.

Where do these photos come from? Clip disc companies solicit photographs from photographers, who are often swayed by cash in hand — a modest lump sum payment sometimes with a small additional royalty attached. This payment is for photographs that will be offered to buyers with unrestricted, unlimited rights for usage. This cheapens the value of stock everywhere. Selling work in this fashion is a foolish and dangerous economic move for photographers.

Internet

Some photo agencies and individual photographers have turned to the Internet as a marketing avenue for stock. Black Star, The Stock Solution, and Custom Medical Stock were among the first agencies to establish home pages on the World Wide Web. It remains to be seen how many "hits," that is viewers visiting the page, have actually translated into paid stock usage.

Most traditional agencies are connected with distributors. Find out if your agency has a deal with a digital network, and what their plans are for new media, electronic rights, and digital distribution.

There is no status quo in stock. It will continue to be a world of rapid and exciting change. Let that air of rapid change exhilarate rather than dismay you. Hold on to the one thing that can't be replaced, your imagination and creative vision. More than ever the market needs fresh ideas and fresh images. That won't change.

The Business of Stock

ot long ago, a client called to ask for a stock photo of a Hispanic family having a picnic. I didn't happen to have it on file, but it didn't sound like a tough request.

"Sorry," I said, "I can't provide that picture but surely you can find it easily." The caller sighed and replied: "Don't be so sure, I've looked everywhere."

The client didn't have time to shoot an assignment. They had wanted to appeal to the Hispanic market, but in the end they settled for my stock picture of a white family having a picnic. I was amazed to learn that mine was the only photograph of a family picnic they had found to fit the bill. It seemed very odd.

Were there other pictures of family picnics in stock agencies?

Yes.

Why didn't they work?

As the client explained it, they were all photographed in a journalistic style. They were "street-shooter" grab shots. They were all technically good, attractive pictures, but they didn't pass muster as stock. One family picture was rejected because the mother wore short tight pants. Another lovely, promising shot showed a black family picnicking in Central Park, but one person was smoking, and there was a can of coke (brand name visible) on the blanket. Yet another scene was rejected because it showed a graffiti-scarred park bench in the background. There were eight agency photographs in the final selection. None worked.

These rejected photographs were all taken by photographers "out shooting." They were fine photographs of real people who looked a little too real for stock. The photos may have matched a subject or concept that was suitable as a stock topic, but they were not really taken with stock in mind. They were not the work of people who understood the special needs of that market.

This anecdote is not an isolated incident. I have heard many variations of it from stock clients who can't find exactly what they need. It may seem as if virtually *everything* in the world has been photographed somewhere by somebody. But that doesn't mean the photographs are suitable for stock. Even so, I am constantly surprised that the seeming glut of images being produced by eager photographers still leaves so many gaping holes in agency files.

The reasons for these gaps, and the way you can fill them by tailoring your techniques for the stock industry, will be fully explored in this book.

What is a Stock Photograph?

The definition is straightforward: A stock photograph is an existing photograph that is available in a photographer's files to be loaned (licensed) for reproduction use to a wide variety of clients. Stock photographs are different from assignment photographs, which a photographer is commissioned by a client to create. Stock exists, whereas assignment is potential or proposed photography.

Essentially, stock comes from four sources:

1. From a photographer's personal shooting, that is, work derived from independent projects, such as those taken while traveling or simply when shooting for the sheer joy of it.

2. From photographs created specifically with stock in mind — that is, photographs based on the photographer's sense of market needs or at the suggestion of a stock agent — pragmatic photographs.

3. From assignment outtakes — these are photographs available after an assignment has been completed, after any time restriction has expired, and the originals have been returned.

4. From stock productions done with agency participation — joint ventures. Though still not the norm, cooperation between photographers and agencies in financing the production of stock is steadily increasing.

Licensing Rights

We speak casually of "selling" stock but, in fact, nothing is "sold"; no product actually changes hands. The client doesn't buy or own an object after the stock transaction is completed. In correct terminology, stock use is the licensing of reproduction rights.

By way of the license, the client receives permission to reproduce a photograph for the usage specified on the photographer's invoice. The usages that are licensed might be as diverse as an illustration for a magazine article, a consumer ad, a calendar or a menu cover. The physical property of the photograph — a print or transparency — is on loan for reproduction purposes only and is returned after use. With proper care, stock photographs can have a long, fruitful earning life and should *never* be sold outright.

The major markets for stock break down into three broad categories: advertising, corporate, and editorial.

Advertising agencies use photographs for a wide range of client products or services in many types of ads. The best known are national consumer ads, which appear in publications circulated to the general public, and trade ads, which appear in publications directed to a particular industry, such as the hospital equipment manufacturers or the metal refining industry. Stock photos sold to the advertising market command the highest prices.

Corporations use photographs for corporate annual reports, often to extoll their productivity to stockholders, for brochures and in house organs (internal magazines). They use photographs ranging from executive portraits (usually shot on assignment) to gritty scenes — often turned into stunning graphic symbols — of workers on an assembly line, in food processing plants or in a textile mill. The prices paid for corporate use can be on a par with advertising but are occasionally in a mid-level range.

The editorial market for stock, primarily magazines, books, and newspapers, has a high volume of "sales" but historically the lowest fees in the stock industry.

Auxiliary markets include a wide variety of uses, from calendars and greeting cards to bank checks and T-shirts. In fact, these markets extend to every conceivable use a picture can have.

Not so many years ago stock photography was thought of as a cottage industry. Now stock has mushroomed into a multi-million dollar business with very specific and fast- growing needs, and complex problems for photographers to handle.

Who Sells Stock?

Some photographers market their own work to stock buyers, but many leave that aspect of the business to one or more of the 200-odd stock photo agencies in the United States and abroad. Originally thought of as picture archives, today's stock agencies are much more than mere repositories of photographs. In addition to handling filing, billing and licensing of reproduction rights to clients for a percentage of the reproduction fee, many agencies spend large amounts of time and money researching and opening new markets for the use of stock photography.

In the United States, the Picture Agency Council of America (PACA) is a trade association which represents the interests of member photo agencies. The British Association of Picture Libraries (BAPLA) does the same in the United Kingdom.

Where did it all start?

History

In the late 1880's, the invention of the half-tone printing process made it possible for newspapers and magazines, such as *Harper's Weekly* and *Frank Leslie's Illustrated News,* to reproduce photographs instead of the line drawings that had been their only illustrations for almost a half century. Since then, the market for photographs has grown from an enthusiastic need into an insatiable demand for exciting images.

At first, providing these images was the job of staff photographers working for these nineteenth century publications; later freelance photographers took up the assignments.

Early in the 20th Century the first photo libraries were set up, "selling" rights to stock images of such predictable subjects as babies, animals and staged photographs of people — all photographs in black and white, of course.

The next development was the emergence of assignment agencies in both Europe and America designed to produce photo stories for magazine syndication. After World War II the advent of color photography influenced the agencies of the period, leading, in the mid-fifties, to the establishment of the first modern photo agency to make available assignment out takes for stock.

Out of a burgeoning demand for stock photos inspired by the post-sputnik needs of the sciences and the TV-generation's craving for visual images, new agencies sprang up all over the map. These agencies, like their predecessors, were still based on whatever photographers chose to contribute — personal work or assignment outtakes; their market was primarily editorial.

A dramatic change occurred when the first agency to serve the advertising market was founded. Entering the bastion of big money assignment photography, this agency introduced aggressive sales techniques and, novel to the stock industry, the concept of worldwide franchise agencies.

With this opening of the previously untapped advertising market and the introduction of tough and sometimes glitzy marketing approaches, we saw, in the seventies, the rapid and irreversible move away from the small-business mentality that had prevailed in the past. As a result, stock photography changed more in one decade than in the previous six.

What was once a Mom-and-Pop, handshake business became irrevocably altered — for the better, in financial terms — but the atelier atmosphere that had appealed to many photographers and agents alike was waning fast. The escalating changes,

however, opened up exciting new opportunities for photographers who wanted to concentrate their efforts on stock.

A bonanza in stock opportunities was under way. Like the forty-niners sweeping into California during the gold rush, every photographer who had heard the word stock rushed into the arena, some lured by the illusion of easy money.

New agencies stretched the accepted boundaries of the industry and prospered. Others overreached and failed. Veteran agencies survived or merged; regional or specialty agencies created their own niches in the hectic shuffling for position in the new marketplace. For photographers, there were success stories, a few horror stories, and a lot of questions about the future of stock and their place in it.

Changing Perceptions of Stock

During this period certain preconceptions were changed or put to rest. For many years there had been the underlying sense, held by photographers as well as clients, that stock was the "poor relation" of assignment photography. Stock was thought of as second-rate photography, commonly described by such negative words as cliche, mundane, trite, hackneyed, ordinary and predictable. A popular phrase summed up the prevailing opinion: "Stock is schlock."

Another widely held notion was that stock is gravy, easy money. Photographers contributed to this fallacy by eagerly taking whatever sum was offered, in order to clinch the occasional stock sale.

The idea that stock photography was "found" money was not easily dispelled. What some photographers didn't realize was that the value of a photograph doesn't diminish simply because the work has already been done, whether last week or last year. The fact that the photograph exists — and does not have to be created anew — does not relieve the photographer from the responsibility of charging an appropriate fee, nor does it relieve the buyer from having to pay it.

The irony in underpricing stock photography is that for many years few people in the industry realized or acknowledged that stock had the value of being risk-free photography. Stock has none of the weather problems, technical difficulties, or schedule delays sometimes associated with assignments. The photograph is there, finished and ready to be examined by an art director and wend its way through a client's approval process.

An early ad from a stock photography marketing company called on photographers to "dust off those old yellow boxes — there's a gold mine in your closet." The attitude that there was stock value attached to any old picture someone had hanging around gave amateurs false expectations. It reinforced the disdain of many buyers who dismissed stock, and it discouraged top photographers, who held their profession in higher esteem, from taking the stock business seriously.

The problem of winning respect for stock was not easily solved. Even photographers involved directly with stock sometimes gave short shrift to their stock agents by sending only seconds or brackets to agencies. When shooting for stock, these photographers often failed to give the same care and attention they gave to assignment work. "After all, it's just for stock," was their attitude.

With the entry of first-rate photojournalists and magazine photographers into the stock field as early as the 1960's, these old and largely negative perceptions began to fade. This shift became complete in the eighties, after the advertising and commercial players had joined the game. As the quality of available stock increased, and with the rise of digital imaging in the nineties there was a movement by clients from assignment to stock, an advantage for photographers who had embraced the new technologies.

Current Trends

The generic nature of stock has not changed. Photographers still shoot universal subjects and concepts. The expression, however, has changed. There is no place for mediocrity. Successful stock today sends more than just a clear message; it stands as an icon that communicates directly. The new stock is executed with high style and meticulous craftsmanship.

Agencies have changed too. Some have bolstered the new image of stock by promoting professional service to buyers, demanding consistent quality from their photographers over a wide range of concepts. Agencies have also made major investments in new technology. Some of the more aggressive agencies have trained their staff in the art of negotiating and pricing stock — an approach unheard of in the old "handshake days" of stock.

Agencies are acutely aware of the need for a constant supply of fresh, exciting new photographs. They actively encourage photographers to produce stock — in some cases, they participate in the process themselves through financial support for set-up production photography.

Where does the best stock come from? (assignment outtakes vs. stock production)

The dizzying changes of the past few years have given rise to an important debate among professionals regarding the effect on photography of the new marketing approach to stock. One of the hottest current disputes is how to reconcile the demand from agencies for saleable images with the desire of photographers to shoot creative, innovative, personally satisfying photographs.

Reduced to simple terms, the agency wants product, while you, the photographer, want to make photographs. Are the two goals mutually exclusive?

According to some photographers, an assignment stimulates their creative juices through a unique chemistry of deadline pressures, the excitement of solving a creative problem, interaction with client and the need to pay the rent. The resulting photograph, however, designed for the assignment, is not always targeted to stock needs.

In today's competitive market, only agencies with an aggressive approach to the business and a thorough understanding of it will survive. Likewise, those photographers who move with such agencies will benefit. Photographers and agencies who stay with horse and buggy methods of production will be left behind. According to the new breed of agencies, photographers who want to make it in stock must follow their guidance almost in lock step — and do this to make money.

On the other hand, shooting exactly what the stock agent wants or says the market needs, especially if it doesn't appeal to you, can result in sterile, mechanical, lifeless — usable, but certainly joyless — photography.

The dilemma is a familiar one. The issue of a photographer's creativity versus someone else's needs has always plagued photographers in assignment work. Until recently it was not a problem for stock photographers. Now they, too, face these questions: first, how does this pressure to create saleable product affect the creative satisfaction of a photographer? At what point do creativity and innovation become deadened by production of the predictable image? Where is spontaneity in seeing, in personal vision, in the excitement of experimentation?

Second, what will this tension do to the appearance of stock? Will stock become only a more technically polished version of the stock of 30 years ago — the aesthetic cliche? By a slavish devotion to marketing, are we creating a body of facile, sterile work? However sophisticated the technique of such photography, I suggest that an abundance of lifeless, predictable work cannot be good for the industry.

Stock Portfolio

The answers to those questions lie in finding a balance, a harmonious relationship between saleability and fine photography. The creative challenge for you, the photographer, is to find a way to breathe life into your own work, making it grow and bloom. The most effective approach is to view everything you shoot for stock as a portfolio piece. Choose the stock concepts that most appeal to you and give them the same care and love as you would give your portfolio samples or an assignment from your most demanding client.

Expectations

There is a niche in stock for the dedicated person. Whether you are an assignment photographer who hasn't yet made the transition to stock, an entry level professional who wants to build a career in which stock plays an integral part, or an avid photographer from another profession who wants to understand and participate in stock, you can find your place.

Where do you belong in the world of stock? One school of thought says that unless you are a top pro, don't try for the mainstream of stock. Be content with the smaller markets, the crumbs from the table — leave the big time for the 'big guys.' That's dangerous reasoning. If you assume you should try only for the fringe markets then you will surely stay on the fringe. This attitude will prevent you from pushing your work and your professionalism to its limits.

Further, as we are seeing a trend toward fewer, more powerful agencies and the consolidation of stock among those agencies, photographers must develop the strength and skills to negotiate successfully in this climate. Start with a belief in the value of your photography.

Realistic expectations are important, however. Stock does not respond to wishful fantasies and cries of "open sesame." Each year there is more competition. All the more reason to set high standards for your work. Approach stock with the conviction that you will produce and market your work on as high a professional level as anyone in the business — that you will develop your style of photography to its fullest.

The fervor and imagination that you bring to photography can be channeled into building a strong stock file. There is great satisfaction and profit to be made in stock photography, but it takes time, energy, and commitment.

How To Shoot For Stock: Style and Concept

Polonius was not thinking of photographers when he advised, "To thine own self be true." But as a guide for shooting stock he couldn't have been more apt.

Style

In photographic terms, the application is to style. Style is your point of view, that distinctive, characteristic way of seeing that distinguishes your work from others — your personal vision. It is the expression of an idea. It is the form rather than the content of a photograph. Style is how you shoot rather than what you shoot.

As true in stock as it is in assignment work, developing your own style is central to success and joy in photography. It is important to understand, define and refine your style and know where it fits in the market.

Over the years, certain markets for stock have been characterized by specific styles, and certain assumptions have been made, such as that images which are:

- close up, evocative, with a sense of immediacy, with clear, simple messages are found in advertising.

- strong graphic statements that reduce the subject to design elements are found in corporate and advertising photography.

- literal, detailed, spontaneous, authentic and informative are found in editorial work.

- surreal, inventive, fantasies are found in fashion and advertising photography.

Today, many of those stylistic conceptions have been shattered. In the client's frantic search for new approaches, preconceived notions have been turned upside down. Everyone is using everything in an effort to break the old molds. We see that advertising is currently adopting a style of grainy, gritty reality once seen only in photojournalism, while many magazine photographs are stage-managed productions using the slick lighting style previously associated only with advertising.

Important as it is to be aware of market trends and faddish swings toward specific styles in stock, what counts most is understanding your own photographic style and where it fits within these trends.

This is where Polonius comes in. Know who you are as a photographer. Have a sense of your own style and be true to it.

In pinpointing your style, a first clue is how you feel about photography. Do what you

care about — what you can do wholeheartedly with the full passion of your love for photography. Keep what is spontaneous and authentic in your view and style.

Many photographers are lured by the stories of huge sums to be garnered from certain types of pictures. They leaf through catalogs, read articles on best-selling stock, and visions of sugar plums begin to dance in their heads.

Trying to shoot in a style that isn't natural to you is a recipe for failure. However that doesn't rule out experimenting with new techniques or taking risks to stretch your photographic abilities. What it does mean is that you should avoid shooting what doesn't feel right or what doesn't excite or please you photographically — saleable or not. If it's contrary to the way you see the world, to what you care about visually, then it won't work — for you or for stock.

If you are represented by an agency, don't simply ask your agent what is the most lucrative area of stock, ask yourself what is it that excites me, gets the juices flowing? Then get your agent's view of the potential market for this type of work.

Use your strengths and improve on them rather than trying to mimic what you can't carry off. You don't want to be a second-rate copy of another's style. The woods (and agencies) are full of pale imitations — and they don't sell well.

Trust your abilities, be proud of your style, hone and polish it. If you shoot what you feel passionate about in a style that excites you, the chemistry will show and those pictures will be saleable to the right client.

If you bring to your stock an authentic original quality, it won't feel like pat and predictable stock, but like photography — and it will be yours.

Understanding the philosophical underpinnings cannot be overemphasized. It is as important as choosing the right material to shoot.

You may be lucky enough to have a clear grasp of your work and a well-defined shooting style. If so, you can skip the next section.

Otherwise, ask yourself how you go about the difficult task of analyzing your work.

Analyzing Your Style

A number of years ago I learned something about my style, quite unexpectedly, through the eyes of a photographer friend. We had both been to China on different types of assignments. Hers was magazine travel photography; while mine included an editorial shoot for a book publisher. We decided to have supper one evening and view each other's China pictures.

"It's fascinating to see how you shoot", she said, after seeing my work. "It's so different from what I would have done with that scene."

When I seemed puzzled, she continued, "Your pictures are telling me a story of how people live in China — they give me information and understanding of the culture. Mine, on the other hand, are designed to make the country look attractive, to be appealing to a visitor or a tourist."

It was suddenly clear that she had identified our distinct points of view with great accuracy. Her comment told me something I should have known about my work but hadn't — I had never stopped to analyze or assess my style.

Using the insights of other photographers is just one of several steps that can help in defining your style. Here are some others:

1. **Look at your assignment portfolio work and tearsheets.**

 Sort them according to the various styles you have produced on assignment for clients. Which ones have been most successful for you photographically? Separate the portfolio pieces to represent the work that you most enjoy doing or that you are most proud of and see where it falls. Is it most suitable to advertising? Editorial?

2. Look at the history of your personal, non-assignment work.

What choices have you made in terms of style? What appeals to you? Have you been using your photographs to tell a story? To make a graphic statement? To create a fantasy?

3. Look at your technical strengths.

Sort your work again, this time according to what you feel has been most successful and what interests you most in technical terms. Is it creating drama with filtered strobe lighting for high-tech subjects, working in the dark room to make special effect "sandwiches" or using natural back lighting to capture the mood of a location?

4. Consult with colleagues, workshop leaders or photography teachers.

Just as you did with photographer friends, ask which aspect of your style is most successful, what your strengths are, which aspect needs more development and where your work might fit in the market. Take them off the hook. Let them know that you are not looking for a "good" or "bad" judgement. You can get a very valuable professional critique if the reviewer believes that you are ready to listen and not be defensive. If you are simply looking for praise, you'll learn a lot less.

In reviewing portfolios for students, I usually ask: Where do you see yourself in the market? Where do you want to be in five years? What kind of clients have you targeted.

This helps to see if photographers have analyzed for themselves. Based on their answers, I can give a useful critique. If you offer this information to a colleague or teacher who is willing to review your work it will say to them that you've taken the first steps to understanding your own work.

5. Compare your style.

Match your work to photographs you see in magazines, annual reports, brochures etc. Is your approach most consistent with the ads you see, or is it closer to an editorial style of photography. One easy research technique for the purpose of pinpointing your style is a clip file. As you'll see below, a clip file, is composed of samples of photography you cut from a variety of publications.

Setting up a clip file

A clip file will be very helpful in developing strength in every aspect of stock photography. You'll use the clip file for market research; to identify concepts; to analyze lighting techniques, use of color, gestures and the integration of the photograph with the copy — in short, for everything that you can learn from dissecting a photograph.

The one thing you *won't* use your clip file for is copying. That is copyright infringement and, very simply, it's against the law. Even if you make small changes in your version of a photograph that you have seen, if it is "substantially similar" you could be held liable, as you'll learn in Chapter 14. To avoid the dangers of copyright infringement, use the reference photos to identify the idea behind a photograph, distill the concept and look for a new way to express that concept. (We'll discuss this more under the section on concepts later in this chapter and in the assignment section of Chapter 4.)

A great value in looking at published photographs is that, like them or not, these are the pictures that won out — they were chosen for use. Keep in mind that any photograph you see published went through a complicated screening process — whether in the planning of an assignment or the thorough research for just the right stock picture.

Start by collecting photographs from magazines, brochures, annual reports, newspapers. If you don't subscribe to many magazines, invest in a big batch to get your file started and your mind whirring. Buy

copies of magazines covering a wide variety of topics from news to sports and fitness, from family or bridal magazines. Don't forget the foreign language publications. Inundate yourself.

Once you've exhausted what's available on the newsstands, scour your dentist's and doctor's offices for medical magazines (beg some back issues). Then make a trip to the library for some annual reports. Select a few corporations that use fine photography in their annual reports, then write to them asking to be put on their mailing list. Even junk mail finally has a use — some of what you receive will be sales pitch mailings from credit card companies, utilities or others using high-end consumer marketing tools. Look at the style of photographs they use to help understand lifestyle trends and the markets they are trying to reach. Finally, don't forget the streets, bank ads in windows shout slogans at us every day — and provide great "tag" lines to think about.

Through this research you will raise your awareness of how everyday subject matter can be distilled into basic generic concepts, messages that are the essence of saleable stock.

Uses for Your Clip File

Clip photographs of all styles from magazines, brochures and annual reports, as described in this chapter. Organize into basic category groupings (family, executives, scenics etc.) Use your clip file to understand the following aspects of photography:

1. Identify Concepts
Analyze advertising photographs to determine underlying concept portrayed. What symbols were used to convey the concept. List them. Do a flash test — what words or symbols are instantly communicated by the photograph. For editorial photographs, analyse what information is conveyed. Is there an immediate message?

2. Neutral Space
Analyze advertising photographs for empty or negative space where the copy is placed. Imagine the photo without type or logo. Where was extra space placed — which quadrant of the photo. How large is the "subject?" Where is it placed in relation to type?

3. Shape/Format
Look at the design of ads, book and magazine covers. How many are verticals, how many horizontals? Note the elements that make the verticals successful.

4. Color
Analyze the use of colors — which colors predominate? What mood or effect was created? Was color used to direct the eye?

5. Gestures
Analyse the gestures in a photograph — are they authentic? How close are models? Is there eye contact? Does the body language seem genuine?

6. Headlines
Note the headline copy used in ads. Find new ways to illustrate the concept expressed — a new execution to fit the old concept. Compile your own list of tag lines to illustrate.

7. Analyze your style
Looking at a wide range of published photographs see where your work fits — or how it might be developed. What market are you best suited —advertising, editorial?

8. Don't use your clip file to copy the execution of a photograph — use it for understanding the structure.

Elements of Style

Once you have a clear idea of your style, the next step is to match it with what is useful for stock. Let's consider the elements: composition, technique and production — elements that are used to express or reinforce your personal style. When used properly they will enhance a photograph's usability as stock. Conversely, there are other elements, prohibitions that can diminish a picture's useful life as stock.

Here we'll concentrate on the design components of a photograph. Later, in chapters 4, 6, and 7, we'll cover the technical and production details that also have a strong influence on your stock.

Composition

The composition of a photograph has an important impact on its effectiveness as stock and includes:

Shape: "Your 35mm camera will not break if turned on end" is one stock agent's way of bringing this point home to photographers.

The message is: shoot verticals — vertical pictures are very much in demand. Full page ads, posters, book covers — all lend themselves to this shape. Further, there is a paucity of vertical photographs in the hands of stock agents. When a subject lends itself to either a horizontal or vertical shape, photographers seem to compose more often in a comfortable horizontal. If a subject seems to work only as a horizontal, stop. Look over the situation to see how you can get a good vertical out of the scene. Challenge your creativity. Hoist that camera upright! Whenever possible cover yourself by shooting both shapes.

If you can't remember to do verticals try imagining that the picture you're shooting is for an ad appearing on the back cover of the New Yorker. The fee alone should be an incentive. There will be some situations that don't lend themselves to a given format — but a flexible, imaginative photographer will meet the challenge by designing an arresting photograph in any shape. Solve this one: shoot a horizontal of a totem pole.

Space: " Great picture but where can we put our ad copy?" Neutral space in a photograph is a boon to advertising agency art directors or corporate communications executives. They need a place for their logo, headline or copy that won't destroy the photograph. Designing some blank space into a photograph solves that problem — your challenge is to do it artfully.

This may not come naturally to you. If not, try making a series of grids for your viewfinder (or do it mentally) and compose variations with your subject in different areas of the picture; top third, middle third, bottom third and left, right, or center of each of those thirds, leaving neutral space for type. (See the sample storyboard sketches in Chapter 6.)

You may resist this idea as corrupting your photography to fit an imaginary art directors layout. But remember, done properly it can and should be a dramatic photograph on it's own, without the text. Over the centuries visual artists have used negative space for dramatic or surreal effect.The photographer's challenge is no different.

I learned the value of negative space almost by accident, one twilight evening early in my career, while on an assignment for a farm equipment manufacturer in Wisconsin. Having finished the day's work I was drawn outside by the glorious light — the chiaroscuro in the clouds. My final shot was a silhouette of farm buildings against the sunset with a brooding cloud overhead. I shot the picture for the love of a beautiful scene — but it happened also to have a perfect balance of space for type — the upper third was the dark storm cloud, the center was a slash of red and gold, while the bottom third showed the darkened barn roofs.

Though it hadn't been part of the assignment discussion, the client paid for brochure cover usage and it has sold very well ever since — all that and I enjoyed shooting it!

Look at the ads you see in magazines and imagine that the copy isn't there — some photos still work beautifully. Notice that sometimes text is dropped-out in white from a dark background, other times an art director will want to surprint dark type on a light background. (See the storyboard sketches in Chapter 6 for approaches to designing for negative space.)

Take it as an artistic challenge to design exciting photographs that have neutral space, that work well with or without text.

Focal Point: Sitting in a darkened room, a person is wired to a machine hooked up to a computer and is viewing a magazine page displayed on a screen. The machine is one of the newest market research tools. By means of a computer, it measures the position of a viewer's eye as it scans each page of a magazine. This allows it to track and chart where the eye moves and record how long it stays on a given subject within a photograph. The machine knows how long the eye lingers on the headline copy, or the page itself.

Style Tips for Stock

To enhance your natural style, keep in mind the points in this checklist that will affect your stock.

TRY FOR PICTURES THAT ARE	AVOID PICTURES THAT ARE
Simple, clean in design	Cluttered, confused, busy
Have clear messages, strong impact	Too detailed, burdened with information
Direct. Viewer's eye goes to subject	Unclear in center of interest or point of view
In pleasing colors, with balanced tones, hot or warm accents	Washed out, discordant or clashing in color
Believable in gesture, filled with interaction and emotion	Contrived, artificial stiff or posed
Authentic in body language	Out-of-synch with topic in use of body language
Clear of brand names	Filled with logos, trademarks, trendy sayings, ads
Vertical	Horizontal exclusively
Designed with space for type	Designed without room for copy
Model-released/Property-released	Not model- or property-released

Advertisers are using this sophisticated technology to give accurate readings of what attracts and holds the viewer's attention.

What they have learned can help in designing effective stock photographs. Photographs that hold the viewer's attention have a simple, clear, arresting center of interest. Viewers look first at people in a picture, closest at the face and come back again to the eyes, and the rest of the face. They respond most to evocative photographs with a sense of immediacy.

If the viewer's eye doesn't know where to go in a picture you have a confusing message. The viewer's eye then often goes quickly to secondary areas of a picture, however a strong directional movement or color should bring them back to the central element, the theme of the photograph that reinforces the concept.

Backgrounds

In general, backgrounds should be clean, simple and clear of distractions. A good background can take many forms but must always support the main purpose of the picture. Some successful backgrounds are neutral: uninformative settings for the subject, such as an out-of-focus wall of trees framing Dad, as he strides forward with a child on his shoulders.

Another form is the supporting background, which gives information that reinforces the theme of the picture. Consider the concept "Memory." The setting is a cluttered attic. The subject could be a housewife reading old letters, a girl playing dress-up, or a middle-aged man with a football trophy. Whichever person is chosen, they will be surrounded by trunks, clothes and artifacts of the family's past — and possibly a rain-spattered window under the eaves. Richness of detail reenforces the point of the photograph. However, the details must be blended and merged, creating a pattern which highlights the dominant character. Otherwise you have clutter and distraction.

Color

The emotional impact of color on a viewer is profound. It may be the single most influential element in a photograph — followed closely by the authenticity of gestures. Color attracts the eye, sets a mood, and, ultimately, can reinforce societal values.

Research shows that color creates subliminal associations in the viewer and touches us on a non-verbal level. In the color coding box in this chapter, you'll see the evocative aspects of the colors of the spectrum.

Use them to affect your photographs. Understanding the evocative nature of color will help you use it to send clear, strong messages; a contradictory use of color may confuse or distort the intended message.

For example, understanding that reds and warm colors attract the eye and signify love and strength will make them desirable in such photographs as a family sporting scene, or that of a romantic couple by a fireplace. Your agent may advise on color trends, but watch for changes if colors are overused. In the eighties stock agencies reported that warm colors tended to sell better than cool ones. But after a few years of power reds dominating photos, the palette shifted to gentle pastels and subtle greys and whites were skillfully introduced to stock.

When analyzing photographs in your clip file, see where color (in props and wardrobe) was used effectively or where you think it was distracting.

A recent ad for a car manufacturer featured a photograph that confused its message through misplaced use of color. I had to look several times to get the point. The photograph showed a trusting father giving keys to the family car to a teenage son, who was leaving for the prom. The message was conveyed through a close-up which included only the son's chest and father's and son's hands giving and receiving the keys. The focal point of the picture was the car manufacturer's symbol on the key. The concept intended was trust in the product.

Where it went wrong was in the wardrobe propping. The son was dressed in a black tux, the hands and keys were centered on the white shirt front — then just as your eye should have gone to the keys, it was pulled to the top of the picture, away from the keys, to the son's red bow tie. A non-essential element in the picture was given the strongest, most evocative color. Grave error. Though this mistake was made in an assignment photograph, it could easily happen in stock and does.

Color plays a powerful role in stock. From our earliest awareness of the exciting visual aspects of color and light, they have always attracted photographers. A sophisticated understanding of the effects of color on the viewer can only enhance your enjoyment and success in photography.

Gestures

Body Language is of primary importance in a photograph, and a close second to color in the impact it creates in a photograph. The physical relationship of people in your photographs should send a clear message to viewers.

There are two elements to consider. First is the authenticity or appropriateness of the body language to the role of the person in the photograph. Is the person or relationship believable? If you even have to think about it, the photograph doesn't work. Having the right gesture is a part of the all-important non-verbal communication of good stock.

For example, a successful executive stands with an air of authority. The average person in a suit is not necessarily going to convey an appropriate commanding impression. If you don't have the real thing, try to find a model who understands power and can act the part.

It helps to research. Watch people in offices, on the streets, in the halls of power (make sketch notes). How do competent, successful men and women stand, use their hands, tilt their heads? Use your clip file to see which pictures of executives feel convincing to you. Observe parents and children in

a park. What are the tender gestures that come naturally between them? This knowledge will aid you in directing your models and helping them to role-play their parts.

A second aspect to keep in mind is the relationship among people in a picture as expressed by physical space. Does a given group feel like a family? What are the clues? Is the picture intimate? How close do they stand to each other? Is this pair really a couple? Are they touching? Is there eye contact? Do you believe? Any contrived or awkward mannerism will undermine the conviction of your photograph. (See Chapter 7 for tips on working with models)

Spatial relationships also imply hierarchy and role. Who is in charge? Are the people in a group colleagues, a boss with staff? Show role reversal, the father as a nurturing parent, a woman in a power situation.

Other Aspects of Style

The style of your photographs will be very much influenced by technical choices in lighting, lenses, format and film, as you'll see in Chapter 3.

Details count. Careful attention to propping, models, locations, set decoration, and choice of models is essential to any set-up shooting you do for stock. Chapter 6 will provide guidance on production elements which can affect the style and value of your pictures — and how to avoid the pitfalls that can ruin your stock.

Concepts

It's been said by successful stock agents that they are not just looking for good photographers — they are looking for good photographers with *brains*.

Now that you have a grasp of what is involved in shooting for stock we can turn towards the "what" to shoot. This is where you can separate yourself from the crowds of stock photographers out there — by being a thinking photographer.

"OK, so what should I shoot?" The temptation for many photographers is to grab at

Evocative Color

Note some of the predominant associations and moods connected with colors, both the positive and negative connotations which can be used in designing your stock.

RED: Dominant color. The eye goes there first.

Evokes:	love, passion, heat, bravery, stop
Negative:	war, rage, blood, danger
Examples:	Valentine, god of war, red-handed, see-red

YELLOW: Lifegiving color. The sun

Evokes:	joy, optimism, happiness, prosperity, gold, riches, glory, power, splendor
Negative:	cowardice, warning, sickness, quarantine.jaundice
Examples:	yellow journalism, yellow streak, gold credit cards, "all that glitters..."

BLUE: The color of tranquility, the cosmos, infinity

Evokes:	relaxation, trust, integrity, security, escape, cosmos, universe, among the stars, blue water.
Negative:	sadness, melancholy, depression, cool, cold
Examples:	Blue Skies Smilin' at me, blue chip, blue Monday, Singin' the Blues, blue with cold

GREEN: The color of nature and life

Evokes:	health, growth, fertility, Spring, rebirth, renewal, lushness, cool, go/safe, money, youth,inexperience
Negative:	envy, jealousy, poison, nausea, sickness
Examples:	Green light, green around the gills.

BLACK: The color of mystery and power

Evokes:	sophistication, chic, elegance, classicism, power, authority, mystery, uncertainty,
Negative:	death, mourning, fear, evil
Examples:	tuxedos, limousine, blacklist, black sheep, black magic

WHITE: The color of peace

Evokes:	purity, cleanliness, innocence, light, truth
Negative:	cowardice, surrender
Examples:	white knight, white horse, white elephant, white flag

subject matter — which is given through specific assignments in Chapter 5 — and to ignore the integral relationship between subject and concept.

The most successful stock today is that which conveys an immediate message to the viewer; it will communicate a thought or a concept.

If concepts are the ideas or emotions conveyed in a photograph, then it is through the use of icons or symbols that the idea is conveyed. Find the right symbol and there's your subject matter.

For example, the concept of *winning* can be conveyed by a photograph of a runner breaking a tape in a race; a still life of first-place medals; a silhouette of a hand with a trophy raised high; a horses's nose edging ahead of another's; a blue ribbon on a calf; or a simple laurel wreath.

The actual subject matter may be track, horse racing, 4H, or a classical Greek wreath, but the icons chosen convey the concept of winning.

This is nothing new. Thousands of years of history have honed and polished the symbols that we recognize and respond to in art.

The bull as a symbol of power and mystery may have first been used by the cave painters of Altamira, Spain, appearing again (reincarnated) as the Minotaur of Crete. A scroll represents not only the Torah of Judaism but all things ancient and sacred. A slingshot is the weapon of the biblical David, but also has come to mean the triumph of the weak. In the Catacombs of Rome the fish communicated as the symbol of the early Christians as did the icon of the lost lamb in Byzantine mosaics. Out of the decadent 18th century came the cherubs of romance and love — borrowed from an earlier and more innocent use.

The flag, the bald eagle, and George Washington emerged in 19th Century American folk art and endure as symbols of integrity, pride and patriotism.

In our own century and our own industry

an early proponent of the value of understanding non-verbal communication, photo agent Richard Steedman, brought to the attention of the photographic community, through his seminars on the relatively new science of Semiotics — the study of signs and non-verbal communication, some fascinating research in this area.

For centuries painters and sculptors have tapped into the collective emotional consciousness of groups and nations through the use of icons. This is merely an update filtered through the sociological and marketing points of view of the late 20th century.

How well you make use of this information and match your concepts to a symbol (subject matter) will make the critical difference in your success in stock — especially in the big money area of advertising.

Decoding a Photograph

An excellent technique for understanding concepts is to start with your clip file (here it is again), study the photographs in ads and decode them. Take each photograph and identify the concept; then study the icons or symbols that conveyed the concept. Were they successful, were they an imaginative use of symbols, or were they cliches (overused icons)?

What symbols could you use to convey a similar message? How could you say it better? What fresh approach could you bring?

It is important to understand that this process does not mean copying another photograph — what one agent calls "creative cloning." Not only might it expose you to a legal action for copyright infringement, but the imitation would simply undermine your creativity. The reason to study these pictures is in order to understand their success or failure and to bring an innovative solution to the problem.

Although the value of this approach was first recognized by the advertising community, there are valid applications in all areas of photography.

Symbols

Like the icons throughout the history of art, visual symbols are used to evoke certain emotions and associations. In stock they are commonly used to convey a series of basic concepts. Match these symbols with the list of concepts on the next page. Build your own list. Do you see other associations with these symbols used in photographs — or other symbols that would clearly express a concept?

Ball (baseball, football, soccer).............. competition
Ball (toy or rubber ball)......................... childhood, innocence
Sports (Football, running, boxing,
 pole-vaulting, tug of war):.......... controlled warfare, business competition, pushing to the limit
Teams... cooperation
Barn raising.. cooperation
Hands — shaking................................... cooperation, partnership, trust, honor
Hands — fist.. anger, threat, power
Hands — holding.................................... security, tenderness, trust, friendship
Dog... loyalty, friendship, trust
Horse.. endurance, strength
Bull... strength, mystery, power, Wall Street
Columns.. strength, security, power, history, tradition
Stone wall... permanence, stability, dependability
Fences.. stability, order, traditional values, good neighbors
Family... traditional values, warmth, nurturing, roots
Graduate... achievement, pride
Teddy bear.. childhood, innocence, comfort
Attic.. memories, tradition, fantasy, dress-up
Apple pie.. Mom, America, wholesomeness, traditional values
Apple...health
Bread, wheat...health, staff of life
Patriotic symbols (Flag, eagle,
 Statue of Liberty)...................... America, democracy
Rural icons (picket fence,
 front porch, barber pole)............ America
Modern equipment
 (Fax, car phone)......................... current, up-to-date
Road.. straight & narrow, mystery, adventure, unknown
Arrow.. hitting bull's-eye, hitting the mark, straight arrow
Wheel.. simplicity, eternal, movement
Clouds...heaven, cloud nine

Concepts

Convey these concepts through the use of visual symbols such as those in the symbols box or find new icons to illustrate the following ideas:

> Togetherness (family)
> Togetherness (couple)
> Tenderness (family)
> Tenderness (couple)
> Romance
> Sharing
> Fun
> Independence
> Winning
> Achievement
> Victory
> Teamwork
> Cooperation
> Partnership
> Competition
> Overworked Executive
> Stress
> Fear
> Values
> Trust
> Tradition
> Security
> Loyalty
> Responsibility
> Stability
> Courage
> Melting pot
> Role reversal
> Freedom
> Heaven

In terms of stock photography, there are several ways to make the transition from thinking and shooting subject matter to thinking and shooting concepts.

You can take headlines from your clip file and dream up a new way to illustrate those headlines. Let your mind roam. Or take a group of concepts and see how many possible images you can list that would make interesting visuals. Start with the symbols you've already seen used for a given concept. Now push your imagination to come up with new ideas for photographic illustrations. (There will be some suggestions for concept shooting in the stock assignment section.)

The concept of teamwork and cooperation has been illustrated with a variety of symbols: tug-of-war, barn raising, hands across a stream, and the ubiquitous handshake.

You can reverse the process by looking at what appeals to you: a prop, subject matter, or a location that is at hand, and pull out the inherent concepts. For example, if you live near a farming community, rather than planning a literal photographic coverage of farm activities, scout the location to find the symbols it has to offer.

A farm provides metaphors for abundance, harvest, fruitfulness, growth, sowing and reaping. Once you've considered the concepts it can offer, choose some specific subjects to use as your symbols. Perhaps a close-up of a back-lighted hand dropping seeds in a freshly plowed furrow for sowing; a cornucopia basket full of fruits and vegetables or a hand plucking from the tree a succulently ripe fruit, glistening with dew drops, to show reaping or harvesting.

And there are others:

- Power/strength: a handsome black bull silhouetted at the crest of a lovely green field.

- Nurturing: a ewe nuzzling a baby lamb.

- Challenge/risk taking: a spindly-legged foal struggling to walk.

As stock photographers we can become visual translators — from concept to icon to subject matter or the reverse — finding the symbols inherent in the subject and finally ending up with the expression of a concept.

The excitement of this approach is that you are able to cut through the mundane and find fresh ways to see — and you are freed to use your brain as well as your eyes. It is a great, creative escape.

Equipment, Lighting, and Film

The stylistic decisions you make with your eye and brain must be transferred to the film. Your understanding and mastery of equipment and technique will determine how close you come to your original vision.

There are choices to make in the areas of lighting, lenses, format and film. Consider carefully the contribution they make to the mood and style of your photographs — and to their marketability as stock.

Lighting

Since lighting sets the tone for a photograph, decide first on the atmosphere you want in a picture and then choose the lighting that will create that mood. Whether interior strobe lighting or exterior available light, your conscious choices will influence the mood of the picture. The right lighting can reinforce a sense of intimacy, the drama of technology, or the power of an institution.

Except for the occasion when you intentionally create a surreal effect, good lighting for a stock photograph will be consistent with the setting and mood of a picture. For example, the romantic glow of warm, golden lighting would be appropriate for a couple by a fireplace but would not be consistent with a modern laboratory scene. The exception might be when a sense of the past is warranted — such as in a recreation of Madame Curie or Louis Pasteur in their labs for an ad by a pharmaceutical company or a uranium corporation.

It isn't necessary for lighting to mirror the reality of a setting but it should enhance rather than conflict with the message. Lighting in a textile mill may be the flat, greenish institutional fluorescent which renders the worker and the threads of the weaving loom with a boring sameness. Use strobe lighting to highlight the texture of the threads, creating patterns on the workers face. Or color gels can be used over the background lights to differentiate the worker from the weaving equipment. It isn't the real lighting, but it dramatizes one aspect of the plant and is consistent with the essence of the location: a textile factory.

One word of caution — if you develop a single, standard approach, especially in your strobe lighting, using it as the one solution for all situations, you could limit yourself. Some photographers have a tendency to use a flat, even lighting for everything — just to be safe. All the details are clear and sharp,

but there is no extra contribution made by the lighting to the message of the picture. By using this approach, the photographer is missing a good opportunity to differentiate the pictures and reinforce the mood.

Interior Lighting

For interior shooting in stock today, controlled artificial lighting is virtually essential and in most cases, strobe is the choice of professionals. Since buyers have become accustomed to the technically expert photographs currently found in agencies, they will accept no less than top quality lighting.

The first decision to make in choosing interior lighting is whether you'll use strobe (flash) or tungsten (hot) lights. From personal experience I advise using strobe. Tungsten lights can be tricky. They draw more current and are uncomfortably hot on the models.

Tungsten is useful as a contributing mood light where your main light source is strobe. Tip: for a golden glow of warmth in a nighttime home scene, insert a 500 watt bulb in a lamp that's in the picture; shoot on a tripod, expose with a slow shutter speed (1/4 to 1/2 sec). The shutter triggers the flash, which goes off at synch (usually between 1/60th and 1/125th sec), exposing the main scene lighted by the strobe, then it stays open to fill with tungsten, adding a natural-looking glow from the lamp.

Photographers who have a command of interior lighting often mix their lighting for more dramatic effect; this includes using tungsten hot lights with strobe, and, on big productions, even the use of movie lights.

If you are one of these experts at lighting you don't need this section; but if you are trying to improve your interior lighting skills, it's much better to get a solid base working with strobes before starting the creative mix of lights.

The next decision to make is among the strobe units — whether to choose a battery-operated unit or one that requires alternat-ing current (electrical outlet). Travel photographers or those working out of reach of AC outlets, get good results with battery pack strobes, in units of 200-watt seconds, which are sometimes rigged with a small umbrella over the shoulder or bounced off a reflector card.

But these are measures for special circumstances. Mainstream situations will give the best results when lighted with at least a basic strobe lighting system.

If you have been working with strobes for your assignment work, on location or in the studio, the transition to stock is easy.

If you are just learning to work with strobe, you're in luck. There have been many improvements in equipment over the past few years, making strobe lighting easier to use than ever before. Equipment is lighter, simpler and more flexible. Some manufacturers have reduced their power packs to a mere seven pounds (from the former weight of 12-15 pounds), with an output of 1000 watt seconds.

Power for strobe flash units comes from the AC outlet at 110 volts and must be boosted up to 370 volts before the strobe fires. This function is handled by the capacitor in the unit.

There are two basic designs in strobe systems. The more commonly used design has a power pack on the floor. This unit houses the capacitor and all controls for light output to each head, up to four. The advantage is that you can control the ratio of light to the heads from one spot — instead of having to move light stands or go to each head for adjustment. The disadvantage is that you have something else on the floor for models to trip over. The heads however, contain only flash tubes, so are light and easy to handle.

The other design features the capacitor as a part of the flash head itself. This type is generally called a monolight. The head is heavy. Variations in light output are controlled individually on each head, which means if you are using three to four lights

you have that many places to go to when adjusting power output. Their design makes monolights useful on location for working in small spaces, since there's no power pack on the floor.

Visiting your dealer, trade shows and photographer friends will give you the basic research needed for a decision. Before investing in a system, see if you can rent a set of the lights you're considering and try them out for a few days to learn their quirks and strong points.

Write out a list of the basic items you want and submit it to several dealers so you can make comparisons on price.

What to look for:

- A lightweight power pack
- Fast recycling time (seconds needed to recharge capacitor)
- Variable output control (click stop)
- A manufacturer with a good reputation among photographers
- A manufacturer who has been around a while (longevity)
- Good service facilities (fast turn-around time)

Starting out, you can do a nice lighting job on moderate size spaces, with two units totalling at least 800-watt seconds of power, then moving up later to three or four units with a total of 1200 to 2400-watt seconds. (A word about "watt seconds." The term watt seconds has been commonly used by manufacturers, and by photographers, to indicate the relative power of light output of a strobe. Variations in the construction of the capacitor can affect the actual power, the watt second output. When you've narrowed down your choices, ask the dealer for a detailed explanation of the power output of the unit being considered so you can compare apples with apples.)

A basic starter set should include:

 2 heads
 2 light stands
 2 umbrellas
 2 reflectors
 2 slave cells — one for back-up
 (newer designs have slaves built-in)
 2 synch cords — one for back-up
 1 battery pack 800 to 1000-watt
 seconds or equivalent monolight
 heads
 protective case(s)

As you gain command of the lighting and feel comfortable working on location, you will want to add the following:

1-2 additional heads, umbrellas, stands, and slaves (to light larger spaces with greater subtlety), remote synch unit, soft box (for more subtle lighting of people), barn doors, scrims, snoots (for directional lighting), color gels (for dramatic effect or color correction), color temperature meter spot, and an exposure meter

Next, critical tools for taking the guesswork (and anxiety) out of lighting are a good flash meter and Polaroid testing equipment.

The meter allows you to measure light at various points in your picture, helping you to accurately forecast exposure.

The Polaroid shows you what the meter doesn't — hot spots, reflections in a computer screen, a harsh shadow where you don't want it, or an unflattering fall of light on a model's face. It provides a look at the lighting balance, depth of field or motion freeze. You see *exactly* what you are going to get. There are also technical advantages to using a Polaroid back when checking to see if the strobes are firing or to alert you to camera malfunction.

I heartily recommend that you have some Polaroid testing system — it will change your life! With plenty to worry about in this business — there is no reason to prolong the stress by working literally in the dark without a Polaroid for testing.

You can use a Polaroid back for your camera or a separate Polaroid camera, with adjustable f stops, just for testing.

Most of the medium format cameras — Bronica, Hasselblad, Mamiya and Rollei — have Polaroid backs as standard options. A Polaroid back for 35mm cameras was developed through the ingenuity of that great friend of photographers, Marty Forscher, of Professional Camera Repair Service in New York. Termed the "ProBack" and originally designed for use with the Nikon system, it is now available for most professional models of 35mm cameras and can be custom made for many others. (Check with your dealer or the NPC corporation in Newton, Mass.)

The prints from a Polaroid back give the same size image as the camera's film size but on the just under 3x4" Polaroid film. Processing time for color is one minute; B & W is 30 seconds. The 35mm ProBack can give two 24 x 35mm images per sheet of Polaroid film, shot in sequence. Though the image is only 35mm, the advantage is that you are seeing through the lens exactly what you will get, however small the picture.

Another route is to use a separate Polaroid camera, one of the older models which have f stops up to f64 and give you an image approximately 3x4". The larger image is a bit easier to read than a 35mm though it is only an approximation of what your in-camera framing will be.

I've had good luck with the Polaroid model 180, which has both focusing and framing in one viewfinder and with the older model 195 which requires separate viewing for focusing and framing. Both are good workhorses — almost indestructible despite repeated efforts on my part. These cameras are no longer made by Polaroid but can be found on the used market. (One source for used Polaroid equipment is Sy Hecht, Camera Mart, Babylon, New York).

Exterior Lighting

Though exterior lighting is familiar terrain for photographers, it doesn't hurt to remember the old maxim that the only light worth shooting by is from dawn until 10:00 AM or from 4:00 PM until sunset. That's a truism. In most cases you do want to avoid the harsh overhead light of noon.

Back or side lighting with or without reflector fill is inevitably more pleasing in photographs of people; light overcast or open shade is another style of lighting which is flattering to people. Avoid those harsh shadows from direct sunlight; eyes disappear and features are exaggerated. Reflectors or fill flash can be used to eliminate the greenish cast caused by foliage overhead.

Lenses

The choice of focal length is a matter of aesthetic choice but will affect the look and therefore market for your pictures. A rule of thumb is that wide angles characterize editorial photography — you get a broad view, the whole picture, with lots of information in both foreground and background. In advertising there is a tendency toward a close-up feeling — a sense of immediacy, often with the background out of focus.

Go back to your famous clip file — quickly separate advertising photographs from editorial photographs. Note what lens appears to have been used in each. See how many of the ads look like they were taken with 105mm or longer and how many editorial shots feet like 24mm. This will help when you're experimenting with your style and composition and give a clearer understanding of what lens choices to make for which market.

Cameras

Use what you've got or whatever you think would improve your way of seeing. Having a wide range of lenses available for whatever cameras you have is more important than which brand or model you use or whether it

is the newest autofocus or a solid old work-horse. I find a motor drive indispensable for the energy it saves. You are much more likely to get the perfect moment or expression and you can be more efficient with bracketing.

Format

Far and away the most common film size in photo agencies today is 35mm. More stock photographers shoot that format than any other and most agencies are set up to file 35mm. There is, however, an increase in the practice of duping the select images up to 4x5, especially among the agencies geared for advertising. The presumption is that some buyers find the large format easier to look at (especially those who do their critical editing by holding the chrome up to a desk lamp).

There is a shift toward medium formats, especially by some advertising and travel photographers. The traditional medium for-mat size that we've known for years in the Rollei, Hasselblad, Bronica and others is a 2 1/4 x 2 1/4" square film size which yields 12 pictures on a 120 roll. Then Mamiya, in it's RB series of cameras offers, 10 rectangu-lar pictures of 2 1/4 x 2 3/4" on a 120 roll. More recent entries, the Pentax 6x7 and the Fuji GW670II give the same 10 rectangular 2 1/2 x 2 3/4" images on 120 film in a more portable camera. An interesting variation is the Pentax 645 which hits in between the 35mm and the traditional 2 1/4" with 15 im-ages of 1 5/8 x 2 1/4" on a 120 roll.

There are variations on this theme. Stay in touch with your dealer and the trade press, or go to the trade shows to find the newest developments by manufacturers.

If you are already working in large format, by all means continue. As with many other aspects of stock, the choice depends on what works best for you and what your agency requests. There are enough variables to worry about without shifting from your com-fortable, tried and true choices of equipment — especially if they are compatible with your agency's marketing strategy.

Film

Virtually from the beginning, color reversal film (transparency/slide) has been the choice for stock. It is first generation and therefore sharper than a print from a negative. Recent technological advances have made all our previous assumptions open to question. There are rapid and major improvements in color print film by Kodak and Fujii. We are seeing — especially from photojournalists — color prints in many of the news photo agencies. And, already we are seeing the grainier, high-speed color print film in some of the news photo agencies. Stay alert to the changes, watch the trade press, talk to your dealer and test new films as they come out. But unless instructed otherwise by your stock agency, stick to color transparency film for your stock shooting.

As long as the results are technically ex-cellent and the color pleasing, the choice of film is up to you. Your taste will be the de-ciding factor.

I had been a die-hard Kodachrome user. Kodachrome 25 and 64 were like classic good wines. Recently, though, I have tested Fuji, Provia and Velvia in natural light situ-ations with very nice results. However, I wasn't thrilled with the skin tones in tests done under strobe lighting. Many photog-raphers have been attracted by the vivid col-ors Fuji or the new Ektachromes such as Lumiere deliver, particularly in landscape or other exterior work. Those colors are consid-ered less "natural" looking than Kodachrome, but offer a more punchy, vi-brant color, which is becoming very popular.

Except in very special circumstances, faster films are not generally regarded as good for stock because of the increased grain.

Filmless (digital) cameras will provide the next "film" you must master. A few agencies handle digital files already and there are elec-tronic rights agencies which are totally digi-tal. Some agencies handle digital files but that is not yet the norm (see chapter 13).

If you haven't settled on a film, I suggest some tests, using films that appeal to you most and using the same lenses and conditions for each one.

Try the following:

- Landscape or cityscape — sunny (include a variety of colors: green trees, blue sky, white clouds, red barn, grey skyscraper, yellow traffic sign, red & white flag,)

- Landscape or cityscape with people, same day, location and lighting (check skin tones.)

- Same location — open shade/light overcast, no people.

- Same Location — open shade/light overcast with people.

Have all of the processing of this test film done by your professional lab on the same day. Let them know it is a test so that all film will go through on the same run.

Then go through the same process in the studio with strobe lighting. Use grey cards and color control patches (available at most camera stores) as well as objects of various colors. And, of course, people.

Check your results. Match the whites to see which are cleanest. Match the reds. Which are most vibrant? Match greens — do they move toward the blue or yellow? Which pleases you? If you work through a stock agency, discuss it with your agent who probably has a preference for a particular color tonality.

Black-and-White is alive, if not awfully well, but should be making a comeback soon. Fewer photographers have been shooting black and white and the resulting shortage of good black-and-white images in the market for the past 5 years most likely came about because of a switch to color by most clients. The increase in color re-

quests had been dramatic enough to discourage the production of black-and-white, a factor compounded by the additional costs involved with producing black-and-white and the comparative stagnation of reproduction fees for black-and-white in the past ten years.

As all photographers but few buyers understand, it costs more to produce a file-ready black-and-white stock photograph than it does a color transparency, all other things being equal. If the talent and time, expenses for props or location are the same, consider the following statistic:

A B&W print costs 3 1/2 times more than a 35mm slide to put in the file.

Let's say you did a shoot of a grandfather and grandson fishing in a tranquil lake. On one of the variations, done near a covered bridge, you shot one roll of B&W and one roll of color. Editing out bracketing, bad expressions and so forth, let's assume an arbitrary yield of eight excellent pictures on each of the rolls of 36 exposures. Consider that both black-and-white and color require similar work in marking copyright credit and file caption labels. We are down to calculating just the cost of materials, which is when you see how much more expensive it is to produce a finished black-and-white print. (Your time in processing and printing B&W must be figured at the same cost as a custom lab print.)

Given that black-and-white photography is in short supply and that the market has been glutted with color, it is natural to assume a pendulum swing back toward it — and that is just what appears to be happening. It is possible, too, that black-and-white will command its rightful price if the buyers, aware of the shortage, are also informed by photographers about the cost factor. Love of black-and-white photography has worked against photographers in their efforts to equalize the price. This is a good moment to put some energy back into black-and-white, if that's your strong suit — and you are willing to charge for it!

Filmless Cameras

While you will want to continue with silver-based film for your current traditional stock shooting, know that filmless cameras are here and in use.

Among the main users of filmless camera, when speed is more of an issue than critical sharpness and color balance, are photojournalists working on newspaper deadlines. Catalog studios also find the resolution acceptable for the often relatively small images needed, especially when weighed against the savings on film and processing.

They are worth serious investigation by those who plan to do digital imaging which include the merging of several images. The prices will be coming down and capabilities increasing. The resolution may not be up par yet — especially for photos including people in action — but the time is coming.

For more information on filmless cameras, including a thorough pro/con listing of characteristics, get the excellent and highly readable new book *Digital Imaging for Visual Artists* (see bibliography) by Sally Wiener Grotta and Daniel Grotta.

Technical Excellence

Mastery of the technical aspects of shooting for stock — the lighting, lenses, format and film — is essential to building a file of marketable stock. Color remains the top seller in stock, large format dupes are gaining in popularity, good interior lighting is expected — this information will influence your choices. But the key to your success is how well you merge your own style with these techniques.

Shooting What's Needed

There are significant, saleable subjects for stock photography that are largely ignored, even by many professionals. Though travel, nature and animals have been traditional best sellers — and certainly they are appealing subjects, rivaled only by couples on the beach and executives at desks — there is more room for success in other areas.

What you need to know is that there are large gaps in the photo files and that agencies are crying out for photographers willing to cover these areas in the style needed. But many photographers are puzzled about exactly what to shoot — where to invest their valuable time and energy.

Compounding the confusion is the fact that many of these photographers, eager to get into stock, look to see which pictures are selling well as a guide for their own shooting. Seminars and books constantly tout the current "bestsellers," proclaiming the amount each of those images has earned. Ironically this leads still more photographers to go out shooting for a slice of the same pie — glutting the market with the same subjects. These misguided but energetic shooters are just increasing the competition — drowning each other with couples on the beach, clouds, or whatever other hot subject was discussed at a recent seminar.

An easy way to avoid that pitfall is by concentrating on what hasn't been covered at all, or been covered in the right way.

That's what the assignments in chapter 5 will offer. They will target specific areas of overlooked subjects — the stock ideas you never thought of — the ones you've known about but couldn't get a handle on. They will also outline certain concepts that are in constant demand.

Just as important, you will learn how to get from the idea stage to the actual shooting, by using the stock assignment forms. These will provide guidance on how to shoot for an excellent untapped market, and, in many cases, without even having to leave your own bailiwick. The assignments are designed to help make the pictures happen by cutting through the confusion of what to shoot, the morass of details and the production procrastination that can block the way from an idea to finished stock. Chapter 6 completes the job by showing how to produce a stock shoot.

Why are there gaps?

In the past stock came mainly from assignment outtakes. Some of the gaps in stock agency files exist because certain topics have simply never been part of an assignment.

Other subjects may be available in stock as assignment outtakes but were shot with the narrow purpose, style, and shape of the assignment in mind, rather than a generic approach. This severely limits their re-sale value.

Many of these gaps are still not being filled because the subjects are unknown to the average photographer. True, some photographers who shoot only for stock have begun to fill a few of the gaps left behind by assignments. But most of them, dazzled by the bestseller-syndrome, get sidetracked into going for the same market as everyone else — shooting what has already been done to death and essentially ignoring large productive subject areas. You can step in to fill these gaps.

What are these Gaps?

Essentially, they fall into three categories:

- **Holes:** Those subjects or concepts that have rarely, if ever, been covered. Some of them will surprise you. It seems they should be readily available but, surprisingly, they are not.

- **Style:** Those subjects that have been covered but not in the right style. For all the reasons discussed in Chapter 2, there are many photographic topics that are available in stock but that have a very limited application due to the style in which they were shot.

- **Supply:** Those subjects that are available, but never in enough supply, or which constantly require updating.

Let's talk about the holes — those photo topics that you can't imagine haven't been shot. The saga in Chapter 1 of my client's search for a Hispanic family picnic is the tip of the iceberg. With amazing regularity, I hear stories from clients of photos that should be easy to find but aren't. Here is another one: gymnasts.

For a trade ad of a new vitamin supplement, a client needed a photograph of people — teens or young adults — doing gymnastics. They wanted to avoid celebrity or world class competitors. Wouldn't you expect them to find it in stock with ease? I did. But no, their search turned up lots of grainy pictures shot with high-speed color film in available light — without releases. Most of the pictures appeared to have been shot during local competitions and were set in school or community gymnasiums, grabbed during the actual event under existing light.

What the client needed, which would have secured the sale for an enterprising stock photographer, was a bright, sharp, strobe-lighted picture, of healthy-looking (model-released) athletes in colorful gym clothes doing routines on the balance beam, rings or parallel bars. In the end, unable to find an appropriate existing photograph, the client gave out an assignment. Will the well-lighted, model-released pictures that resulted from the assignment make it into stock files? Not easily. The assigning client placed the vitamin company logo on the wall in the center of the picture. Making it good stock would require extensive computer retouching.

The gaps in stock supply result because there are recurring areas in which there can never be enough pictures — family, especially ethnic, tops the list; as do any subjects that are part of a rapidly expanding market, such as upscale Hispanics, the elderly. And there are topics that require constant updating: scenes showing computers or other high-tech equipment, for example. These topics are not redundant — while couples on the beach are.

Societal trends change rapidly — and you can be sure that advertisers and magazine editors watch them like hawks. To be ready for the next wave of picture requests, stay up with the times, read the newspapers and magazines. Be aware when ski-boarding supplants skiing as the sport of the young. Follow what's happening in the world today to get additional clues for good future stock.

Don't forget about technology. Today the fax machine in the office or home setting, is as essential for current looking stock as the computer was ten years ago or cellular phones, just five years past. What is the next bit of technology that will be hot? Watch for it (read the business section of the paper), and when it happens, be quick to include it in your pictures. Don't wait until you see it in someone's stock photo catalog.

Stay alert to changing events. By the time you read this, there may be a demand for travel pictures of Bosnia. If the current uneasy peace holds in the region, it could be only an eye blink before editors request photos of the renaissance of the Balkans.

The stock assignments in the next chapter will give you an entree into current and classic stock needs. You can maintain that advantage by staying informed.

Stock Assignments

As stock shooters, we are often out there alone, handling everything from the concept to the final execution — and sometimes without the necessary tools to make sure that saleable stock results from a shooting. The assignment photographer receives guidance, information, and support from an art director. With the *stock photo assignments* provided you will have the same edge for your stock shooting.

The 25 stock assignments in the next chapter are designed as a series of step-by-step outlines giving detailed photo specifications. Their purpose is to give a cohesive approach to each day's shoot, by helping you concentrate on the essentials of your stock shooting without losing sight of the critical details.

Going from an idea to the actual creation of good stock is not easy. It can be a formidable task to organize a shoot and then carry off a flawless shooting day. There are just too many things to remember.

You need to:

- make sure all the models are dressed properly, (does that jacket need ironing?)

- ensure that the props are in hand (are all the labels removed?)

- see that the location is the way it looked when you scouted it, (someone has been doing repair work on the steps, can I avoid it with a different angle?).

- check schedules (now one of the models has to leave 1/2 hour early!)

Having the tight shooting script provided by the assignments gives you something to hang on to in those moments of chaos, something to give focus and direction to the shoot.

Just as an assigning client gives you explicit instructions, the assignments will let you know what to shoot: the underlying concept, the problem to be solved, and, in most cases the subject itself. There are lists of models and props needed, and tips on what to avoid or include. To help you get the most out of each set-up day, the assignments detail 4 to 6 variations for each scene.

These assignments go beyond what most clients put on a storyboard or photo specification. Here are the most useful approaches, the do's and dont's, advice on avoiding the most common pitfalls — all available, at your fingertips, while you're shooting. You have the information on procedures needed for a successfully planned shoot.

When you are free to add your own unique interpretation, just as you would be on an assignment, your creative vision is what makes these pictures come alive.

And, since the stock assignments ahead are your version of having an assignment client working out the specifics of a shoot for you — all that is left for you to provide is someone, breathing down your neck, to make sure it gets done!

Planning a Stock Project

Experts in the field, including experienced stock shooters, agree that the most valuable stock is part of a body of work and, with rare exceptions, much more useful than random single shots of various topics. Agents and buyers want to see coverage in depth. That means various executions of the same concept or area of interest.

But many photographers make the mistake of shooting in a haphazard way, not realizing the importance of developing a cohesive coverage. Specialize! At least for the short term. Concentrate in an area either that especially interests you, one that lends itself to your skills, or for which you have easy access to locations.

Go for coverage. If you are building a file of photographs of family scenes and accumulate 8 to 10 pictures covering 5 different concept executions for each family — *that* is coverage. Naturally you will have many variations — horizontal and vertical, wide and close-up pictures — to offer on each of these situations.

One photographer I know made a small fortune doing studio still life close-ups of flowers. He then branched out into vegetables. Last heard from he was working on shells. A simple idea, but he did it in depth and well.

The way to make this body of work happen is to choose your areas for shooting and then set a production schedule. It helps to actually write out a plan.

Create a *stock project*, give it a title, and then forecast a schedule for completion. You can use this plan, and the stock project approach to keep yourself motivated and to explain your purpose to others — especially when you're asking for their help.

The best way to use the assignments that follow is to select your assignments based on technical and aesthetic considerations. To aid you in doing that, match your skills and preferences. Then look over each of the assignments to see which match the strengths and interests you've identified.

Choose from the assignments in the next chapter, once you've got 8 to 10 that seem right for you to start with, then go to the concept lists and expand from there. This will give you a broad scope from which to make your plan.

Stock Forecast Plan

At this stage you should forecast a 6-month shooting schedule. Plan the amount of time you will devote to building a stock file. It won't happen just by thinking about it — there is never enough time. But if you create a plan, it becomes manageable and you will make it happen!

List the number of assignments you will shoot per month:

- How many shoots per month can you handle (1 day each)?

- How many set-up days will each require?

Put proposed shooting dates on a calendar, then work to meet that schedule. There will be some adjustment as you learn of model or location availability, adjust to changing weather conditions, but having a schedule gives you a step up in planning.

Before making final assignment choices, look ahead to see the aids — sample letters, storyboards — to help carry out the production aspects of a shooting. Knowing that these production techniques are available will enable you to plan for shoots that might otherwise seem too daunting — and open up certain stock assignment possibilities.

Creating a stock-shooting blueprint will avoid the low yields that result from scattered shooting and offer an integrated file of stock subjects in an amazingly short time.

Ethnic Diversity

Most stock photographs are made more useful if they include people of various eth-

nic background engaged in mainstream pursuits.

You'd be in great shape if you covered every ethnic group in all assignments that called for people! That's a possible long range goal, but it's nearly impossible when starting out — and a recipe for frustration. (There are so many things to do that, like the laboratory rat in the maze, you could run yourself ragged and end up not doing any of them).

When setting your stock plan, one approach is to take a category of assignments, for example families, and cover them in all variations and in all ethnic groups until you have excellent in-depth coverage for all groups in those specific topics.

Another, equally sound approach is to take one ethnic group and cover it in a wide range of topics and concepts, until you have that group very well covered. An excellent file, say, of blacks, in every assignment listed here, would have great value.

The value of photographs of ethnic groups can be pegged in a rather analytic fashion to the percentage (and thus the buying power) of the population they represent.

Roughly follow this population breakdown:

White	62%
Black	21%
Hispanic	12%
Asian	4%
Native American	1%
Women	54%
Elderly	19%
Handicapped	5%

Of course, this may vary greatly depending on what regional markets you target. In New Orleans, for example, Blacks comprise some 54-60% of the populace. Hispanics are a major factor in South Florida, California, and the southwestern United States.

In 1991 we'll have the results of the 1990 census. Look at those figures carefully. Seeing where the changes are will give some direction for your coverage of specific ethnic groups. Interim demographic studies have shown that Hispanics are the most rapidly growing segment of the population, with Asian-Americans next.

If you live in the southwest, have an interest in the culture, and speak a bit of Spanish, you might concentrate on photographs including Hispanics. If you have good contacts in the black community, this might be a logical group to work with. In this country, we have a diverse culture — good stock should reflect that for one very pragmatic reason: stock photography clients market to all segments of that diverse buying public.

Concepts in Assignments

As you approach the assignment section and begin to make choices, note that among the assignments, some are expressed as *concepts,* others in the more traditional *subject* format.

No matter what assignment you choose to shoot, remember that almost any subject can be expressed in a symbolic as well as a literal or pictorial fashion.

For example, take voting as a topic. Here is the same scene with two interpretations, one conceptual, the other, literal.

Photo:	Close-up of a hand at ballot box with a flag behind, tight, graphic, symbolic.
Concept:	Democracy, suffrage, government "by the people"
Photo:	Medium-wide angle. Group voting, mixed ethnic, voters in line, and poll watchers.
Subject:	Voting, election process

Starting with the same raw material, you have two possible approaches. If they are model-released, and well-lighted, both will be good stock. (See chapter 14 for a full discussion of model releases.) The symbolic approach is suited to ads, public service messages, campaign literature, book covers or

unit openers. The literal, pictorial approach might be used for textbooks, encyclopedias, and government brochures.

In terms of planning a shoot, the three major markets — advertising, corporate, and editorial — actually boil down to two, advertising and editorial, since corporate clients can often use photographs that are suited to the advertising market.

So the choices you make in designing the style of your shoot will affect whether the photograph is likely to be considered by the lucrative advertising market or only in the high-volume but lower-paid editorial area. This is why the conceptual approach is critical to keep in mind, as it is the key to successful sales to ad agencies and corporations. Turn any *subject matter* into a *concept* — it will benefit you in the long run.

It's worth a look at some other subject areas to see how they translate into concepts. A word about photographs of families: no matter what the specific activity involved, a successful stock photo of a family should convey one or more of the following concepts: intimacy, togetherness, caring, play, leisure.

When you are shooting any of the family scenes in these assignments, keep these concepts in mind. As the scene is set up, ask yourself: Does it feel intimate and caring? Is this group a unit, are they interacting? Does it show playfulness, people having fun? If not, adjust the activity, the positions, or the action of the models until it feels right.

In the assignment forms, there is an indication of the concept (or concepts) that can be conveyed by the subject. If, in the energy and enthusiasm of getting a great stock file going, you exhaust the assignments provided, you'll begin to create your own. In Chapter 5 you will find a blank form to use for creating additional assignments.

When preparing your own assignments consider how to approach each shot. Again, start with the concept you want to convey, then match with subject ideas that are appropriate and interest you, the locations and models easily available in your area.

Approach it from another angle. If you have a particular subject you're really dying to shoot, continue to analyze that subject in terms of concept. What basic concept does it symbolize? Can it be read to mean something general, universal? If that is clear in your mind before shooting, there is greater assurance that you'll have a terrifically usable stock picture.

A subject as simple as fishing, for example, with certain variations in the actual photograph, can convey different concepts.

Fishing has been used

- as a metaphor for peace and tranquility: the quiet pond with a lone fisherman

- as a sport, showing action, vigor, and the challenge of nature: the person with rod bent double, landing the "big one"

- as a symbol to show togetherness: a grandfather teaching a boy how to bait a hook

- as a sign of the contentment of retirement: a silver-haired couple fishing contentedly on golden pond

- as a symbol of the emotion of pride: person with trophy-size fish held up in triumph (or child with pride in a fish of any size).

But before you spend time and film on a fishing scene, or any scene, be clear about what concept possibilities are inherent in the subject and which ones you want to try for. Design the picture accordingly. Otherwise (forgive me), the resulting picture may be neither fish nor fowl...in stock terms.

The assignments are next. Make your choices and get started. Have fun!

Thirty-Five Stock Assignments You Can Shoot

Now to the photography itself. The assignment forms indicate the purpose or concept for each shooting — what an art director would have assigned you to convey. The forms include specific guidance on models, lighting, and props, to make sure each assignment results in saleable stock. They also tell you what not to do.

Building Coverage in Depth

This system will be most effective if you approach it as a starting point. Take each assignment and expand on the variations as if you were building a file from each one.

To begin your shooting, narrow down the assignments in this section to those that interest you most — those which match your style and abilities. Carefully analyze each one to find additional variations that are inherent in the topic. Imagine how you could cover each model in each situation — and find new ways to express the idea behind the subject. The variations I've listed on the assignments are intended to lead you to other possibilities, not to limit you to what's there.

For example, look at Assignment 2, Gymnast. There are just six variations listed, but if you expand the ages and genders of each model, using each piece of gymnastic equipment, it adds up fast. You could do each of these with an instructor in the picture, and some should be repeated with different ethnic groups.

Clearly, you will need a number of shooting sessions to cover all of this. (Remember, you are not grabbing pictures but building a file of professional-level photographs.) Each variation should be as fine-tuned as if it were the only shot on an advertising assignment.

Assignment 12, Elderly/Winter, also lends itself to multiples. Consider it a two-winter project. The first year, take three couples through a series of winter events and sports. The second year, do another group. Think long-term.

Not every assignment will yield multiples in quite such a convenient manner, but imagine every conceivable approach. That's how you come up with fresh angles and variations. You are building deep coverage. That's what justifies the investment in advance planning. It will pay off handsomely.

Clients (or your stock agent) will come back to you for depth of coverage. It's important that they know you are not just a one-shot file.

Why These Assignments?

The topics in these stock assignments are needed because most stock photographers have not covered them in the right style, or because there can never be enough coverage on certain subjects. In some cases the topics presented have barely been covered at all.

Included are assignments that are fairly easy to organize and set up, while others are major productions that require considerable advance planning, such as the Crowd (#13) and Festival (#14) scenes. Because of the effort involved, however, there have remained gaps in these topics — meaning the situation is ripe for the enterprising photographer. These topics are well worth your time and energy.

Let's look at the assignments with problems of style: the Team (#2), Gymnast (#1), Emotion/Pride (#9), and Family Meal (#7). From time to time you will find a decent team photo — perhaps of a school soccer team or a Little League game — but these pictures rarely have the critical elements required for saleable stock: model releases, role reversal, and players from different ethnic groups. Often these team pictures are shot casually when a child or friend's child is playing — documenting (or grabbing) reality, complete with uniforms that have sponsor brand names.

There is good coverage of professional and amateur gymnastics. But such pictures are almost all shot in available light, indoors, and with grainy high-speed film, creating problems with sharpness and color balance. Most are taken during actual competition when additional lighting would not have been permitted. Even editorial clients, unless they are showing a specific, newsworthy individual competitor, are demanding a higher level of quality in color and sharpness than previously. And without a release there is no advertising use. This gap may seem surprising, considering the coverage of the subject. Until I saw a wide selection of gymnastic pictures a client had received from various agencies, it did not strike me that such a seemingly common subject had not been properly covered.

To shoot a photograph which shows the feeling of pride, Pride (#9), there must be a context to convey the emotion. There are many photographs of sports winners which indicate pride and pleasure in achievement. But they are usually news photographs — busy, confused ones showing signs in the background and unidentified people. For advertising use or even a psychology book discussion of emotion, stock agencies need clean, clear depictions of emotion done in rich, sharp color. Two things must be evident: the facial expression of pride and the source of the pride. An artifact, such as a trophy or blue ribbon, can give a visual clue. All distractions must be removed. This is quite a simple set up.

Pets (#16) is an interesting topic — done to death in a predictable manner. It is a large market and offers extraordinary opportunity for the imaginative photographer who can bring a new style and look to it. Don't bother if your approach is the same as what's been done.

Some topics are so valuable in stock that there can never be enough of them —or there is a combined need for the right style and quantity: Family Meal (#7), Elderly (#6 and #12), Teens (#s 11,18,19), and Houses (#8).

The Hispanic family picnic anecdote in Chapter One clearly presents the problems associated with many family photographs that aren't designed for stock: careless propping, unsuitable wardrobe, cluttered backgrounds, poor model interaction, and a lack of model releases.

Senior citizens have become vocal about demanding representation that puts them in a positive light. Advertisers know from demographic research that the over-fifty population is rapidly increasing and they must pay attention to this market. You can rarely go wrong photographing active seniors — the topic is a perennial bestseller.

There is good material currently in agen-

cies on this subject but they run through it fast. In spite of the number of pictures available, there are relatively few photographers who are successful in this market. If you are good at photographing people and have access to attractive elderly people, get in on this action. (This is where choosing models, having model releases, leaving space for type, and being sure to have verticals will make a big difference in sales.)

The challenge is to find new and interesting settings in which to show the elderly as happy, productive people. The coverage of Seniors in Northern Climes (#12), will be particularly valuable because the enjoyment of winter by the elderly has not been well-covered. Most portrayals of seniors show them in warm, Florida-like climates. Advertisers want to show seniors in a broad spectrum of life styles. (They know that older people would resent the characterization that they only live in lotus land.) Any way you can show the elderly as mainstream will help sell the picture.

There are never enough photographs of Homes (#8) that have property releases. The gap here is in the available quantity of photographs and in the need for releases.

We see the exteriors of houses regularly pictured in ads for insurance, banking, and so forth, but there are not many photographs available in proportion to the need. Stock agencies are always looking for a fresh supply.

Releases are critical to obtain good sales here. Getting them will be easier for photographers outside the major metropolitan areas. In small communities the offer of a portrait of the house will often get you the release.

Houses are an excellent topic for the photographer who is not proficient with strobe lighting, or not yet comfortable with directing models. It could be part of an ongoing project to build a file of different styles of housing.

Once the location research is done and property releases obtained, this coverage could easily be handled on weekends, or with just a few hours at a time devoted to it during the week. It can be a very pleasant type of photography because you don't have the pressure of finding models.

A stock agency would be delighted to get a collection of house photographs taken correctly, that is, with property releases, taken in good light and in a variety of seasons, avoiding telephone wires, dented mail boxes, and the like.

Any coverage of teens is useful — the assignment topics Teens Dating (#11), Teens Showing Affection (#18), and Teens Showing Dress Conformity (#19) fill specific needs for editorial as well advertising usage. There is good overlap here.

There is wide application for these pictures: ads for acne medicine, insurance posters, bank ads for education loans, textbooks on family living, community service warnings about drugs or aids — the list is endless.

Anyone who has raised teenagers can imagine the reasons why these photos are hard to get — adolescents don't like having their pictures taken, especially with the opposite sex. Researching the models (and getting releases) is the key to this topic. There are outgoing teens who would find it a lark to be in pictures. High school or junior college drama students are ideal, as are professional models, of course.

People Communicating by Means of Speech (#15), is a neglected topic also. There are photographs that incidentally show communication, but which were not shot for that purpose — and usually they don't quite make it. Photographs of people making speeches usually have much to do with who the person is. Photographs in this assignment featuring teens have saleabilty to book publishers, while the executive and management types are useful for corporate brochures.

Gaps can be created by emerging trends that must be documented, such as heightened health awareness, new legislation re-

sulting in smoking bans (#10), and the concerns of activist groups (#22) like MADD (Mothers Against Drunk Driving) and SADD (Students Against Drunk Driving). They have primarily editorial application.

These topics are naturals for photographers working in the friendly atmosphere of small cities or towns. There is often less cooperation in large cities, where life is hectic and where a photographer requesting assistance is more likely to be a nuisance than a novelty.

Coverage of Main Street America (#3) and the Shopping Mall (#4) is almost nil. I've had numerous requests from clients for these topics.

There are photographs of malls but they rarely include models who have signed releases. The subject is especially good for photographers in warm climates like Florida, Arizona, and California, where malls have good daylight because of open designs commonly featuring skylights, atriums, and patios. Community activities such as benefit raffles, art shows, and musical events are also more likely to be held right in the mall.

This is not difficult shooting if you scout the location and bring a few attractively dressed models. By changing the model's clothes (jackets are enough) and moving them about, you can get a variety of angles in a few hours of shooting.

An absolute gap, Handicapped Person Socializing (#5), is part of a greater need for photographs that show the handicapped in a positive light and reflect the productive contributions they make to society. This topic will be especially saleable in the textbook market.

There is some coverage of handicapped people in various occupations, but at this writing, I know of none in the major photo agencies which shows attractive, lively handicapped people in social situations. How do I know all this? Through clients, particularly when I've been working with them on large-scale assignment projects. I've had occasion to see the research compiled for other seg-

ments of a project and to hear the concerns expressed by clients about what they can't find. (Listening to clients is the greatest research you can do!)

The studio set ups (#19 and 23,) are simple themes that have constant application. Once you have the techniques worked out, go further with them. Search for more sophisticated expressions. Play with words or objects to see what concepts you can illustrate. Take rope or string (knotted, tangled, frayed) and see what graphic representations you can bring out of them. Or try fire — things that are burned, scorched, charred, fried. What concepts do they suggest?

The studio set up Writing (#24) is primarily for an editorial market. English textbooks constantly need strong design and fresh approaches in expressing the concept of language. Alternates shot with corporate writing utensils would widen the market. This assignment combines studio shooting with the chance to use your street-shooting awareness.

There are a few tough assignments (#20, 24), Cecil B. De Mille extravaganzas; but if you have access to some of the props or locations needed, half the battle is won. They are well worth trying. (If you have contacts at a school or university that has a stadium, it won't be difficult to group a crowd. Or if you live in a rural county seat and have access to a corner of the fair grounds, that, plus some streamers and six people become the close-up of a festival.

Perhaps you are thinking, what ever happened to the just-walking-around-shooting-what-I-see-and-like method of creating stock? Is there any market for that? After all, these assignments are not as simple as grabbing a camera on Saturday and going out to find the light. Of course, good photographs on almost any subject can be applicable and may sell very well. (There are a few brilliant photographers who have been doing it that way for years.) Be aware, however, that you will be competing with those who have cut out that niche already. And there are also

all the *others* — those photographers who don't have the discipline or energy to concentrate on what is needed.

My system is designed to help the photographer who is dedicated to building saleable stock in a short period of time. Once you have a start on a good file, by all means continue to walk around and shoot. With your heightened awareness of what makes good stock, your spontaneous shooting will probably have greater potential.

Markets Covered

Though some of these assignments are limited to specific markets suitable only for corporate or advertising use — many of the assignments could be used in any of the markets. It simply depends on your style and execution. As we discussed in Chapter 2, the literal, informational, wide-angle approach leans toward editorial style, while advertising is looking more for the close-up, the graphic, and the symbolic.

Revised Assignments

This second edition includes new assignments in keeping with the changing trends in society, in the market, and in the stock agencies.

The new assignments reflect contemporary lifestyles. The phenomenon of the health club (#27) as a surrogate home shows a significant shift in socialization patterns, not merely part of a fitness craze but an alternate aspect of community life, the pub of the twenty-first century. Showing teenagers (#21) with the power of discretionary income highlights the fact that young adults keep getting younger in terms of their force as consumers. The preoccupation with health care will continue to expand as Baby Boomers age, and Gen X-ers move into mid-life (#10, 30). Today's business life (#25, 26) blends executive power with an unabashed casual outlook. Look around for your own examples.

Digital Assignments

For those with experience in image manipulation, there are several digital assignments (# 32, 33, 34, 35). Digital images require hard work but can be extremely creative and valuable stock.

The basis of every digital image must be an idea with powerful impact. Just as with traditional film photography, dazzling execution isn't enough. Technique without substance will produce shallow, ultimately unsalable photographs.

Expertise and access to imaging equipment are essential starting points, but these assignments will be most useful for those who have experience producing stock and already have large stock files to provide a bank of images for scanning. A knowledge of computer graphics is valuable for creating sophisticated combinations of photos and digital effects.

The ideas for digital images listed in the assignments are just the beginning. Many traditional photo topics lend themselves to image manipulation, so use the assignments as a jumping off spot. Try creating an image of the "cybernerd" to portray the twenty-first century hacker in total absorption and obsessional involvement with electronic technology. Or approach a more complex issue such as global water problems and illustrate the global aquifer being sucked dry through a straw by greedy humankind. Have fun!

Creating Your Own Assignments

Once you've completed all the assignments, apply the same approach to other subjects that appeal to you. The blank assignment form in this chapter can be used to modify any of the assignments or to create new ones for yourself. Go to it!

STOCK ASSIGNMENT No 1

Category: *SPORTS (Gymnastics)*

Purpose: *To symbolize skill, poise, concentration, and competitive spirit. To show strength, muscle tone, good health.*

Subject: *gymnast alone and with class or instructor, doing range of gymnastic exercises*

Variations:

a. *teen on high bars* d. *single with instructor*

b. *boy on rings* e. *group with instructor*

c. *girl on balance beam* f. *teen on parallel bars*

Frame Shots	Space for Type	Lighting
☑ Horizontal	☑	
☑ Vertical	☑	☑ Exterior (available light)
☑ Wide	☑	
☑ Medium	☑	☑ Interior (strobe light)
❏ Close-Up	❏	

Models: *teens 15-19 boy & girl* **Ethnic:** *white, Asian & black*
 kids 6-10
 adult Instructor

Props: *leotards & exercise clothes in* **Locale:** *nice-looking gym*
 bright colors

Include: *extra space in horizontal &* **Avoid:** *leotards with busy print, writing,*
 vertical for type *or logos, bare legs*

Note: *Lighting is important to this assignment. Need strobe coverage to get sharpness and good color balance. Also, have instructor point out proper form so that photo shows accurate gymnastics. Take notes of various maneuvers for caption purposes.*

Category: *PEOPLE (Kids): Groups/Teams*

Purpose: *To show varying aspects of team sports as an icon for cooperation, concentration, strategy, health, energy and healthy, active kids as symbol of future. Concept of group.*

Subject: *team in action — soccer or baseball (Little League) include girls (role reversal)*

Variations:

a. _____ *goalie in action* _____ d. _____ *coach with 1-2 players* _____

b. _____ *girl catch/throw, cu* _____ e. _____ *team prep/psych for game* _____

c. _____ *pitcher (& catcher), cu* _____ f. _____ *opposing teams shake hands* _____

Frame Shots	Space for Type	Lighting
☑ Horizontal	☑	
☑ Vertical	☑	☑ Exterior (available light)
❑ Wide	❑	
☑ Medium	☑	❑ Interior (strobe light)
☑ Close-Up	☑	

Models: *kids, team age range 8-10, and coach*

Ethnic: *ethnic background mixed gender mixed*

Props: *Ball, bats, gloves, etc. If team shirts have brand name, create fictitious teams, use colored sweats.*

Locale: *attractive playing field*

Include: *clean background, trees, fields*

Avoid: *team shirts with sponsor names, brand names, billboards, graffiti in background.*

Note: *It would be good to do this as two separate shoots. First, shoot what happens naturally at an actual game. Then do a recreation shoot using one team at practice or at a special session for photography (offer team portrait as inducement). Do the best scenes you remember from the real game with extra coverage, e.g. the girl with the most intent expresssion at bat, two kids with coach, two kids in opposing jerseys shaking hands.*

Category: *COMMERCE* — *Downtown (Central Business District)*

Purpose: *To symbolize small town/city America, "Main Street" as center of commerce, services, culture, and values of traditional town.*

Subject: *central business district of town or small city — include stores, bank, PO, church*

Variations:

a. *street level/crosswalk* d. *with school, library*

b. *with small office bldg* e. *with town hall*

c. *pedestrians/traffic light* f. *with cars/traffic jam*

Frame Shots	Space for Type	Lighting
☑ Horizontal	☑	
☑ Vertical	☑	☑ Exterior (available light)
☑ Wide	❏	
☑ Medium	☑	❏ Interior (strobe light)
❏ Close-Up	❏	

Models: *family or 1-2 adults* **Ethnic:** *varied*
 to position walking, crossing
 1-2 teens on bike.

Props: *nice clothes, shopping bags on arms* **Locale:** *city/town*
 of models, flowering plant to place in
 foreground, bicycle (optional)

Include: *Flags, trees, flowers, colorful awn-* **Avoid:** *national brand name stores, gas*
 ings, church spire. Stores: barber, *stations, fast food, liquor stores,*
 hairdresser, pet store, shoe repair, *wires, graffiti, dated posters, x-rated*
 ice-cream parlor, restaurant. *movie marquees*

Note: *The location search is the crux of this shot. Bird's-eye angle good (try for 2-3rd story view), intersection with stores, park, possible view of residential streets behind. For ground-level shots use models in foreground to give activity. Need bustling, cheerful look. Clear bright day, crisp color.*

Category: *COMMERCE — Malls*

Purpose: *To show mall as a development in retailing and representing a societal change; a shift to the mall for buying, socializing, as a center for teens. In the photo, make clear what a mall provides: weather control, variety of shopping in one location, social center, cultural multi-use facility. Show pleasant atmosphere, design characteristics, benches, fountains, people walking/shopping.*

Subject: *interior of shopping mall try to show two levels, escalator, interior space*

Variations:

a. *show 2 people on escalator*

b. *show 2-3 people window shopping*

c. *social/charity/fundraising*

d. *show teens at mall-video*

e. *entertainment/cultural*

f. *art exhibit/performance*

Frame Shots	Space for Type	Lighting
☑ Horizontal	☑	
☑ Vertical	☑	☑ Exterior (available light)
☑ Wide	❑	
☑ Medium	☑	☑ Interior (available light)
☑ Close-Up	❑	

Models: *Mom, Dad, and 2 kids, 1-2 single adults*

Ethnic: *2 white and 2 black or Hispanic*

Props: *non-brand name shopping bags, bright color clothing*

Locale: *mall*

Include: *shoppers (model-released so you can position at will)*

Avoid: *brand name stores, people not model-released (backs ok), liquor stores*

Note: *Scout mall and find 2-3 locations where only generic store names are visible in your angle, e.g., The Party Store, Katy's Clothes, Hubbell's Gifts. Regional department stores are ok, e.g., Marshall's in Florida. Shoot available light, filter for fluorescent. Run one test roll of color. Best are atrium malls with skylights.*

Category: *PEOPLE* — *Handicapped Person Socializing*

Purpose: *To show a handicapped person in a positive, active role, participating in mainstream life.*

Subject: *handicapped man or woman in wheelchair or with crutches at party/social gathering*

Variations:

a. _____ *group, talking/laughing, snacking* _____

b. _____ *talking to seated guest* _____

c. _____ *at table, board game* _____

d. _____ *at backyard barbecue* _____

e. _____ *playing guitar, singing* _____

f. _____ *guest at birthday party opening presents*

Frame Shots	Space for Type	Lighting
☑ Horizontal	☑	
☑ Vertical	☑	☑ Exterior (available light)
❑ Wide	❑	
☑ Medium	☑	☑ Interior (strobe light)
☑ Close-Up	☑	

Models: *3-5 minimum*
6-8 maximum, handicapped person — attractive, vital

Ethnic: *white party crowd mixed ethnic*

Props: *bright-colored clothes, musical instrument, birthday props, snack trays*

Locale: *home — interior or backyard*

Include: *healthy generic food.*

Avoid: *cigarettes, liquor, busy backgrounds.*

Note: *Social interaction is the key to this photo. Set scene, create conversational topics for handicapped person and guests to keep the body English alive. Suggest hand gestures. Keep handicapped person as focal point for others — eye contact is important.*

Category: *PEOPLE — Elderly (with technology)*

Purpose: *To portray the elderly as alert, productive people leading active lives, participating in society, and managing modern life.*

Subject: *elderly couple and/or a single elderly person in various activities including confident interaction with digital technology to symbolize the acceptance of change*

Variations:

a. *playing computer games, using Internet*

b. *man (or woman) using computer e-mail*

c. *woman at computer, financial program*

d. *man w laptop in retirement setting, golf course*

e. *woman using multimedia w grandchild, homework*

f. *woman gardening using cell phone*

Frame Shots	Space for Type	Lighting
☑ Horizontal	☑	
☑ Vertical	☑	☑ Exterior (available light)
☑ Wide	☑	
☑ Medium	☑	☑ Interior (strobe light)
☑ Close-Up	☑	

Models: *Male and female 60-70 attractive and energetic but natural, believable — not plastic or perfect. Optional: grandchildren 6-7 years.*

Ethnic: *various, especially Hispanic*

Props: *computer (conceal brand names), cell phone, gardening props, checkbooks, kids notebooks*

Locale: *home exterior and interior*

Include: *air of confidence & competence in elderly using technology, not fearful or tentative, playful energy.*

Avoid: *stereotype of glamorous elderly*

Note: *The portrayal of the elderly should be authentic, believable, and real. Okay to shoot standard scenes (e.g. bike riding, tennis) which are always useful but much preferable to show elderly accepting change and adapting to technology. Do some silhouette or deep shadows for symbolic shot of elderly with technology.*

Category: *FAMILY*

Purpose: *To symbolize family togetherness, communication, warmth, security, good health, food & nutrients, social interaction, concept of "group."*

Subject: *Family at dinner table, eating meal. Parent serving food, passing plates. Cheerful conversation & smiles.*

Variations:

a. _____ *teen standing, serving others* _____

b. _____ *teen seated, interacting w/Dad (med)* _____

c. _____ *teen talking, interacting w/Mom (med)* _____

d. _____ *child (seated) serving self* _____

e. _____ *child talking w/Mom, then Dad (wide)* _____

f. _____

Frame Shots	Space for Type	Lighting
☑ Horizontal	☑	
☑ Vertical	☑	❏ Exterior (available light)
☑ Wide	☑	
☑ Medium	☑	☑ Interior (strobe light)
☑ Close-Up	☑	

Models: *Mom, Dad (30-40)*
teen (13-16) girl
child (8-10) boy

Ethnic: *shoot this assignment 4 times with white, black, Hispanic & Asian families*

Props: *Colorful (solid) tablecloth, Food: chicken or fish, rice, salad, tomatoes (or ethnic food if nonstereotypical). Beverages: milk, water. Clothes: bright colors, simple, classic styles.*

Include: *colorful foods,greens, reds, etc.*

Avoid: *unhealthy food, high cholesterol food, brand names on products (ketchup, condiments, etc.), alcohol, ashtrays, cigarettes.*

Note: *Shoot after real dinner is eaten, so models won't get hungry and cranky during shoot. Provide "prop" food. Don't really eat (chewing looks ugly). Have them serving or poised, food on fork, ready to eat, while talking.*

Category: *HOUSING — Houses*

Purpose: *To show American homes in a variety of styles, sizes, landscaping, locations, and economic range. As symbol of stability, security, contentment, family goal.*

Subject: *houses/homes - modern, ranch, Victorian, split-level, 30's charming, with porch*

Variations:

a. ___ *small/cozy/modest* ___ d. ___ *near the water* ___

b. ___ *large/imposing/expensive* ___ e. ___ *lighted windows/twilight* ___

c. ___ *in wooded area* ___ f. ___ *family with real estate agent* ___

Frame Shots	Space for Type	Lighting
☑ Horizontal	☑	
☑ Vertical	☑	☑ Exterior (available light)
☑ Wide	☐	
☑ Medium	☑	☐ Interior (strobe light)
☐ Close-Up	☑	

Models: *optional for some variation* **Ethnic:** *varied*

Props: *For sale sign. Planter with flowers by the door.* **Locale:** *all regions of USA; all attractive seasons*

Include: *Various materials — adobe, clapboard, stone. Optional — mail box, fences, birdbath, sun dial.* **Avoid:** *signs of disrepair; scruffy lawn/landscaping; cars in driveway; clutter on porch, steps, or walk.*

Note: *GET PROPERTY RELEASE. This is critical to the value of stock photographs of houses. Offer of a "portrait" of the house (or of the family in front of the house) may be a trade for permission (and possible introduction to models for other uses). Shoot varying amounts of yard, lawn in foreground, and sky in verticals. Be careful to square up horizons; avoid having buildings tilt forward.*

Category: *PEOPLE — Emotions — Pride*

Purpose: *To capture the emotion of pride in achievement, accomplishments, and the sharing of that emotion.*

Subject: *person (adult or child) alone on stage, podium, finish line holding trophy/award/ribbon*

Variations:

a. _____ *smiling/ thrilled* _____ **d.** _____ *showing award to parent/friend* _____

b. _____ *arms up triumphant* _____ **e.** _____ *blue ribbon painting* _____

c. _____ *shaking hands with donor* _____ **f.** _____ *with dog and ribbon* _____

Frame Shots	Space for Type	Lighting
☑ Horizontal	☑	
☑ Vertical	☑	☑ Exterior (available light)
☑ Wide	☑	
☑ Medium	☑	☑ Interior (strobe light)
☑ Close-Up	☑	

Models: *1-2 adults or*
2-3 kids (age 7-10) or teens

Ethnic: *various*

Props: *trophies: baseball, bowling, track, soccer, blue ribbons*

Locale: *school, stage, sports area, horse show, dog show, crafts show, 4H, music recital*

Include: *symbol of event: finish line, bleachers, curtains/stage.*

Avoid: *busy backgrounds, extra crowds, signs/ads*

Note: *Spontaneity and believability of emotion is crucial. If the scene is a setup, give models something to feel or laugh about — teasing can help get the right look. Keep the scene simple — concentrate on expression. Make symbols of the event subtle and non-intrusive.*

Category: *HEALTH CARE*

Purpose: *Symbolize the role of health care workers for the next decade by showing health care professionals providing care using the current rapproach.*

Subject: *health care professionals — nurses, nursing assistants, and home health aides, male and female, giving treatment to patients of all ages.*

Variations:

a. *male nurse taking blood pressure*

b. *female nurse adjusting I.V.*

c. *nursing asst. cleaning patient glasses*

d. *nursing asst. reading get-well card/patient*

e. *nursing asst. adjusting pillows*

f. *nursing asst. feeding elderly*

Frame Shots	Space for Type	Lighting
☑ Horizontal	☑	
☑ Vertical	☑	❑ Exterior (available light)
☑ Wide	☑	
☑ Medium	☑	☑ Interior (strobe light)
☑ Close-Up	☑	

Models: *male and female, patients all ages*

Ethnic: *various*

Props: *Medical wardrobe, health aide or nursing smock, white pants, flowers, plants, get well cards, small personal objects, bed jackets, robes. Medical props b.p. cuff, I.V. tubing.*

Locale: *clean, bright hospital, clinic or nursing home*

Include: *interaction between patient and health care worker.*

Avoid: *sterile or depressing locations, busy backgrounds*

Note: *Medical wardrobe — nurses don't need to wear all white. Pastel color tops are used with nurse's pin and stethoscope. Nursing assistants wear smock tops and white pants but no nursing credential pin. Since doctors have been widely covered, there's more need for mid-level health care workers who will assume increasing amounts of the health care burden in coming years.*

Category: *PEOPLE — Teens — Dating*

Purpose: *To show teens learning to build interpersonal relationships. Symbol of future.*

Subject: *teens dating — enjoying each others company — couple alone and with peers, in activities*

Variations:

a. _____*walk home school/talk*_____ d. _____*goodnight hug/kiss*_____

b. _____*walk/talk hold hands*_____ e. _____*teen introduction to parent*_____

c. _____*doorway, leaving on date*_____ f. _____*teen couple at dance/party*_____

Frame Shots	Space for Type	Lighting
☑ Horizontal	☑	
☑ Vertical	☑	☑ Exterior (available light)
☑ Wide	☑	
☑ Medium	☑	☑ Interior (strobe light)
❑ Close-Up	❑	

Models: *2-6 teens attractive, appealing 15-17 year-olds*

Ethnic: *repeat with all ethnic groups*

Props: *school books, jackets, tennis rackets, guitar, records*

Locale: *home: party, rec room, ping pong; school dance; street, park, movie*

Include: *activities —playing music, talking, laughing*

Avoid: *trendy clothes, fad hairstyles.*

Note: *Mood and physical closeness are important. Use good acting students or kids who are actually dating. This will make the scene more believable.*

Category: *PEOPLE* — *Elderly*

Purpose: *Portray vigorous elderly people actively pursuing interests in a northern environment. To show that seniors can cope with and enjoy winter activities — that they are more than hothouse flowers.*

Subject: *elderly couple enjoying winter activities and sports, having fun, being playful*

Variations:

a. _____ *walking on snowy trail* _____ d. _____ *making snowman* _____

b. _____ *cross-country skiing* _____ e. _____ *grandchildren/snowman* _____

c. _____ *playing, splashing snow* _____ f. _____ *standing with sled* _____

Frame Shots	Space for Type	Lighting
☑ Horizontal	☑	
☑ Vertical	☑	☑ Exterior (available light)
☑ Wide	☑	
☑ Medium	☑	❑ Interior (strobe light)
☑ Close-Up	☑	

Models: *attractive, slim couple with silver hair 60's*

Ethnic: *white, Hispanic, black*

Props: *colorful ski clothes — hats, scarf, mittens, sled, snowman, skis*

Locale: *snowy fields, rural look, fresh snow*

Include: *Smiles. Must look comfortable, warmly dressed. Good interaction.*

Avoid: *models looking cold and miserable, brand name on sled*

Note: *Need bright, sunny day, so winter looks appealing. For skiing shots, rural setting is necessary, but close-ups of couple having snow fight or building snowman can be in any backyard or park with neat, clean look. Elderly are rarely shown in cold-weather sports. This breaks the stereotype that all seniors loll in a warm climate.*

Category: *PEOPLE — Crowds*

Purpose: *To show the diversity of America (melting pot). A cross-section of the culture and the buying public.*

Subject: *a crowd of alert, happy faces watching event*

Variations:

a. _____ *laughing, applauding* _____ d. _____ *looking off camera* _____

b. _____ *looking intent, serious* _____ e. _____ *looking on camera* _____

c. _____ *looking pleasant* _____ f. _____ *some with kids/teens* _____

Frame Shots	Space for Type	Lighting
☑ Horizontal	☑	
☑ Vertical	☑	☑ Exterior (available light)
☑ Wide	☑	
☑ Medium	☑	❏ Interior (strobe light)
❏ Close-Up	❏	

Models: *mixed ethnic and age group 20-35 people, a few with silver hair*

Ethnic: *All. Important to represent white, black, Asian, and Hispanic*

Props: *Request models wear simple, brightly-colored casual clothes. Too many hats or sunglasses distract. Take extra pens, clip boards for signing releases.*

Locale: *use stadium/bleachers of local college or high school*

Avoid: *Cigarettes, beer or soda cans. Clothes with obvious sayings, logos.*

Include: *Use university, sports club or church group that might be getting together anyway (e.g. Little League parents, faculty picnic). Check ethnic and age breakdown and bring models to balance out. Include some teens, some kids.*

Note: *This is not an easy one, but very valuable if carried off. Pass out model releases before shooting. Have assistant go through crowd and collect signed releases, noting a description, hair, or shirt color on the release. Throw a picnic as a thank you — or bring a cooler for after the shoot. Offer comp prints or donation to the club.*

STOCK ASSIGNMENT No 14

Category: *PEOPLE — Crowds and Family — (Festival, Block Party, Fundraiser)*

Purpose: *To show community involvement. People participating or volunteering at local event.*

Subject: *block party, ethnic festival, or benefit, couple or family enjoying event*

Variations:

a. *couple sampling foods*

b. *couple strolling, smiling*

c. *family sampling foods*

d. *family strolling, happy*

e. *playing game, ring toss*

f. *volunteer taking tickets*

Frame Shots	Space for Type	Lighting
☑ Horizontal	☑	
☑ Vertical	☑	☑ Exterior (available light)
☑ Wide	☑	
☑ Medium	☑	❑ Interior (strobe light)
❑ Close-Up	❑	

Models: *5-10 Bring couple, family of 4, use in foreground, real crowd behind.*

Ethnic: *use one couple, black or Hispanic, in scene*

Props: *neat casual clothes, stuffed animals, balloons, pinwheels, food: apples, nuts*

Locale: *ethnic festival or block party, or use empty fairgrounds, school*

Include: *good interaction, playing games, carrying prize. Interesting ethnic food or healthy food (not sweets)*

Avoid: *cigarettes, beer, brand name signs, background people in shorts, unkempt clothes, shooting, dice games.*

Note: *Two possible approaches: Go to real ethnic festival, taking your models, released, colorfully dressed, and use background crowd out of focus. Or create your own neighborhood event setting up at fair grounds, or school. Make signs: "Cliffside Library Benefit," "Elm St Block Association," " Avon Scholarship Fund," Use streamers, balloons, and pennants.*

Category: *PEOPLE — Communication*

Purpose: *To show verbal communication, power of persuasion, efficacy of spoken word and gesture.*

Subject: *person speaking with energy, enthusiasm, conviction, using hand gestures, eye contact, presenting/receiving awards, giving a speech, sales report*

Variations:

a. _____ *adult man speaking — using mike* _____ d. _____ *older woman speaking* _____

b. _____ *adult woman speaking — mike* _____ e. _____ *teen girl sports banquet* _____

c. _____ *woman using chart/pointer* _____ f. _____ *adult presents award to teen* _____

Frame Shots	Space for Type	Lighting
☑ Horizontal	☑	
☑ Vertical	☑	☑ Exterior (available light)
☑ Wide	☑	
☑ Medium	☑	☑ Interior (strobe light)
☑ Close-Up	☑	

Models: *1 or 2 each scene*
2 adults, 1 woman silver hair
Teens — male and female

Ethnic: *white, black, and Asian*

Props: *microphone, pitcher, flip chart, pointer, award plaques, index cards/ notes, clothes: professional look*

Locale: *auditorium, podium, or conference room*

Include: *people speaking with notes, props to indicate sales conference, business meeting, charity drive, poetry reading*

Avoid: *closed eyes (watch for light-sensitive models), awkward or stiff gestures.*

Note: *Not a complicated setup. Use props and signs to indicate variety of scenes for communication. Good acting needed here. Provide real speech ideas or reading material to help models gain authenticity. School drama club or local theater group can provide good models.*

Category: *ANIMALS* — *Domestic*

Purpose: *To show the evocative nature of pets in a variety of strong, graphic statements. To capture their essence and appeal. To communicate loyalty, trust.*

Subject: *symbolic or unusual views of dogs, cats (puppies, kittens)*

Variations:

a. *paws — extreme close-up*

b. *limpid eyes — super close*

c. *tail wagging, blurred motion*

d. *dog/cat curled, asleep;*

e. *mouth profile, tongue hanging out*

f. *profile of elegant cat*

Frame Shots	Space for Type	Lighting
☑ Horizontal	☑	
☑ Vertical	☑	☑ Exterior (available light)
❑ Wide	❑	
☑ Medium	☑	☑ Interior (strobe light)
☑ Close-Up	☑	

Models: *clean, well brushed, classic (not exotic) breeds, the "everyman" of pets*

Ethnic:

Props: *if used, clean collars, avoid if distracting*

Locale: *simple, clean field, or interior*

Include: *fields, tree limb*

Avoid: *puppy in a basket, ball of yarn, "poster cute" postures — overdone*

Note: *Texture and lighting (evocative mood) are important.*

Category: *HOUSING — Gardens*

Purpose: *Show the lawn as accoutrement of upscale housing — landscaping used as setting for corporate or domestic architecture.*

Subject: *lawns: fresh, green, well-manicured sweep of grass, with and without buildings in background*

Variations:

a. _____ *in corporate setting* _____ d. _____ *include curb/sidewalk* _____

b. _____ *with border gardens* _____ e. _____ *southwest "dry" lawn, stones* _____

c. _____ *in traditional garden* _____ f. _____ *southwest include cactus* _____

Frame Shots	Space for Type	Lighting
☑ Horizontal	☑	
☑ Vertical	☑	☑ Exterior (available light)
☑ Wide	☑	
☑ Medium	☑	☐ Interior (strobe light)
☐ Close-Up	☐	

Models: *none* **Ethnic:**

Props: *flowering plants to place as needed* **Locale:** *all regions of US, include types of grass bred for different climates*

Include: *curved path, flagstone, railroad ties, other landscaping features* **Avoid:** *cracked sidewalks, curbs, weeds, scruffy plants, bare spots*

Note: *Avoid lawns with dappled sunlight. Need good, rich light for saturated color (late day, early morning). Uses: ads for a wide variety of landscaping equipment (watering devices, lawn food, cement manufacturers) builders'/contractors' brochures.*

Category: *PEOPLE* — *Teens*

Purpose: *To symbolize romance, affection, and physical attraction, (in a discreet manner) for use with sensitive editorial material or advertisements*

Subject: *young couple, in profile, silhouette, or symbolic close-up, showing affection and physical contact*

Variations:

a. *holding hands (cu)* d. *kissing, backlighted*

b. *hands, fingers locked* e. *head on shoulder*

c. *swinging hands, walking* f. *hugging/arms/shoulder*

Frame Shots	Space for Type	Lighting
☑ Horizontal	☑	
☑ Vertical	☑	☑ Exterior (available light)
☑ Wide	☑	
☑ Medium	☑	☑ Interior (strobe light)
❑ Close-Up	❑	

Models: *Good hands, well manicured. Slim, attractive. Use real-life couples, actors, or professionals.*

Ethnic: *white and black*

Props: *girl's bracelet, school books, blue jean jackets, casual clothes.*

Locale: *studio or exterior: park, twilight*

Include: *full-figure silhouette, walking away from camera*

Avoid: *recognition of models*

Note: *Use professional models, actors, young-looking 21 year olds, (using real-life couple helps avoid embarrassment.) Make sure that models and parents understand the nature of pictures, let them see samples of finished photographs to show that anonymity was preserved. Note on release that prints were shown and nature of possible use discussed.*

Category: *STILL LIFE*

Purpose: *To illustrate the idea of a rainy day.*

Subject: *objects that suggest rain, wetness — rainy day in the context of a home, business, bank*

Variations:

a. _____ *closed umbrella, dripping* _____ d. _____ *kid's rain boots, puddle* _____

b. _____ *executive umbrella* _____ e. _____ *rain slicker on peg* _____

c. _____ *wet trenchcoat, corporate setting* _____ f. _____ *window, rain spattered* _____

Frame Shots	Space for Type	Lighting
☑ Horizontal	☑	
☑ Vertical	☑	☐ Exterior (available light)
☑ Wide	☑	
☑ Medium	☑	☑ Interior (strobe light)
☐ Close-Up	☐	

Models: *none* **Ethnic:**

Props: *bright-colored umbrellas, rain gear, banker's umbrellas, antique umbrella stand, trenchcoat* **Locale:** *studio*

Include: *good lighting, imaginative composition of common props* **Avoid:** *sloppy execution, mediocre props*

Note: *Do as many variations on rain — in the studio — as you can devise. Start with the standard: slicker, boots (use strong graphic composition). Move on to props that suggest executives, bankers, and rain. Try 8-10 solutions to work past the obvious.*

Category: *PEOPLE* — *Executive*

Purpose: *To show the concept of the overworked, harried executive. To illustrate the headline "Are You Drowning in Paperwork?"*

Subject: *man in business suit almost submerged in computer printouts, mouth gasping for air, hands reaching up, clutching papers.*

Variations:

a. _____ *woman executive* _____ d. _____ *briefcase in teeth* _____

b. _____ *senior executive* _____ e. _____ *one hand only, emerging* _____

c. _____ *clutching briefcase* _____ f. _____ *close-up face, gasping* _____

Frame Shots	Space for Type	Lighting
☑ Horizontal	☑	
☑ Vertical	☑	☑ Exterior (available light)
☑ Wide	☑	
☑ Medium	☑	☑ Interior (strobe light)
❏ Close-Up	❏	

Models: *business man 38*
business woman 38
silver-haired executive

Ethnic: *black, Hispanic, white*

Props: *business jacket, tie*
hat, cuff links, briefcase
computer paper, memos

Include: *enough props to make scene convincing*

Locale: *Could be created in a studio, with figure emerging from hole in cardboard flats, water splashed to give wet look. Or could be rigged in a swimming pool (use net to keep papers from floating away).*

Avoid: *makeshift measures*

Note: *Do this with full lighting, or large format. This is good for the experienced studio photographer.*

STOCK ASSIGNMENT No 21

Category: *PEOPLE* — *Teens*

Purpose: *To show the consumer power of the teenage population.*

Subject: *teens 2-3 shopping and buying rollerblades, skateboards, ski boards, music CDs, electronics, or other products of interest to teens*

Variations:

a. *teens looking at rollerblades*

b. *girl teen trying on helmets/rollerblades*

c. *shopping for wake board, snow board*

d. *selecting CDs from rack, talking/laughing*

e. *teens buying multimedia/electronics store*

f. *buying/handing money to clerk*

Frame Shots	Space for Type	Lighting
☑ Horizontal	☑	
☑ Vertical	☑	❑ Exterior (available light)
☑ Wide	☑	
☑ Medium	☑	☑ Interior (strobe light)
☑ Close-Up	☑	

Models: *2-4 teens 14-17 years old, lively, pleasing looking*

Ethnic: *mixed ethnics in photo*

Props: *all products purchased by teens, current wardrobe*

Locale: *sports, electronic, or music department*

Include: *newest products of interest to teens, up-to-date styles, casual energy and interaction between teens, not stagey*

Avoid: *Obvious brand names on products or names of musical groups which could date photo. If shooting in a store use a long lens to put background brands out of focus. Avoid extremes in hair, clothing and make-up.*

Note: *For ease of shooting in stores, consider on-camera flash, rear curtain fill with ambient light (e.g. Nikon SB 25 flash or similar). Research in magazines to keep informed on newest fads in sports or products for teens.*

Category: PEOPLE — Teens

Purpose: To show the current action hobby/sports for teens as a portrayal of exuberant youth pushing to the limit. To symbolize the intense competitive energy of adolescence.

Subject: Teens involved in individual action hobby/sports including most popular skateboarding, wake boarding, ski boarding, and rollerblading. May also include the traditional skiing and surfing.

Variations:

a. group of teens rollerblading, roller hockey

b. girl rollerblading in park

c. skateboarding in rink or competition

d. skateboarding in park

e. boy wakeboarding

f. snow boarding, jumps

Frame Shots	Space for Type	Lighting
☑ Horizontal	☑	☑ Exterior (available light)
☑ Vertical	☑	
☑ Wide	☑	☐ Interior (strobe light)
☑ Medium	☑	
☑ Close-Up	☑	

Models: 14-17 year old boys and girls proficient in their sport

Ethnic: any

Props: all sports gear including protective helmets, knee pads, clothes simple, non-trendy, no logos or brand names

Locale: parks, track, beach, or other natural setting

Include: Dramatic, high energy action. Movement, exciting angles. High off the ground — leaping and jumping.

Avoid: obvious brand names on products or clothes

Note: Concentrate on the sports special to your climate or region. For more compelling action, use on-camera fill-flash, rear curtain to get controlled blur and heighten action. Check magazines for sports competitions near you, then make contact with best competitors to use as models in later set-up shooting.

Category: *STILL LIFE*

Purpose: *Symbolize health, nutrition — essentials of life.*

Subject: *Close-up, graphic of essential, symbolic foods: bread, grains, fruits.*
Dramatic lighting, texture. Space for type essential.

Variations:

a. *bread — whole & sliced*

b. *bread, grains, sheaf*

c. *apple — whole & cut*

d. *apple & fruits*

e. *fruit & vegetables*

f. *rice grains*

Frame Shots	Space for Type	Lighting
☑ Horizontal	☑	
☑ Vertical	☑	☑ Exterior (available light)
☑ Wide	☑	
☑ Medium	☑	☑ Interior (strobe light)
☑ Close-Up	☑	

Models: *none*

Ethnic:

Props: *only perfect specimens of food,*
need to show excruciating detail

Locale: *studio (or possible exterior — weath-*
ered barn siding, stone fence, natural
backdrop)

Include: *use second choice fruit as stand- in*
when lighting is right, bring perfect
food from refrigerator

Avoid: *blemished fruit, foods*

Note: *This topic has been covered many times, but it is constantly being requested.*
Need excellent execution. Try new approaches, experiment with variations in lighting.

STOCK ASSIGNMENT No 24

Category: *COMMUNICATION/STILL LIFE*

Purpose: *To express the idea of writing or the written word and the implements of writing. Writing in unusual places.*

Subject: *Written words (in English) or people writing in odd settings. Alternate: studio setup of writing implements, paper, books.*

Variations:

a. _____signing baseball_____

b. _____writing on cast_____

c. _____autographing playbill_____

d. _____skywriting_____

e. _____hand/calligraphy_____

f. _____writing on music score_____

Frame Shots	Space for Type	Lighting
☑ Horizontal	☑	
☑ Vertical	☑	☑ Exterior (available light)
☑ Wide	☑	
☑ Medium	☑	☑ Interior (strobe light)
☑ Close-Up	☑	

Models: *hand models (well-manicured)*

Ethnic: *all*

Props: *all writing paraphernalia*

Locale: *studio and location*

Include: *writing anywhere that's unusual or makes a strong visual statement*

Avoid: *brand names on pens, pencils, bright nail polish, rough hands*

Note: *Editorial is a primary usage for this — English textbooks constantly need strong design and fresh approach in expressing the concept of language. Alternates shot with corporate writing equipment would widen the market.*

Category: *BUSINESS — Executive*

Purpose: *To portray today's business executive (male and female) as a representative combination of power and casual lifestyle. To show an energetic, cheerful young executive moving on the fast track.*

Subject: *young executive in a suit riding a bicycle with knapsack on back, pumping fast, jacket and tie flapping, (some with toddler in baby seat at rear of bike)*

Variations:

a. *male in dark suit, tan leather knapsack*

b. *male in dark suit, w racket in backpack*

c. *woman business clothes, bike w briefcase*

d. *woman wearing helmet/business clothes on bike*

e. *male in suit, briefcase, baby in seat*

f. *woman in suit, briefcase, baby in seat*

Frame Shots	Space for Type	Lighting
☑ Horizontal	☑	
☑ Vertical	☑	☑ Exterior (available light)
☑ Wide	☑	
☑ Medium	☑	☑ Interior (strobe light)
☑ Close-Up	☑	

Models: *2-3 energetic looking young adults, toddler optional*

Ethnic: *various, especially Asian and Hispanic*

Props: *upscale bike, leather backpack, briefcase, helmet*

Locale: *clean unidentifiable urban street, glass walls, out of focus or blurred background*

Include: *very little, rider and props*

Avoid: *clutter, detail*

Note: *This should have a breezy, upbeat, non-traditional look.*

Category: *COMMUNICATION/BUSINESS*

Purpose: *Show pervasive need for instant communication. Express with symbols of U.S., European, and Asian cultures.*

Subject: *Person in business clothes with cellular phone on moped, stopped at light or moving with blurred background. Use neutral unidentified background. Make international through use of ethnic models and props.*

Variations:

a. *dark haired male/moped & cell phone*

b. *dark haired female/moped & cell phone*

c. *Asian male/ moped & cell phone*

d. *Asian Female/moped & cell phone*

e. *male on racing bike & cell phone*

f. *female on racing bike & cell phone*

Frame Shots	Space for Type	Lighting
☑ Horizontal	☑	☑ Exterior (available light)
☑ Vertical	☑	
☑ Wide	☑	
☑ Medium	☑	❏ Interior (strobe light)
☑ Close-Up	☑	

Models: *3-4 trim, business types*

Ethnic: *dark haired, Hispanic and Asian*

Props: *cellular phone, bike or moped, briefcase, helmet*

Locale: *street/urban keep unidentifiable, out of focus buildings, green trees, park behind*

Include: *shoot tight on person and vehicle*

Avoid: *legible names in background, on props*

Note: *This shot calls for a sense of motion, the person communicating while on the move, in a hurry, just paused at traffic light, or moving out — impatient, energetic. Also, should have an international look as natural to Madrid as Chicago.*

Category: *HEALTH — Health Club*

Purpose: *To show the role of today's health club as community surrogate, a place used to inte-grate fitness with social life, dining, and relaxation. Portray the health club as a respite from the stress of the business world, with emphasis on socialization.*

Subject: *people (both genders) in exercise clothes using the dining and social facilities of a health club as well as exercising*

Variations:

a. *2 people eat healthy food, club dining area*

b. *3 people socialize, health club dining area*

c. *1 person dining area — eat, read newspaper*

d. *1 person dining area — eat, use laptop*

e. *1 person eat, read, watch news on TV*

f. *person working out alone or with trainer*

Frame Shots	Space for Type	Lighting
☑ Horizontal	☑	
☑ Vertical	☑	☐ Exterior (available light)
☑ Wide	☑	
☑ Medium	☑	☑ Interior (strobe light)
☑ Close-Up	☑	

Models: *3-6 healthy, fit adults* **Ethnic:** *any*

Props: *healthy low fat food, sports wardrobe, head bands, gym bags, racquets, laptop, newspapers*

Locale: *state of the art health club and spa*

Include: *people in exercise clothes, healthy food as well as props (newspapers, laptops) that integrate fitness with business life*

Avoid: *brand names*

Note: *This assignment approaches a photo story, i.e. showing many aspects of the life of a health club, but each photo should also stand alone as a symbol of the integration of fitness and social life.*

Category: *PEOPLE* — Ethnic Women

Purpose: *To portray ethnic women in upscale or powerful roles in society.*

Subject: *black and Hispanic women, alone (or with men in background) as well-dressed consumers, discerning shoppers, or using leisure time*

Variations:

a. *discerning buyer window shopping*

b. *at boutique/mirror, trying on elegant clothes*

c. *black or brown hand with credit card*

d. *relaxing in resort w drink/umbrella table*

e. *closeup black or brown hand with cool drink*

f. *closeup black or brown hand with fan*

Frame Shots	Space for Type	Lighting
☑ Horizontal	☑	
☑ Vertical	☑	☑ Exterior (available light)
☑ Wide	☑	
☑ Medium	☑	☑ Interior (strobe light)
☑ Close-Up	☑	

Models: *very attractive young women plus some fabulous fifties, may need hand models for close-ups*

Ethnic: *black and Hispanic*

Props: *fine clothes, jewelry, make-up*

Locale: *upscale resort or shop*

Include: *first class props, make-up, manicure*

Avoid: *tacky details*

Note: *The impression of these photos should be of ethnic women with discretionary income, in command of their world, women who have made it. Men can be out of focus in the background. Any resort setting should be have blue sea, palm trees, or other indicators of privilege.*

Category: *HEALTH*

Purpose: *To create an icon of a healthy body to symbolize health and fitness.*

Subject: *The female and male body shown in simple graphic shapes, silhouette, and anony-mous close-ups as well as full body. Any activity: emphasis is on health and perfection of the form.*

Variations:

a. *torso front or back in repose*

b. *torso front or back movement*

c. *reaching arms*

d. *runner or swimmer stretching*

e. *touching toes only arms and feet*

f. *back or side view arm with weights*

Frame Shots	Space for Type	Lighting
☑ Horizontal	☑	
☑ Vertical	☑	☑ Exterior (available light)
☑ Wide	☑	
☑ Medium	☑	☑ Interior (strobe light)
☑ Close-Up	☑	

Models: *perfectly fit young adults*

Ethnic: *all*

Props: *simple sports wardrobe*

Locale: *clean natural setting or studio*

Include: *perfect specimens, stunning lighting*

Avoid: *clutter*

Note: *A simple, elegant execution with exquisite lighting is critical to this photo. Use the human form as a still life. Could have digital version: create echo of shape, heighten movement, alter colors. Superimpose over background of healthy food. Symbolize the key to good health — the combination of healthy eating and exercise.*

Category: *PEOPLE* — *Elderly/Health Care*

Purpose: *Portray the current trend of providing health care at home with the new approach of restorative and rehabilitative approach to health care.*

Subject: *show an elderly person being cared for at home or in a facility by a compassionate health professional, receiving care and encouragement through restorative activity, communication, and interaction with a nurse, nursing assistant, or home health aide*

Variations:

a. *exterior porch — read letter to elderly*

b. *exterior porch peel potatoes/fruit together*

c. *elderly & nurse looking at photo album*

d. *elderly & nurse potting plants, smiling*

e. *nurse walks next to elderly, encourage, smile*

f. *assisting elderly to feed themselves*

Frame Shots	Space for Type	Lighting
☑ Horizontal	☑	
☑ Vertical	☑	☑ Exterior (available light)
☑ Wide	☑	
☑ Medium	☑	☑ Interior (strobe light)
☑ Close-Up	☑	

Models: *male and female* **Ethnic:** *various*

Props: *health aide or nursing smock, white pants, letters, photo album, snap-shots, fruit, vegetables, bowl, pots of flowers, food tray*

Locale: *attractive settings in and around the home*

Include: *eye contact, pleasant interaction*

Avoid: *depressing look, cluttered details*

Note: *Create scenes that give a sense of independence and dignity to the elderly. The health care provider assists when necessary in an activity but encourages and supports, with words and smiles and gestures what the elderly person is doing.*

Category: *HEALTH — Foods*

Purpose: *To symbolize the foods currently said to have extraordinary healing and energy giving properties.*

Subject: *still-life photos of vegetables, fruits and other foods, grouped according to the health values (or vitamin content) they offer*

Variations:

a. _____*vitamin C*_____ d. _____*B-12 meats & fish*_____

b. _____*calcium*_____ e. _____*B-12 fruits & vegetables*_____

c. _____*vitamin E*_____ f. _____*betacarotene*_____

Frame Shots	Space for Type	Lighting
☑ Horizontal	☑	
☑ Vertical	☑	☑ Exterior (available light)
☑ Wide	☑	
☑ Medium	☑	☑ Interior (strobe light)
☑ Close-Up	☑	

Models: **Ethnic:**

Props: *baskets, weathered wood, tiles*

Locale: *Shoot interior in studio or kitchen on butcher block, weathered board, ceramic tiles, or silhouette. Shoot exterior on slate, rock wall, bale of hay, in basket.*

Include: *Prime fruits, vegetables, and other foods. The produce must be exceptionally fresh, attractive, and unblemished. Other foods, such as fish, must be fresh.*

Avoid: *tired, wilted fruits and vegetables*

Note: *Keep these photos viable and add new topics by continuing research for newest trends in preventive and restorative benefits from various foods. Antioxidants, vitamin C's effect on cardiovascular disease and cancer, plus nutritional debates on the benefits of betacarotene. (The publication of Consumer's Union,* Consumer's Report on Health, *is an excellent resource. They list foods high in each vitamin.)*

Category: *DIGITAL*

Purpose: *To symbolize the conflict between citizens and government as portrayed by a struggle between taxpayers and politicians.*

Subject: *show tug-of-war with U.S. dollar stretched to the breaking point between symbols of taxpayers and government*

Variations:

a. *single executive man pulls against politico*

b. *single homeowner pulls against politico*

c. *family with 2 kids (& dog) pull*

d. *executive woman pulls*

e. *college student pulls student loan $*

f. *shape of home vs. shape of U.S. Capitol*

Frame Shots	Space for Type	Lighting
☑ Horizontal	☑	
☑ Vertical	☑	☐ Exterior (available light)
☑ Wide	☑	
☑ Medium	☑	☑ Interior (strobe light)
☑ Close-Up	☑	

Models: *various* **Ethnic:** *any*

Props: *dollar, Wardrobe suitable to roles* **Locale:** *studio for base photos*

Include: *innocent, wide-eyed shirt-sleeved homeowner and family in contrast with pork-barrel, rotund political* **Avoid:** *sloppy propping or low quality scans*

Note: *For base photos to scan in, shoot people in studio in position of action. To simulate the action of pulling on a dollar bill use a sheet or fabric for models to tug. Then scan in and manipulate. Make the family wide-eyed and innocent in contrast with politician. Could do variation for trade war with Japan, American executive pulling yen toward US map and Japanese pulling dollar toward Japan. (Must have access to top equipment and expertise in imaging and computer graphics.)*

STOCK ASSIGNMENT No 33

Category: *DIGITAL — Information Superhighway*

Purpose: *To show the information superhighway as a positive force to be approached with confidence.*

Subject: *People riding strands of colorful optic fibers down a highway (created with cyberworld colors) stretching to infinity. Their position is as if riding on a magic carpet (or as if holding the reins of a horse or the steering wheel of a vehicle) facing forward eagerly with expressions of excitement and optimism.*

a. _____*male executive w briefcase*_____ **d.** _____*steering wheel on fibers*_____

b. _____*woman executive w briefcase*_____ **e.** _____*teen riding skateboard of fibers*_____

c. _____*family plus pet rides optics*_____ **f.** _____*child riding bicycle of fibers*_____

Frame Shots	Space for Type	Lighting
☑ Horizontal	☑	
☑ Vertical	☑	❑ Exterior (available light)
☑ Wide	☑	
☑ Medium	☑	☑ Interior (strobe light)
☑ Close-Up	☑	

Models: *Exceptionally attractive and current looking. Should use professional models here. (Dog, if ambitious.)*

Ethnic: *any*

Props: *wardrobe, male and female executive, brief cases, family sports clothes, kids book bags, knapsacks*

Locale: *shoot models in studio*

Include: *bright, hot, high energy colors for fiber optics to give cheerful optimistic mood*

Avoid:

Note: *For base photos to scan in, shoot models in the studio in the position of their action. (Must have access to top equipment and expertise in imaging and computer graphics.)*

Category: *DIGITAL — Information Superhighway*

Purpose: *To portray fear of the information superhighway. Show it as a confusing or threatening image.*

Subject: *Anxious persons riding strands of colorful optic fibers down a highway, created with cyberworld colors, stretching to infinity. Their position is as if perilously perched in the front of a roller coaster or at the wheel of a vehicle, facing down, backward, ahead with a timid, hesitant expression or covering eyes, looking around in terror.*

a. *in traffic jam on highway*

b. *executive losing grasp of brief case*

c. *woman executive holding papers tight*

d. *family in roller coaster*

e. *person running down highway*

f. *teen hitchhiking*

Frame Shots	Space for Type	Lighting
☑ Horizontal	☑	
☑ Vertical	☑	❏ Exterior (available light)
☑ Wide	☑	
☑ Medium	☑	☑ Interior (strobe light)
☑ Close-Up	☑	

Models: *should use professional models or good actors*

Ethnic: *any*

Props: *wardrobe, male and female executive, brief cases, family sports clothes, kids book bags, knapsacks*

Locale: *shoot models in studio*

Include: *anxious, threatening colors, acid green, harsh yellow, gloomy blue for fiber optics to give heighten sense of insecurity and dread*

Avoid:

Note: *For base photos to scan in, shoot people in studio in position of action. (Must have access to top equipment and expertise in imaging and computer graphics.)*

STOCK ASSIGNMENT No _35_

Category: *DIGITAL -- Sensitive Issues*

Purpose: *To symbolize the conflict between smokers and non-smokers — particularly the issue of secondhand smoke.*

Subject: *Show various scenes of smokers creating smoke and non-smokers being affected or trying to protect against secondhand smoke. In some the smoker has a self-righteous expression and the non-smoker is aggrieved or innocent. In others the smoker appears more adamant or aggressive about the right to smoke.*

a. *smoker wreathed in smoke halo*

b. *non-smoker choked by wreath of smoke*

c. *smoker & non-smoker bound by rope of smoke*

d. *smoker with cigarette as a sword*

e. *non-smoker with shield or gas mask*

f. *smoker with child breathing 2nd-hand smoke*

Frame Shots	Space for Type	Lighting
☑ Horizontal	☑	
☑ Vertical	☑	☐ Exterior (available light)
☑ Wide	☑	
☑ Medium	☑	☑ Interior (strobe light)
☑ Close-Up	☑	

Models: *1-2 young adults*

Ethnic: *Anglo-European*

Props: *cigarettes (smoke) normal wardrobe, mask/goggles*

Locale: *studio for base shots*

Include: *skillful lighting*

Avoid:

Note: *This is a less complicated digital image to create than some others since you need only 1-2 models photographed singly against a dark background plus smoke shots for the base. The key is refined imaging with the shapes created by the smoke. Could do variation showing a pregnant mother, smoke shaped as a dagger pointing at the unborn child. Sensitive issues must have model release with the subject of the photo especially noted. Also, check with your stock agency for their handling of sensitive-issue photos. (Must have access to top equipment and expertise in imaging and computer graphics.)*

STOCK ASSIGNMENT No ___

Category: _____

Purpose: _____

Subject: _____

Variations:

a. _____ d. _____

b. _____ e. _____

c. _____ f. _____

Frame Shots	Space for Type	Lighting
❏ Horizontal	❏	
❏ Vertical	❏	❏ Exterior (available light)
❏ Wide	❏	
❏ Medium	❏	❏ Interior (strobe light)
❏ Close-Up	❏	

Models: _____ **Ethnic:** _____
_____ _____
_____ _____

Props: _____ **Locale:** _____
_____ _____
_____ _____

Include: _____ **Avoid:** _____
_____ _____
_____ _____
_____ _____

Note: _____

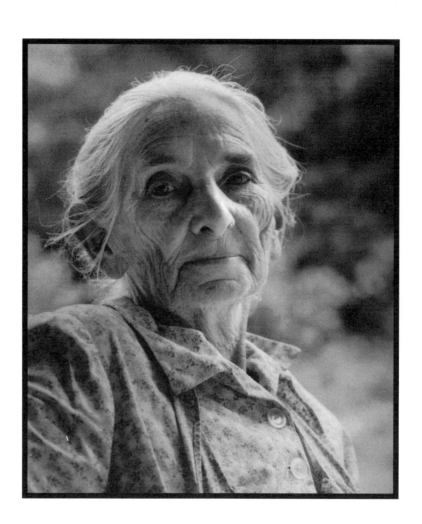

Preparing the Shoot

The production of good stock photography is more complex today than it was even a few years ago. There are many details that must be planned and organized in order to have the bright, well-executed professional stock that is required in today's competitive market. The information, techniques, and sample letters in chapter 6 will go a long way to making it manageable. They will take the drudgery and uncertainty out of producing stock.

Plan Your Project

Before dealing with the logistics of a shoot, it's important, as you saw in the last chapter, to have a cohesive stock plan to give focus and direction to your shooting. You have chosen stock assignments listed in chapter 5 based on your interests and on what your locale has to offer. Now make sure to group them into themes. Pick a theme and give it a name. It will give direction to your shooting and make it much easier to explain what you are doing to prospective models or location sources.

Start with a title, for example:

- Family Life in the 90's
- The Greying of America
- The Changing Seasons
- Where We Live: Houses and Homes
- Fitness—Health or Obsession
- Fitness—At All Ages
- Special People—Handicaps and Courage
- Women in Business

As you progress with these projects, they may change shape. These titles are not merely intended to suggest the classic photo essay approach, which covers different aspects of a story. You may very well end up with a series of single photographs, in differing executions which symbolize the concept of your project. The purpose of a theme is to help you explore one topic thoroughly, finding as many creative solutions as possible. Move on only when you've exhausted your imagination in one concept area. It's the stock equivalent of quality time.

Once you have the title, you have to get your foot in the door. Compose a written statement. It'll help you get a grip on what

you're doing with the shoot. You'll be more convincing when it comes to asking for access to locations you want to use.

A lame approach such as: "Well, I want some pictures for my stock file" is not going to win you that access. You have to be more persuasive. This is not to suggest that you should misrepresent what you are doing. Believe in the reality of your concept and share it. If you have a professional commitment to your stock project and feel a genuine enthusiasm, that excitement interests others.

If the project intrigues you visually and intellectually, it will bring you personal satisfaction. You can treat stock like sausage production and crank it out, but a genuine interest in what you're doing will have the additional merit of creating the best stock.

Remember to share your project description with your stock agency. Tell them about your photographic plans — make it easier for them to provide guidance. (An organized mind is highly prized by agents.)

This approach is much like the preparation that goes into a typical assignment, say an ad campaign, a series of books, or an annual report — all are groupings of photos unified by a single need, style, or subject matter, and all are carefully thought out beforehand.

In writing your stock description, include any potential uses, in addition to stock, that you see as possibilities. These might include exhibitions, book publications, etc. Or, if this is unlikely, be straightforward about the fact that the shooting is strictly for stock. Just make clear that it is a project of aesthetic and intellectual interest to you.

Incorporate your description in your letters requesting assistance from models, organizations, or location sources. (See the sample letters in this chapter.)

Setting Up Systems

Start your files immediately. Set up an organization that will work for gathering source information and to give a framework for your photo coordinator. Valuable model contacts or source information, if written on scraps of paper and stuck in random corners of your desk, are as good as down the drain. With the always tedious task of filing, sooner is always better than later. Start before it gets out of hand. Avoid the unnecessary frustration of not being able put your fingers on a valuable snippet of information.

The files listed in this chapter and chapter 7 provide a place to safeguard the valuable information you collect. Make sure the following files and systems are in place before beginning any production shoots:

Clip file
Location files (polaroids)
Model file - sources
Model-release file
Prop/supply source file
Assistants file (names & addresses)
Stock job forms - in numerical order
Stock photo files (basic categories)

It won't take more than a few hours to set up all these files. It's a matter of typing a few labels, but it could cost you dearly, six months down the road, when you urgently need a model's home number or a bit of prop information and can't put your hands on it.

Now to the shoot. This section is devoted primarily to setting up production shoots on location. Most photographers working in studios already have a production system worked out. But for those who want to adapt these techniques to studio work — there's nothing to it. You have simply saved one step: finding the location.

The success of the shoot depends on the preplanning. Let's look now at the procedures involved.

Setting Up Location Photography

The preliminary work needed for stock photography on location can be handled by the photographer or by a variety of people, in

different combinations. I find that a team comprised of the photographer and a "photo coordinator" works best. This person may be an assistant, a spouse, or an intern.

If you are just starting a stock business, you may want to handle all of these jobs yourself on the first few shoots. This will help you to understand the complexity of the setup process and to know the qualities you'll want in an assistant. It will also ease up on your finances.

As you progress on stock shoots, it will be more efficient to use a coordinator so you can put your valuable time into conceptualizing, shooting, and editing. As a matter of fact you'd be crazy not to delegate the chores.

A good photo coordinator can handle all the logistics of making a shoot happen and ensure it's done right. The activities handled by a stylist, location searcher, and general dogsbody are all rolled into one for the purposes of a stock shooting.

On major assignments done by advertising photographers, there are often seven to ten people preparing a shoot: production assistants, stylists, location scouts, casting, prop, and lighting assistants. If you are an experienced advertising photographer, you'll have the team and the techniques at hand. For obvious financial reasons, your goal in producing stock will be to reduce that team to it's leanest and most efficient size. That doesn't mean cutting corners or sacrificing quality. Especially in the area of advertising, large investments in stock production have been justified and repaid to photographers with ample profit. That's fine once you have experience and a track record in mounting big productions. Meanwhile start with just one excellent person.

In searching for the right "first" person to work with you, it will be helpful to have an overview of the functions of a coordinator — see the coordinator checklist box. This list will also be useful in training a new person into the job, as it gives an idea of what needs to be done in preparation for a shoot and on the set during the photography session.

Finding Help — The Photo Coordinator

If you have a partner or spouse willing and able to handle the coordinator's job of setting up your productions, then you are one step ahead.

Mind you, when we say "productions" that doesn't only mean complicated setups involving models and props — it *can* mean nature photography in a local wildlife preserve. For example, if you want to enter the park before dawn for a sunrise photo, you'll need special permission. Almost every kind of photography, no matter how simple it may appear, requires some advance preparation in order to assure success.

What do you need in a coordinator?

At first glance it seems as if you need someone with qualities of almost mythic proportions: organizational ability, energy, good taste, and a good nature. They should be meticulous, able to think on their feet, able to handle pressure. But most of all, they should realize the critical importance to your photography of having everything in order before the shoot. "Winging it" should not be considered a standard option. A good coordinator will help you avoid a crisis atmosphere.

Finding the right person(s) may seem a tall order, but they are out there — and often looking for the experience and excitement of working in photography.

Major metropolitan areas will have a large photographic community, in which you will find beginning stylists, photo assistants, photographic interns, production assistants, many of them in search of experience. Many will already have some experience and/or downtime. They will often be more than happy to assist on your projects.

Another avenue is to look for the stage manager or lighting engineer of a community theater group or a college drama club. These people are skilled in handling details under pressure.

Photo Coordinator Check Lists

Pre-Production Procedures:

❑ Find models.

❑ Set up "go-see" for professional models from agency. Get head shots or take polaroids, mark with names, day and evening phones.

❑ Research locations. Check if location fees, permits are required. Make appointments to visit, check spaces.

❑ Get permission from organizations/corporations for location use — or as source of non-professional models. Check availability of empty rooms for shooting. Weekends? Custodial fees?

❑ Prepare model-release/permission letter to be sent home to parents of non-professional child models. (Schools, clubs, etc.)

❑ Pick up signed releases. Return to school/camp/drama class. Check each face against release. Choose models.

❑ Visit location (corporate). Take polaroids & notes on space. Check availability of models (adult) for pictures.

❑ Schedule shoot. Call models (or models' parents) advise on clothes, hair, make-up, & jewelry requests.

❑ Wardrobe: Ask models to bring a selection of clothes (2-3 extras). Explain *role* model is to play. Coordinator bring backup wardrobe from prop closet.

❑ Props. Buy, borrow, rent, or make props. If necessary, retouch, tape over brand names.

❑ Pre-check location, with photographer, note reflective surfaces, obstructions, windows, ceiling height, etc.

❑ Make shot list, assign photo spec numbers for each photo. Set shooting schedule with photographer.

Shooting Day on the Set — Bring:

❑ Make-up kit: combs, brushes, elastic pony holders, kids' barrettes (non-reflective, neutral colors, simple design), hair spray, hairpins, nail file/clipper, nail polish remover, powder, cover-up stick in all face tones.

❑ Utility supply kit: tape (white, black, double-face) gumstick, white-out liquid, sticky labels in several colors. Safety pins. Iron, scissors. Fantastic & paper towels.

❑ Props: specific to location (see box prop closet), organized by shot.

❑ Snacks for adults: soda, cold drinks (in cooler), fruit, coffee/tea.

❑ Snacks for kids: fruit, cookies (not chocolate), juice or soda, apple juice, 7-Up or similar (colorless — no orange or cherry, which will stain if spilled).

❑ Helper/baby sitter (teenager) as an extra pair of hands & eyes. Useful if adult models must bring their kids or parents of child models bring siblings. Also useful for walking home kids that are finished and as "gofer."

❑ Distractions for young kids: extra crayons, paper, books to keep them occupied while others are shooting.

Functions on the Set:

❑ Decorate the set. Remove distracting or messy items, add props as needed.

❑ Wardrobe: as models arrive, check clothes and accessory props they've brought (e.g. shoes, briefcase), match with what others in photo are wearing, match to role appropriateness, consult with photographer. Request changes of clothes as needed.

❏ Make-up: check & request removal of extreme nail polish, eye make-up.

❏ Hair: adjust style (stay classic), keep off face if possible. Avoid trendy styles that will date photo. Remove all large hair ornaments, shiny barrettes, ribbons.

❏ Jewelry: ask models (kids & adults) to remove extreme or trendy jewelry.

❏ Double-check schedule with models as they arrive. Make sure they can stay as long as needed.

❏ Have model releases signed by model before shoot. With kids have parents sign a release as kids arrive (unless release was sent in to school or camp and has already been signed). Note on each release your photo spec #, the subject of the photo and date. When possible, attach a test polaroid.

❏ Check photo specs: make sure all props are in shot. Go over photographer's test polaroid.

❏ During shooting, help photographer watch for details: clothing awry, prop not in correct spot or held properly, hair mussed, bad expression, eye blinks, etc.

❏ Pay models (if fee was agreed upon) or sign model agency voucher. Get address to send prints if different from on release.

Follow-Up

❏ Send models thank you letters, complimentary prints, and/or gift.

❏ File model releases (attach polaroid or reject slide for ID of model).

❏ File polaroids or head shots in model file (add comments).

❏ File location information, contact names, telephone numbers.

❏ Return props to prop closet.

What do you have to offer them? Flexibility (scheduling the stock shoots in between their productions), additional experience for a resume, sample prints for their book, and whatever fee you agree upon.

Teachers can make excellent assistants; a little patience and searching will uncover the right one. They have weekends and afternoons available during the school year and a long stretch in the summer. I've had great success using teachers as coordinators. They are thorough, have the patience to work with a bureaucracy (e.g., getting location permits), are good at thinking on their feet, and usually bring a strong commitment to whatever they do.

Until you can justify a full-time employee, using a teacher offers the advantage of having someone who doesn't depend on you for their full-time income. If you can be flexible in planning stock shoots around their schedule, it's a good solution all around.

Pre-Production

Now, where do you (or your coordinator) start? With the organizing of the shoot. It is in this pre-production stage that everything gets arranged: models, locations, wardrobe, and props. Thoroughness and attention to detail at this time can make the difference between a professionally executed production and amateur, nice-try stock photographs.

Models

The people in your pictures, whether professional or amateur models, must be attractive, appealing, and convincing in the roles in which you've cast them. Ask yourself if a person looks like an executive, a teacher, or a construction worker. Are they believable?

The ideal model has a pleasing look (they don't all have to be gorgeous) and a relaxed manner. While you may be tempted to use a willing neighbor or that handy brother-in-law, if they don't have the "look," or are ex-

tremely stiff in front of the camera, you may be wasting their efforts and your film. Someone who has worked all his life as an accountant may not be a convincing carpenter in your photograph.

Finding models — The sources

It's possible to build a rich file of good, non-professional or semi-pro models, in a wide spectrum of ages and types, if you're systematic. The work of finding models and researching locations will sometimes overlap. When requesting permission for access to a source, make it clear exactly what you need.

- Sources for adult models: professional modeling agencies; professional actors (between engagements); university or community drama groups; high school drama coaches; corporations; friends, acquaintances, and other "real" people (e.g. actual construction workers or business executives who look their part).

- Sources for child models: schools, camps, community groups, scouts, church organizations, crafts or science clubs, and so forth. Local drama groups or children's theaters are especially good sources, as the children usually have some commitment to the process and their parents consider acting (and/or modeling) a good experience and discipline for the child. The downside is that they may already be busy with after-school activities. Child-model agencies are possibilities in some locales. Keep in mind that because a child has been registered with an agency doesn't always mean they are experienced professional models — it just means that they are interested in modeling. They are still children, with the shyness and hesitancy appropriate to their ages.

Try starting with relatives, friends, and neighbors as your models. The sources above are for later — when you have outgrown your immediate contacts or are looking for a wider range of choices.

Finding models — The approach

The basic approach to obtaining models is standard but there are variations. Working with children, for example, will require a bit more work, such as getting permission forms signed prior to scheduling the shoot. Parents and organizations are naturally cautious about permitting access to children in their care. And unless you have an unlimited supply of nieces or nephews, you will have to go farther afield sooner or later. Schools have the most stringent permission requirements. Those will be spelled out separately in the steps that follow.

Perhaps you or your coordinator have a friend or a contact at some organization, school, or company. Use their advice and influence to obtain an introduction to prospective models and locations. This can save you a lot of time and gain you access to places and people you might not otherwise have a shot at (no pun intended).

Contacting Modeling Agencies: Even if this isn't your first choice for finding models, it's good to know, before you go another route, what resources are available in your area. Visit an agency and check their head shot files to see if their models match your taste or are suitable to your style of photography. Discuss fees. It is sometimes possible to negotiate a lower fee for novice models, or if you choose a model who is not heavily booked with assignments. It may help your negotiation to explain that you are working on stock photography rather than a firm assignment. Beginning models will sometimes trade their time for some experience and prints for their portfolio. (Be sure the model release they sign reflects what the "value received" actually was.) Above all, be fair.

Contacting Corporations: When contacting a company or corporation, you will often be searching for both models and location ac-

cess. Whether you need the help of a computer manufacturer, an insurance company with newly renovated offices, or a nearby lumber mill, your approach must be made with finesse.

How to make contact depends on your locale. In small towns or cities you can go right to the corporate communications or public relations department with a reasonable expectation of cooperation. In major metropolitan areas, where nobody has time for anybody, the avenue is the same but access may be more difficult. Owner-managed companies are more approachable, make decisions more quickly. They don't have to go through a corporate approval structure of many levels. The very best way, of course, is to have a friend, a contact on the inside.

To help sway them in your favor, there are some assurances you can give a company:

- You will not show their company logo in your pictures.

- You will not allow any pictures taken on their premises to be used by one of their competitors.

- You will not photograph any employee without the employee's permission.

- You will schedule the photography at their convenience.

You are often going to have to offer an incentive. That will be discussed below.

Contacting Community Organizations: Find the name of the person in charge, the one who has the authority to give permission. Again, that friend you may have on the inside would be the best channel for doing this.

Remember, you are asking for *access* to people (potential models) in their organization or program. You will be requesting individual permission for photography or permission to photograph in their facility or both.

An explanation of your request by telephone may work to open the subject, but a letter is preferable — especially if you are speaking to an underling who will report to the boss. You can suggest: "Why don't I send a brief note about this that you can give to the administrator..." This way you are sure that all your important points are communicated to the decision maker.

If you are refused access, it's important to know why. Is it against their policy? Or didn't you present yourself clearly?

Contacting Schools: Depending on the district, it is often advisable to start with the superintendent of schools for permission. Some school principals will feel the need to get final clearance at district level anyway, so if you've started at the top, you've saved a step and had a chance to present your case firsthand. However, it's quite possible to go directly to the principal if the person making contact on your behalf (your coordinator?) has a good relationship already established with a school.

Explaining Your Request: For all sources, corporate, school, or other, let them know the purpose of your stock photography project and your needs. Use the title and description of the project along with the sample letters (see samples later in this chapter). Even when the request is handled verbally, as mentioned earlier, it's a good idea to have a letter to leave with the person you speak to or to send afterwards as a confirmation, to make sure that they remember the details discussed.

At the earliest opportunity, it is helpful to have a tour of the facility, offices, school grade level, etc. You should also meet department managers, club leaders, coaches, or teachers and explain the project directly to them. Their involvement is critical. It's both helpful and courteous to consult them. Examine your prospective locations — and if you want to use any of them in a shoot, con-

sider taking Polaroids of the area, so that you remember what physical features make the space useful or difficult for photography.

Permission Forms: Provide the organization, club, or school with sample permission form/ model releases (see chapter 14). It is a professional courtesy to offer to pick up the cost of photocopying these releases or the actual work of having the copies made. It is important to establish good public relations by avoiding, when possible, any extra burden on the organization you've chosen for your shoot. Remember, they will probably be understaffed.

This procedure is especially important when dealing with children. It is absolutely essential to have parental permission prior to the shoot. However, working with adults tends to be easier. Imagine you are in a government research lab hoping to photograph a serious-looking scientist, with elaborate equipment. You can usually depend on the scientist's verbal agreement to work on a certain day and get the model release signed on the day of the shoot.

Some administrators appoint a contact person, such as an assistant or office secretary to make logistical arrangements once permission is given. Easy access to this contact person in the office speeds up the process and avoids having to bother the administrator with mundane details.

Polaroids of Models: Always carry a Polaroid camera when visiting prospective models or location sources. A quick explanation to your contact person (and a Polaroid for them) will get you permission to take reference Polaroids of locations or prospective adult models. These file pictures can be enormously valuable. You may wrack your brain months later trying to remember where you saw that great looking silver-haired woman you desperately need for a shoot — was she the plant manager of XYZ Electronics or the sales assistant at the stuffed animal showroom? A quick

Polaroid at the moment (with name & home phone) can be worth a great deal to you later.

With rare exceptions, the taking of reference Polaroids doesn't work with children. You should NEVER photograph ANY child without prior parental permission. Kids don't understand the difference between a file Polaroid and a professional photograph suitable for reproduction. They only know that "some lady took my picture." The incident could lead to an unpleasant misunderstanding.

With children, you can get your Polaroids at the next stage of your contact with an organization. You or your photo coordinator will call to see the status of returns of model release/permission forms. Once most forms are returned, it's useful to go to the next club meeting or to the classroom, releases in hand, to meet the children.

After you select the children you need, based on their general look, liveliness of manner, expressive eyes, ethnic background, or the advice of the teacher, scout leader, or gymnastics coach, consider the following: out of a sense of decency (which will also please the school and parents) make sure that the children are not aware of the selection process. Take discreet notes, followed by consultation with the teacher. Quietly ask which children are the most cooperative, and the best able to follow directions. The valuable insights of the adults involved can steer you away from behavior problems you might not be able to detect in a glance.

Explain to the children that each will be chosen for different pictures, that some will be taken now, some another day, but that all will be included. Then, when your project photos are complete, take general photos of the group (anyone who was "released") to include any child not yet used. The important point is to make sure that no child feels left out.

What to offer as an incentive
The cooperation of friends, neighbors, and corporate or community organizations is critical to the stock shooter. You will have to

find ways to make it a fair trade. You get the photographs. What do they get?

Models: What you offer models in exchange for their help in photographs will vary greatly according to whether they are professionals, who are paid for their services, or friends who act as models for the fun of it.

Probably the single most prized reward for any model, after money, is a print of the photograph, closely followed by tear sheets. It's tough enough to get tear sheets from assignment clients, much less from stock buyers. This makes tear sheets a valuable commodity. Share them. It is the best investment in good will you can make. Information about ordering a magazine, book, or brochure containing their picture is also valued by a model.

Be expansive and generous, don't be chintzy with models during a session. Buy treats for the kids, order pizza or a Chinese dinner for the family whose afternoon you've taken up. Send a box of candy or flowers to the office personnel you've used. Do this especially when you can't afford a top-of-the-line fee. Courtesy and a small gift will show your appreciation.

If a family has given me extraordinary co-operation over several days, and I've photographed everyone including the cat, sometimes, in addition to complimentary prints or a gift, I will send them some reject slides. Accompanied by an explanation that the "rejects" are the throwaways, pictures that didn't work because of exposure, focus, or blinked eyes, I send these soon after a session. It's simple enough to do; while you're editing, in addition to a waste basket, keep empty film boxes handy to toss in the rejects. (Mark "personal use only"and stamp your © notice.)

When using professional models, even with those willing to barter their services, discuss the question of residual fees. Once you've recovered costs, try to share a percentage of a sale of their picture with your models — it's a great way to keep good talent.

People like to be cooperative but no one likes to be exploited. Sadly, when it comes to models, we photographers are known to "love 'em and leave 'em". This is particularly true once we have the photograph we want. To be successful in stock, a dependable stable of models is essential. Treat them right.

Corporations and Institutions: Occasionally, some stock photographers trade photographic rights for access to models or locations. I strongly advise against this practice. It is necessary and reasonable to give a company or institution something for their trouble — but it is not necessary to provide free use of professional photographs they would otherwise have to pay for by an assignment or from a stock agency. This sends the wrong message about the value of your photography. How will they feel the next time they are asked by an agency to pay normal rates if they know you are willing to give it away? (See chapter 12, Negotiating Prices, for more on this.)

You can offer several other valuable things, however. Complimentary prints for the company to display in a conference room or in a manager's office — or for any of the employees depicted, are often greatly appreciated. Do some "good will" portraits for the personal use of the managers (I even did some quick pictures of an executive's visiting nine-year-old). However, if this is a prospective assignment client, make sure the portraits are professional quality or don't offer them. Having to explain later, "That was only a grab shot" may not restore their confidence in you if the quality is less than it should have been.

Make sure that all complimentary prints you give out are clearly marked with your name, address, and copyright notice. Add the note: "For personal use only. Permission to reproduce must be obtained in writing."

If they are impressed with the pictures and want to use them in a brochure or company report, you may then want to give them a break on the fee. Let them know that you will

happily give them a discount for specific usage, but not for free. (Think of it this way: the corporate communications officer of an electronics firm probably wouldn't expect to trade you a new VCR in exchange for your helping him out with some photographic advice on taking pictures of his pets.)

Locations

Locations truly are the setting for your gem. They should be believable, generic, and not distracting. First judge a proposed location by it's authenticity. What you look for in a location is a clear, direct statement of what that location is. Whether it's a room, an office, or open field, a location should communicate its essence immediately. Does it feel genuine? Does it look the part, or can you make it look the part? If you are doing a picture of a pediatrician examining a child, it's possible to use the examining room of an internist by simply adding a few child-related props. But you'll be hard-pressed to create a convincing scene if you are working in the corner of a community hall.

Question each prospective location. Does a particular office look like a top executive's seat of power or is it barely more than a cubicle? Will this family kitchen reinforce the warm interaction that is expected by the photo buyer? Anything that distracts from your message must be changed or avoided.

Locations — What works best
A good location is attractive, clean, well-maintained, and in good repair or up-to-date. For stock, tacky or down-at-the-heels spots won't do. This is not a documentary.

Next, look for large spaces, whether in a home or office. (You need space for your lights.) In home settings, try for rooms with pale colors or quiet wallpaper. Avoid mirrored or dark-paneled walls, flamboyant wallpaper, high-gloss enamel paint.

When working outdoors, does your nature location evoke a Robert Frost poem? Will a location read in a photograph as "an inviting trail through the forest"? Or will it merely look like a dark woods with tangled underbrush? Just because it's natural doesn't make it a good location. Even natural sites must be selected to show their features off to best advantage.

Locations — What to offer
Finding the right locations — and the approaches and incentive needed to secure them — is handled very much as you would the search for models.

When dealing with organizations or corporations or government facilities, make a clear request, in writing when possible, and let them know what you can offer them for their cooperation.

Location fees are sometimes requested by an organization, a store, or a school — especially those that have been used before in assignment photography. Determining when a location fee is a necessary investment will depend on how important a location is to your project (and to the size of your pocketbook). Often an organization is asking for acknowledgement more than for money; however they want to know that you realize their time and cooperation has value. If you offer a modest donation to one of their funds or to a favorite charity of theirs, along with an explanation of why you can't pay a higher location fee, they will know that at least you are treating them with respect.

A possible approach: "I wish we could offer you a location fee, as film makers and television people do, but our budget on this project just won't allow it. Could we make a small donation to ... in your name? We can't afford what your time is really worth, but we'd like to show, even in this small way, how much we appreciate your cooperation."

Other small gestures, which may seem insignificant to you, will be appreciated if they are handled in a sensitive way. For example, a community crafts club may be pleased to have the used seamless background paper that you were about to throw out. Their kids can use the reverse side to

make a mural. We are sometimes cavalier about items that others will value — even the lowly film cannisters are a delight to children. Also, don't forget the power Polaroids can have over adults, as well as children. Spreading a few around will increase your good will.

Researching Locations

For the purposes of building your file, never go anywhere without a "point & shoot" camera or a Polaroid camera so you can make visual notes of good locations you come across in passing. Transfer the pictures and pertinent information, such as directions to the location and the property owner's name, to your file.

Exteriors Nature:

As you shoot your file pictures of a natural setting, be sure to note the angle of the sun, time of day, and the directions North, South, East, or West at the site, based on your proposed camera angle. Also note the time of year and what plants or flowers are in bloom.

Exteriors with Structures:

It's not possible to find the owner of every building in a street scene, but for a significant building, and if you want to sell to advertising, it's worthwhile finding the owner before using it in a photograph.

Interiors:

Take Polaroids of all four walls of a location room, whether office, store, or home setting. Note the rough dimensions, the location of windows and doors, reflective surfaces, obstructions. Note other characteristics. Is it high tech, traditional, cozy, elegant, simple? Use your location file form to fill in contact's name and all other details.

Permits

Contact the mayor's office or the Chamber of Commerce for guidance about what permits are needed in the area in which you want to shoot.

National parks have restrictions on photographers (and visitors), which are sometimes puzzling because they can vary from location to location. Though there are guidelines from the Department of the Interior, considerable autonomy is given to individual national park superintendents to determine what constitutes a threat to the environment or wildlife of their area. (ASMP is currently negotiating with the Parks Department to have the guidelines for photography clarified.)

The best practice is to check for restrictions when you first arrive at a park. Then contact the office of the superintendent if you want to shoot in any location or way that is different from what the general public is allowed.

There are certain privately owned attractions, such as Disneyland, Sea World, and various amusement parks, which prohibit showing their facilities in a photograph for trade or advertising. Despite this, it is sometimes possible to get permission for photography through a public relations department. But before setting up a complicated shoot, get your permission straightened out. You'd be heartsick at having to cancel in the middle of a shoot, with a family of models looking on, because a security guard takes issue with what you're doing.

Some photographers, shooting with a low profile, may avoid detection by the security guards — two cameras and a film bag are common for tourists — but without permission, the resulting pictures have very limited value, unless you want the risk of a lawsuit down the road.

Changing Locations

In order to avoid unpleasant surprises, try to double check your location just before a major shooting session. I remember the time that jack hammers were ripping up the courthouse steps I had selected as a good location for a shoot, checked just the week before. Then there was the morning in North Carolina when I was greeted by a body-building

contest, complete with a giant Budweiser can, on the pristine beach I had scouted for a family scene just the night before. At times like these you have to be flexible and think on your feet. We made a quick exit, loading models as we raced the good light to the next beach down the coast. Then there was the spring flood that washed away carefully arranged stepping stones the night before a shoot. The scene had been planned to have seven models, in colorful hiking gear, crossing a mountain stream. It took two of us in waders to construct another "stepping stone" location downstream.

Wardrobe

You should be able to rely on professional models and sensible non-professionals to bring a reasonable selection of appropriate clothes to a photography session. But don't count on it. I've been cautious ever since the time in Florida when a professional model arrived with a critical piece of wardrobe missing — the shoes. In his first scene, he portrayed a young father, dressed in sporty attire, playing with his kids on the front lawn. The tennis shoes he wore were not appropriate to his second role, as a business executive in a suit leaving home for the office. We were on location, but the day was saved when a friendly onlooker volunteered her husband's wing tips.

You can't be prepared for everything (with every shoe size at hand) but you can minimize or avert certain disasters. You can assure the right look, by having some emergency wardrobe available at all shoots. It's useful for times when two models arrive wearing the same color, for children who stain their shirts at lunch, or for the model who doesn't understand a concept such as "dressing for power."

If you happen to be working in or near a model's home, an easy solution is to help them select the right clothes. A bit of tact will avoid the implication that they don't know how to dress. You can put them at ease by explaining that their wardrobe is excellent, but that because of the effect of photographic lights, certain colors and styles work better than others. As to the fit of a model's clothes, you can point out that loose-fitting clothes are more graceful in pictures.

You will greatly improve your chance of having a model bring the right wardrobe if you provide them in advance with a clothing guideline letter, like the sample later in this chapter.

Props

Props in pictures set up for stock can range from the fishing rod used by a grandfather and grandson at the lake to a tablecloth for the family dining at home or the desk calendar in the executive conference scene.

Whether you are choosing candlesticks, glasses, coffee cups, wall hangings, planters, or kids' toys, the rule is to use top quality or don't use it. A good photograph shot with a tacky prop is a wasted effort. We all know how to judge tacky merchandise, but when faced with saving some money on a prop some photographers have been known to go against their own instinctive good taste.

Here's a technique to use if you're not sure: Ask yourself if you would give this prop as a present — or have it in your own home. It may be tempting to pick up a cheap or available prop that isn't quite up to snuff. Resist the temptation.

Within the general range of taste, choose the classic, simple, and elegant — whether the item is a traditional or contemporary piece. Use the newest models of anything that could look outdated, such as computers, telephones, and typewriters — or use timeless, well-designed items in good condition that don't shout "out-of-date." Avoid showing the year on calendars (just white-out the offending date). Remember, a few good props are far preferable to an abundance of mediocre ones.

Consider the following incident. An art director, viewing research photos for Mother's

Building a Prop Closet

GENERAL

Props should be:

simple, classic, non-trendy, free of logos, lightweight, easily transported

Materials:

wood, straw, fabric, nonreflective

Handy items:

baskets, containers for plants, framed items, mounted on Styrofoam (no glass), straw mats, fabric wall hangings, pieces of fabric — decorative throw-cloth, tablecloths, colored paper — construction paper 8x10" & 11x14"

Utility items:

tape (white, black, double-face), gumstick, white-out liquid, labels in several colors, safety pins, push-pins, thumbtacks, rubber bands

OFFICE

Interior:

Both modern & traditional styles of all items. Need simple, quality, dignified look for executive offices.

Desk:

well-designed pencil holders, letter openers, desk blotters, clean blotter paper, plant containers, plants on day of shoot

Wall hangings:

Maps, prints (antique look). Need simple, quality, dignified look for executive offices.

HOME

Kitchen:

Baskets, brightly colored dish towels, plants, colorful plastic mixing bowls, utensils. Fruit in bowl. Solid, brightly colored tablecloths. Construction paper (8x10") to create instant kids' drawings (use to cover hot spot reflections on refrigerator or high-gloss kitchen cabinets). Calendars (obscure year date).

Living room:

Plants, colorful pillows, baskets non-glare wall hangings (fabric). Ethnic artifacts where appropriate — including bark paintings, Ojo de Dios made of yarn, Chinese-style paintings. Prints mounted on foamcore, floral prints.

Kid's room:

All school supplies. Desk blotter, pencil cup, trophies, model cars, stuffed animals, pennants, posters from museum or zoo or historic site. Animal & science posters good, won't go out-of-date. (Avoid commercial ventures: Bat Man, trendy movies, music groups, product ads.)

SCHOOL

Desk:

school supplies, notebooks (blue, red, green), folders, all colors; yellow pads; pencil cases, all colors; pencils, erasers, protractors etc. (real kids' notebooks are too scruffy, have rock star covers, logos)

Classroom:

(if you have empty room in school, re-create a "classroom" look with posters and decorative material available at teachers' supply stores)

- corrugated colored paper (to make bulletin board)
- sheets (30 x 40") of colored cardboard
- Foamcore sheets covered in bright-colored felt
- packs of construction paper (8 x 10" and 16 x 20")
- prop "school papers," kid drawings, reports, balloon shapes (have kids make for you)
- props — commercial (nonreflective): ABC's, animal posters, name charts, homework assignments, science posters, biology — skeleton, muscle diagrams etc.

Day greeting cards saw a series of setup pictures of wide-brimmed, beribboned "feminine" hats set in different fields of flowers. The client liked the concept but not the execution.

"This picture is so close to what we want, the color of flowers is lovely, just the right season for Mother's Day, and the lighting is gentle and beautiful. But that atrocious hat kills it! Look, it's made of cheap plastic. You can see the rough-edged seams. I don't understand, why a photographer would go to all that trouble, find such perfect locations, then ruin the picture with such a bad prop. One simple, well-made straw hat would have been perfect. It's a shame but I can't use it — we need something with better style. Now what do I do?"

Careful attention to the details will give your pictures a clean, current look that enhances their saleability. Decide on the look that you want in a location or the look that it has, and use your props to reinforce it. With some ingenuity there are ways to get around a tight budget and still have stylish props.

The right props are used to decorate the set. They can improve a mediocre location, even make an empty room work. Imagine that a neighbor has a spare room that's rarely used — that could become your location studio. By using the right props it can become Dad's den, a boy or girl's room, Mom's sewing room — almost anything you want.

Collect props and wardrobe piecemeal. When you see them at a good price — at clearance sales, yard sales, or catalog closeouts — buy them. And don't forget to haunt the thrift shops — the outlay will seem minimal, and the props will be on hand when they're needed. Another good time to gather props is when you are traveling. Pick up small souvenirs, museum artifacts, posters, crafts. If it was easy to buy and pack them on your travels it will be easy to transport them to your location shoot.

When collecting your prop wardrobe don't be too proud to accept hand-me-downs from a neighbor's child or a church rummage sale, provided they are in good condition. They'll come in handy.

Making or buying props: Keep in mind that things look smaller in a photograph, especially when dwarfed by human beings. All props should be as large as possible, and more plentiful than in real life, so as not to get lost in the photo. Any signs you may create should be larger and clearer than normal.

Prop storage

Have cheap, fibreboard suitcases to carry props to location. Garment bag for wardrobe. Also useful: artist's oversize portfolio case for posters, wall hangings, signs. Cardboard filing boxes are also useful for transporting and storing props (line inside with plastic bag for weather protection, use luggage belt to secure them).

Organize props by type of location — e.g. office; home (LR, kid's room, kitchen); school. Have each in different suitcase or box, labeled.

Finally, enjoy it. Collecting props is easy and can be fun. It's a justification for indulging in your penchant for picking up odd bits and pieces. How nice to have a rationalization for haunting thrift shops and flea markets.

Prohibitions

A vigorous, attractive silver-haired couple is walking off the tennis courts, looking into each other's eyes, swinging their tennis rackets happily. Back lighting reinforces the mellow quality of the moment. You worked for days getting this shoot organized and now you've caught it perfectly — including the brand name on their tennis rackets! That simple detail will cut the value of those photographs significantly. It's easy to understand why a pharmaceutical company placing an ad for vitamins in *Modern Maturity* magazine doesn't want to plug the tennis racket manufacturer. Regretfully, they'll pass

Props: Removing Brand Names and Logos

Decide the technique you will use based on whether you want a temporary concealment for borrowed props, or, if you own the prop, a permanent one. Tape is usually easy to remove from painted, varnished, or metal surfaces. Any changes to paper or fabric surfaces tend to be permanent. Run a test to be sure.

If the picture is a close-up, tape on a prop may show (and look tacky), so use the more delicate approach of white-out or paint. But if the prop is at a distance or in an action shot (bicycles, tennis racquets), tape or paper labels may be fine for covering the logo.

Supplies:
 White /black/ grey gaffer tape
 White/ black/beige & color paper
 masking tape
 Liquid Paper (white and various colors)
 Labels (self-adhesive, removable) — white
 & colors
 Colored paper (artist's)
 Double-faced tape
 Stick-tack gum adhesive
 Spray adhesive
 Press-type

Techniques:
1. Props with white background:
 Cover with liquid paper (White-Out) or white paint, white tape (gaffer tape or thin artist's tape)
2. Props with black background:
 black marking pens, black tape
3. Props with colored background:
 Use colored tape of a similar or complimentary color. Use colored paper, cut to size of label in similar or complimentary tone. Attach to prop with double-faced tape, spray adhesive. Color edges with marking pens.
4. Create labels using press-type on colored paper, use generic names. Have your prop retouching done ahead of time with enough patience to make a clean job of it.

over your lovely photograph and keep on searching for the "right" stock photo. White tape, skillfully applied over the logo would have solved the problem for you and the client.

Be aware that there are certain prohibitions (see box this chapter) for stock that should be kept in mind when gathering props and when shooting: no logos, no brand names, no alcohol or cigarettes. Also, have workers use correct safety devices (goggles, ear protectors) and procedures. Keep in mind that being sloppy about these details can mean death to saleable stock.

A client once related a story in which the point about brand names came home to me quite vividly. He turned down a lovely multi-generational family picture. The group was gazing fondly at a new baby in a plastic carrier seat — but the brand name of the seat was painfully obvious in the foreground of the picture. The extraordinary amount of work the photographer had put into the scene was virtually down the drain because they hadn't masked out the name. Sales potential for those pictures was halved by this easy-to-avoid error.

A product logo that appears in your photo, for example a can of soda, might not compete directly with the product of a prospective stock user, say a pharmaceutical company. But why should they want to give free advertising to another company or distract the viewer from their own intended message.

There are legal reasons for caution as well. Some of the props that you include in a photograph may be trademarks (usually protected by the Patent Office) which you cannot use without permission. A trademark is defined as "a distinctive motto, symbol, emblem, device or mark which a manufacturer places on a product to distinguish in the public mind that product from the product of rival manufacturers." Some examples of trademark items that might be tempting to use as props in a photograph are Disney characters and the Rolls Royce and Mercedes Benz hood ornaments. Even skylines may not be safe. Recently, a distinctive skyscraper in

Dallas was trademarked. (The Dallas Chamber of Commerce helps photographers clear permission.)

Creating a storyboard

It's the day before the shoot. All the models are ready and you're familiar with the location. Now, take a deep breath, go back to your assignment form, and build a storyboard with sketches of the variations you want to try, plus a shooting list for the order in which

the pictures will be done. You can vary this on the spot, but without having some order in mind before you begin, mass confusion can result. Imagine arriving at a park with five models and a dog for a series of family pictures — with no plan in mind. Well, you get the picture.

In planning the order of events, remember that kids tire easily. First schedule the most effervescent pictures, where lively expressions are critical. Leave the quiet, family-strolling-by-the-lake-in-silhouette shots, where a

Prohibitions

For generic, saleable stock; avoid:

BRAND NAMES and LOGOS

- on clothes, products, all props, backgrounds
- on food products, cereal boxes, soda cans (no Coke, Pepsi, Dr. Pepper)
- in street scenes, shopping centers (e.g., Radio Shack, Macdonalds, Exxon)
- in scenics (e.g., Grand Union or Mayflower trucks on highways)

TRADEMARKS	Need permission to use proprietary symbols e.g., Disney characters, Rolls Royce hood ornament
LIQUOR	Including hard liquor, wine, beer — bottles and cans, with or without labels
SMOKING	Cigarettes, cigars
DRUGS	Drug paraphernalia
FOOD	Unhealthy (high cholesterol, caffeine, sugar, salt)
CLOTHING	Extreme, ill-fitting, trendy, loud-patterned
JEWELRY	Extreme, trendy
DATES	Year on calendars, posters
PRICES	Fruit and vegetable stands, store windows

Keep food and beverages as vague, generic, and healthful as possible. Show meals with salads and vegetables, chicken or fish. For example, adults having a conversation might have cups, presumed to hold coffee or tea, but avoid the "action" of spooning sugar in; Kids should not appear to be drinking coffee or soda — items high in caffeine or sugar.

No packs of cigarettes on a table.

Avoid anything that will date a photograph and limit its saleable life.

There are occasional exceptions to the rules above if you are shooting with a particular product market in mind. For example, if you are directing your shoot toward liquor ads, then the upscale couple by the fireplace will need cut-glass tumblers filled with amber liquid. However, keep in mind that cigarette and liquor advertising is a tough market to crack. In order to reduce the risk of cutting out other markets, the smart approach is to cover the scene two ways — once with the amber liquid and again with a generic liquid or opaque glass. This way you may have your cake and eat it too!

Storyboard

Remind yourself to design negative space into photographs by drawing variations on a storyboard. In these sketches, the empty space (sky or snowdrifts), will allow an advertising client to superimpose type. Choose dramatic snowdrifts so your photographs will be elegant in their own right even without the client's text.

You can also use this technique to plan various postures, gestures, and relationships of models.

lower energy level is required, till the end.

In working out a storyboard, you are acting as your own art director. Let your imagination roam. Think of angles, the juxtaposition of people, the directions models could lean or touch, in order to show the required relationship. Go back to your Polaroid file of body language pictures for reminders of effective placements and authentic-looking movement. Sketch possible relationships of models to be used.

Think of ways to design negative space for the insertion of copy. Draw those on the storyboard. If the placement of the subject and background can be controlled be sure to do your variations with different thirds of the picture free for type. See the sample in this chapter — it shows a downhill skier placed in different sections of the frame. This approach works easily with inanimate objects in a scene, a lighthouse for example. To make sketches for your own shoots, make blank storyboards by tracing over ours or use the larger storyboard pads available in most art supply stores.

It's important to plan your variations before the shoot, when your mind is free to concentrate, because once you're in the middle of shooting there may be too many distractions. This is your chance to devise the creative variations which will improve your yield from the shooting day.

Pre-production planning
Work with a coordinator to double-check everything. Use the coordinator's checklist and your assignment sheets to check props and wardrobe. Go over storyboard with the coordinator to make sure that you are working in concert.

Discuss how you'll handle the unforeseen. Are you working in a public place? Will there be a need for crowd control. If so, who should handle it? Sometimes you can hire a teenager for the day to mind kids, to keep crowds or extraneous singles from walking into your picture or tripping over your light stands —

and all the other little jobs you'll need assistance with.

Production — Sample Letters
The more thorough your pre-production planning on a stock shoot the greater your likelihood of success. The techniques outlined in this and the next chapter are easily put into practice with the use of the sample letters and forms in this section.

Drafting letters
Writing letters is a tiresome business. A thorough, well-written letter, however, can mean the difference between getting permission or being turned down by a valuable source. It is well worth the effort.

You will remember the earlier discussion that a key element of success is your enthusiasm about your stock project

In this section you'll find sample letters that you can modify — scale up or down, make more or less formal, to match your style or the circumstances. Following are points that should be covered in any letter you write requesting help on a stock photography project:

- What you're doing (stock project description)

- Why the project interests you (contagious enthusiasm)

- How it will be used (stock and other use planned)

- What you want from them (access to location, models)

- What safeguards you offer (work at their convenience)

- Their reward, incentive (fee, complimentary prints)

- Who you are (credentials/ professional associations)

- Coordinator's name (and description/ credentials if known in the community)

All of these items may be incorporated in one letter, or, if you prefer, some of your information (e.g., stock project description, professional credentials) may be put on separate sheets, to accompany a shorter letter.

When thanking models or location sources, add a personal touch: a reference to the weather, delight in the location, or the enjoyment of a meal shared.

If you live and work in a small community you might want to make special efforts in thanking those who help you. A slide show I held for a group of models engendered the greatest good will of any thank-you gesture I've made. About ten families had helped me as models for a series of shoots over a six-month period. I put some of the better rejects (at least one flattering one of each person) and some funny rejects into a slide show, held it at the local library, and served coffee and desert. This kind of sharing does a lot to create future cooperation. And it was fun.

SAMPLE STOCK PHOTOGRAPHY PROJECT DESCRIPTION #1

"Family Life In The 90's" is part of an ongoing stock photography project on which I am currently working.

Through this body of photographs I hope to portray the changing aspects of American family life, sometimes using actual families, at other times using a group of people in situations that characterize salient aspects of the modern family. By creating photographs that reveal the intimacy, spirit, and strength inherent in family relationships, I hope to reflect a current trend: the return to the traditional values of family life.

I am still exploring the various possibilities for final publication of these photographs — this has not yet been determined. There is the possibility of a gallery show next year and also the possibility of them being used as a group, in a book publication, or as a photo essay.

In the meantime, I will be placing them with my photo agent and putting them in my stock photo file, where they will be available for use by a variety of clients.

I am excited about the aesthetic possibilities of this project and hope that viewers of the final photographs will share my enthusiasm.

If incorporated in a letter:

Your cooperation on this project is highly valued and very much appreciated. I am excited about the aesthetic possibilities of this project, and, when we have a chance to discuss it further, hope that you will share my enthusiasm.

I look forward to discussing this project with you and answering any questions you may have.

SAMPLE STOCK PHOTOGRAPHY PROJECT DESCRIPTION #2

I am currently involved in a stock photography project titled "A House, A Home," part of a work in progress through which I am trying to build a body of photography on the architecture of the American home. My purpose is to visualize a complete representation of types of dwellings: various periods and styles of architecture, of differing economic levels, ethnic influences and in all locations — urban, suburban, ex-urban, and rural.

In addition, I am looking for a variety of geographic settings in order to show how the design of a house is influenced by its surroundings and climate — in the woods, by the water, in the desert, etc.

I hope to highlight the individuality (gardens, flags, decorative touches) imposed by each owner on a structure — those elegant, charming, and sometimes eccentric details that add a personal stamp.

But, perhaps most important, I want to capture the special warmth that distinguishes homes from all other buildings and that satisfies the most basic human needs:

Home as a symbol of safety, stability, and security

Home as a source of pride and accomplishment

These photographs will become part of my permanent photographic collection of stock photography, available from my files (through my stock agent) to a variety of clients for their publication use.

I welcome suggestions for homes of unusual interest, such as adaptations from other buildings (barns), or in special settings, and would be pleased to discuss this project in greater detail.

SAMPLE LETTER — CORPORATE LOCATION

Mr. or Ms. Higher Up
Vice-President of Corporate Communications
Corporate Row
Technologyville, USA

Dear

As I explained in our telephone conversation today, we are currently working on a stock photography project, "Technology Today," and would appreciate your assistance in allowing us to photograph in your facility (name it).

I have been working as a professional photographer for xx years, specializing in photography of people in their environment. Attached is my professional resume. A special interest of mine has been the interaction of workers with sophisticated equipment.

We would like to photograph the following operations in your research facilities:

(list them....)

The photo coordinator for this project, Pat Perfection, of Upper Rocky Point, Lands End, will be working with me to make necessary arrangements. Pat, the former director of the Community Alliance for Communities, will work with your administrative assistant to schedule the photography at a time that will not disrupt your operations.

As we discussed, I would be happy to make available for your personal use, and for that of any of the workers portrayed, complimentary prints of the photographs.

Your consideration of our request is very much appreciated. We look forward to working with you. Please don't hesitate to contact me with any questions.

Cordially,

Frances Photographer

SAMPLE — PERMISSION REQUEST LETTER TO SCHOOLS
(Can be modified for clubs, camps, theater, or church groups)

Pat Principal Date:
Elementary School
Town, State

Dear

Thank you for considering our request for permission to photograph in your school for our current stock photography project,

As we discussed, the following is the way we usually work when setting up photography in schools.

First, we provide permission request forms which the students take home for their parents to sign (sample attached). Though these forms are sent home to all children in a class (or grade), any child who does not return a parental permission form is not photographed.

Sometimes it's possible to find small tasks behind the camera for these children, so they do not feel left out of the process. If not all children who bring back forms are used, we take some general class pictures (at the teachers discretion) to include these children.

When the releases come back, we consult with the classroom teacher for his or her advice on which students have the best attention span and ability to cooperate and concentrate.

All photography done in the classroom is planned with the classroom teacher to avoid unnecessary disruption of the teaching schedule. If available, it is helpful to have an empty classroom in which to set up the photography.

Since photographs of children must be bright and colorful, we use strobe lighting equipment and color film. This requires some setup time, which we keep to a minimum.

When working in the classroom the photographer will make an effort to:

1. consider the needs/schedule of the teacher
2. make all children feel included
3. minimize disruption
4. make it a learning experience for children — with emphasis on the discipline, cooperation, and social skills needed to be in pictures, and to instill pride in their participation
5. explain (at the teacher's discretion) how the "job" of professional photography works - giving a career vignette for appropriate grade levels

For the school we provide:

1. A set of prints of the pictures, so the teacher can create a bulletin board to share the experience with the children — to show them the fruits of their labors. These prints are available once we have completed the editing process — about four to six weeks after the photo session.
2. A complimentary copy of any publication that we are able to secure that includes the photographs.
3. An honorarium to the school, of a modest amount. This is due to restricted budget on our project.

Most photographs will be taken in the school. If possible we contact parents the night before (particularly for a child with a featured part), in order to suggest the type and color of clothing suitable to photography. Parents generally appreciate this advance warning.

It is sometimes possible that photos may be needed in other settings such as homes, parks, stores, etc. Naturally, parents would be contacted in advance for permission and to arrange a convenient shooting schedule. Many parents enjoy watching the process at weekend or after-school photography sessions.

A few questions:

1. Do you have any empty rooms that we might use?
2. If we have a schedule problem, may we arrange to shoot in the school on weekends (with payment to the custodian required to open and safeguard the school)?
3. If we have permission from the parents in advance, may we do some photography after school?

Please let us know if you need more information about this project. We understand your time pressures and appreciate any cooperation you are able to extend.

Thank you for your consideration of our request. This is a very exciting project and we hope that you and the students will enjoy participating.

Yours sincerely,

Signature
Photographer (or) Photo Coordinator Telephone_____

SAMPLE LETTER — Adult Models: Wardrobe

Date: _____

Dear

Thank you for agreeing to help with our stock photography project _____

We will be in touch regarding the location and schedule for the photography session. In the meantime, we hope the following information will be of help in choosing your clothes for the shoot.

As we discussed, in the photograph you will be playing the role of _*"Executive in Sales"*_ Please keep in mind what would be appropriate wardrobe, for example:

_____ *suit or dress with jacket.* _____

Do you have any of the following accessories or props:

_____ *briefcase?* _____

In order to coordinate with the colors that other models in the sequence will be wearing, we would appreciate your bringing a selection of clothes and accessories. If possible, we need three to four different tops (blouses, shirts, sweaters, and/or jackets).

We hope this request isn't an imposition and that you realize it is necessary to the creating of a successful photograph.

To make it easier for you to select what clothes to bring, the following is what is most suitable for photography and what works best under photographic lights:

COLORS:

For home, leisure, or sports:	solid, bright colors; some bold stripes or simple plaids.
For business scenes:	neutral colors, including tan, beige, and grey

Preference	Please Avoid Darks/Lights
red, blue (periwinkle or royal) kelly green, bright purple clean yellow	black, dark brown, maroon forest green, white

STYLE:

Simple, good clothes, not too elaborate.
Except for special requests, timeless,
classic styles are better than trendy fads.

Natural fabrics: wools, cottons (including tweeds) usually work better than synthetics.

Please: no brand names or logos. It's best to avoid all writing.

Loose-fitting, long sleeved clothes tend to look more graceful in photographs.

HAIR: Simple hair styles work best in photos.

JEWELRY/ MAKEUP:

We must avoid extremes in jewelry and makeup.

We hope this information will be a help. Again, thank you for your cooperation in this project. When you see the pictures, we trust you will find it was worth it. If you have any questions, feel free to call.

Thank you.

Photo Coordinator _____

Telephone _____

Photographer _____

Telephone _____

This sample letter can be modified for use with child models.

SAMPLE — THANK YOU LETTER TO MODELS

Date:

Dear Friends,

Thank you so much for your help during our recent photography session for my stock photography project _____ . We are very pleased with the photographs. They look very good and we appreciate your cooperation and hard work. They were a great contribution to the success of the pictures.

Here are prints of some of the photographs, for your personal use. I hope you enjoy them. (As you see from the stamp on the back of the pictures, anyone who wishes to reproduce them will have to contact me.)

We've also included some of the reject slides — the throwaways — in the hope that you might find it interesting to see why we have to shoot so many pictures. There are variables, such as exposure, lighting, sharpness (focus), expressions (eyes closed), wind-blown hair, and so forth, that can spoil an otherwise good picture and make it unsuitable for professional use.

Keep in mind when you look at the rejects that there were many excellent photographs in which you looked great and the scene was very natural. These rejects should provide some amusement at least. (Or be more casual: "give you some laughs!" also refer to some incident that happened on the shoot: "Did you notice that the spot where you spilled the pizza on your shirt didn't show?")

Once again, our thanks and appreciation for your warm welcome. I hope we can work together again before long. (Include personal variations, e.g., "It was great working with you in the sunny, friendly Southwest" or "Next time, let's hope there's no snowstorm to slow us down.")

Best wishes,

Photographer _____

Coordinator _____

(This can be personalized to the individual models, on a computer, or done as a photocopied form letter with a handwritten note at the end. If you don't have a coordinator/partner on the project you'll prefer to use the singular throughout the letter.)

On the Shoot

Whether you are shooting on location in a natural environment, in a research laboratory, a family home, or in a studio — you are still "on the set." You will select, arrange, and turn the location to your stock purposes.

In addition, you and an assistant must be completely prepared to handle all the functions listed among the photo coordinator's procedures in chapter 6. This is the day that counts. Any slip-ups now will affect the pictures.

You will have your equipment in order. Props and wardrobe will be ready, the models scheduled. Unless you've had a chance to be there the day before, it's wise to arrive at a location early in order to make any necessary adjustments to the set.

Decorating the Set

Strangely enough, real places seldom look really right for photographs. Taking a real location and making it look more real for a photograph is done by decorating the set. First, decide on the look you want. Select what's actually in the location that works — then enhance it with your own props. By a process of elimination you can remove distractions and retain significant props that reinforce a message.

Some examples: Antique candlesticks on a mantelpiece give an air of quiet, traditional stability to a room. If that's the look you're after, they should be retained. You might eliminate a distracting mirrored vase of artificial flowers, however.

In a kitchen scene, a simple, colorful cannister set would stay on the counter, for most types of stock photographs, while the beat-up blender, the rusty brillo pads, and grimy recipe box would go. Some brightly colored dish towels and hot pads from your prop closet could be strategically placed to cover blemishes on the counter, or help draw your eye to the center of the picture. Does it look too sterile now that you've cleaned up? Add a note pad, child's drawing (on construction paper), or a calendar (with the date removed) on the refrigerator door — all from your prop collection. If you've checked the location beforehand, you'll know what to dig out of your prop closet. (See box "Prop Closet" in chapter 6 for more ideas.)

The ideal is to create an attractive, uncluttered location that has an air of reality without distracting from the focus of the picture.

In an office scene, you may want some clutter present to show that real work is being done there. Or you may need a look of quiet elegance, depending on whether you are portraying the average office worker or an executive. You need to set the tone.

The decision-making, power-wielding executive will have a restrained, dignified, highly polished image. Show this by placing a few expensive-looking items on the desk. (He or she probably has underlings to handle paper and clutter.)

Working with Models

It pays to remember that professional models are only human, after all, if you hope to get their best performance. But when it comes to non-professionals, the requirements are more acute. You must help them to help themselves. They want to do well or they wouldn't have agreed to work with you; but they need understanding, reassurance, and guidance.

Here are a few guidelines to get the best possible results from the models you use:

Set your models at ease. Take the pressure off them. Take the responsibility on yourself for a successful shoot (you will hear sighs of relief). That will free them to listen to your instructions — tense models often can't hear what you're asking them to do.

This approach is especially important when working with children, even if they are professional child models. I will ask them if they are uneasy or how they feel about being in the pictures. I say: " Don't you worry about anything. It's all on my shoulders. You'll be fine. I'll let you know exactly what I want. It's my job to make the picture good and to tell you what to do. If something goes wrong, then I messed up, not you. I want you to have fun."

The over-active child who has volatile reactions or occasional fits of silliness requires special treatment. I give the same reassurances but follow with a pleasant but firm declaration: "Now it's time to settle down. I'm really depending on your help. I need your cooperation so try to listen and do as I ask. Please be patient so that we can all finish and go home."

Be respectful. Make any suggested changes in wardrobe or hair style gracefully. Present reasons rather than criticisms: "That's a very nice blouse you're wearing, but I may have to ask you to change because the color is too close to the tone of the background." Or: "The floral print is charming but spaghetti straps suggest summer and the other models are wearing long sleeves." A little delicacy will go a long way.

Be clear. Tell your models what you want and why. Explain the concept and purpose of the pictures, who the characters are, what their roles are, what the mood should be, and what actions you expect.

Explain that you understand it may take a while to find the right action, that you will try many variations. Tell them that if one variation doesn't work or feels awkward, you'll try another. They sometimes come up with helpful suggestions.

Let models know roughly how much time you will spend on each segment. Explain why you use so much film and need so many pictures. In short, include them in the process.

Devise an appropriate dialogue. To help them act out the proper roles, have your models enact an assigned dialogue — lines you suggest. Sometimes it works to let them chat about anything they like. But generally, to get the right expression, you need dialogue with the right tone. Chatting about a recent comedy won't create the serious mood needed to show two executives conferring over a sales

Give them a break. When you notice glassy eyes or stiff body language, it's time for a respite. Give two kinds of breaks, and state them clearly. One should last just a few seconds to relax hands and shoulders. Have them stay in place, but allow them to loosen up. Then provide a full-scale, 10 minute break during which they can leave their "mark," have a cold drink, or a brief walk.

Make it fun — for everyone. If you maintain a professional manner, but with a relaxed and friendly undertone, it can be an enjoyable experience all around. Models who enjoy themselves will want to help you again. Creating the atmosphere of a gulag for people who give you their Saturday afternoon isn't pleasant — or smart. Your purpose in shooting stock is to make it good, without the pressure exerted by clients. It's your life, make it enjoyable. "After all, it's only a picture" is the way the renowned photographer Gregory Heisler puts it in perspective.

Working with Animals and Toddlers

There are special complications when working with what I call the "un-trainables" — toddlers and non-professional animals. Animal trainers can provide every imaginable creature, trained to act on cue, but the fees involved are considerable. Few stock shoots can justify that expense. Toddlers and untrained animals should be used sparingly, for visual flavor and only when you are lucky enough to find an adorable, well-behaved dog or a self-possessed toddler.

If you are using both people and animals in the same scene, check to see if there are allergies to consider. Are your models comfortable with cats, dogs, or other animals? Some people are allergic to animals. Others are afraid of them. In choosing a non-pro animal, determine whether or not it is accustomed to being held and played with. Perhaps it usually runs wild.

If you want lively animals, don't feed them immediately before a shoot. They will look more alert. An added advantage of hunger is that it serves to keep them in position. Bits of food will get their attention or help direct them to stay in the spot you want. If you want a sleepy look (by the fire) or a cuddly quality (in a lap), warm food will sometimes calm an animal and induce a drowsy state.

An early mistake I made was combining a wild country kitten with a city boy who had never held *any* animal before. Finally, after

The Law and Using Child Models

- Always get releases for child models prior to beginning the photography. Make sure that the signatory of the release is the actual parent or guardian — that they are authorized to sign for the child. In most states a foster parent is not authorized to sign a release.

- Do not work alone with children. Always have an assistant or parent on hand. It makes the child comfortable and gives you a witness to the fact that the child was treated with kindness and respect, that the photographs were on the same topic as the one explained to the parent, and that they were done with propriety.

- Check your state law for any special requirements relating to the use of child models. Some states, like California, have stringent restrictions and may require that a certified teacher be present during the shoot.

several plates of warm milk were fed to the cat, they got cozy and I got the intimate look needed for the photograph.

Toddlers are another question. They don't react well to hunger — nor do their mothers. Make sure that a toddler in a picture has something to do (or someone to entertain him). That entertainment needs to be more interesting than the photographer, camera, and flashing lights.

Create action in the picture that uses the toddler profile or from the back — if you don't want them staring in-camera. Keep them contained — in Dad's arms, holding hands with a sibling, or in a high chair. If allowed to run loose there is no stopping them. And be fast — there can be some lovely sponta-

neous moments. Be ready for them.

Finally, let animals and babies get used to the flash of the strobes, which might startle them at first, before you start to shoot.

Getting a Model's Signature

Getting a signed model release may be the single most important thing you do — aside from taking a great picture.

The technique you develop for getting a release signed is a very important skill. This is especially true in a situation that you have not setup, one where you don't know the people in the picture you have just taken. Many photographers are reticent about asking a stranger for a signed release, feeling that it's an imposition. Or they are not sure how to handle the situation if they are turned down. Others, foolishly, are abrasive or aggressive and do get turned down.

As we'll see below, different circumstances call for different approaches and can vary, depending on whether you are working with:

- professional models
- semi-pros (aspiring actors, models, amateurs from a drama club)
- local community contacts
- friends
- strangers who speak English
- strangers who speak a foreign language

Getting a signature is part of the bargain you strike with your photo subject, so it is important to be clear and straightforward about your needs and about what you have to offer. Don't make promises you can't (or don't intend to) keep. If you promise prints, send them.

When models agree beforehand to be in a picture, as happens when you set up the photography, you are reasonably certain to get a release (be sure to get the release signed before starting to shoot). The relative certainty of getting releases is why setting up your own productions is highly recom-

mended for stock shooting. This practice will cover professional models, friends, and community contacts.

That just leaves working with strangers, which can constitute a much more delicate situation. If you are on location, especially doing travel photography, and a perfect picture depends on a pair of strangers walking through the slant of afternoon sunlight in your picture, it's worth the effort to try for a release. If a mountain trail photograph just cries for some hikers, it's tempting to photograph the ones that appear around the bend, worrying about the formalities afterwards.

A sure way to get turned down is to stick a full legal release under someone's nose, without any explanation, just after you finish shooting a picture.

A surprising number of people will cooperate if you approach them in a friendly, professional way. Also, as you'll see in chapter 14, there are ways to soften the presentation of a release to make it less threatening.

The best tactic is honesty, with a bit of tact and friendliness or hominess.

Introduce yourself as a professional. Say a few words about your project, and explain that you'd like to send them some copies of the pictures. Say that you'll need their address in order to send the prints and that you need their permission on this form.

While they are digesting all that, you can go on to explain what you'll be doing with the pictures. Some photographers use a release that has a definition of stock photography on the back. I use a variation of my project description as a letter of introduction (see sample in chapter 6).

Offer them a copy of your introduction letter to take home. It relieves them to have your name and address. Giving a signature to a mystery person who then vaporizes in the distance is unsettling to most people. I have much greater success when I am exchanging addresses, not just demanding theirs (and I haven't had it abused with a rash of pestering calls).

In the United States, always carry copies

of the release and letter in English and Spanish — and have it translated into the language of any country in which you'll be doing a lot of photographing.

Captions

Keep notes on any important information that would be useful for captions or for your location file. For easy and accurate gathering of caption information, especially for travel photography, just shoot a frame of every entrance sign, informational plaque, botanical label, historical marker, or street sign near your subject. This has the additional advantage of being locked in with the very roll of film it applies to, handily available when you are editing processed film and are ready to write captions.

If you eschew writing in notebooks, you can use a pocket-sized tape recorder to take verbal notes as you move from one location to another. Label your film rolls, or have your coordinator do it, to match your caption information.

Photography

The final stage of your production is the actual taking of the photograph. This is what all the work has led up to — an exhilarating, fleeting moment of visual delight. Savor it.

Tomorrow, you can edit and enjoy the results.

Editing and Organizing

Now we come to the systems — an important bridge between shooting and selling stock. Build it carefully — or you may feel like you're clinging to a rope bridge over a raging river chasm.

In this chapter we'll take the processed film through the editing process, prepare pictures for the file, and discuss the equipment and supplies needed. Finally, we'll look at the systems: the files and forms which make it all work as a business. For the purposes of this chapter, and unless otherwise specified, all references will be to 35mm color transparencies — slides. Though some stock shooters will have larger format color transparencies as well as black-and-white contacts or prints to file, the majority of stock is still in 35mm color.

Editing

When editing film, be quick and be ruthless. It's almost impossible to be too critical.

Editing your film soon after a shoot will make the job easier. You will have a much clearer idea of what you are looking for because the details of the shoot are fresh in your mind. You'll know which expressions to look for and which to ignore. If you remember that there was a boring half-roll shot as the models were getting adjusted, you can skim the work, looking first for the pictures of that special, spontaneous moment you recall, the one when the cat jumped into the grandfather's lap and the child giggled. After selecting those, go back over the earlier shots, when the grandfather and child are simply reading together, to see if they can hold a candle to the others. If you wait too long to edit, you'll waste time slogging through the dross before you find the gold.

You can learn a surprising amount about your work by looking at the film quickly, soon after you've shot it. You may see quirks, trends, or problems — both technical and aesthetic — that will continue to plague your shooting if you don't catch them early. By the time you see them in a delayed edit, the damage is done. Are you drifting toward a tendency to under-exposure? Are you shooting too many horizontals? Are there equipment problems?

Some years back I noticed after one shoot that I was tilting my horizons — indoors and out — especially when there was an exciting moment. It appeared that I was pulling down on the right — the shutter side — and the picture would be slightly askew. In most cases, it was occasional, or could be cropped to square up. But it was important to notice the tendency, so I could correct it before I ruined something really special during the next shoot.

An old East Indian adage warns: be especially alert on a sunny day — there may be tigers hiding in the shadows. As you become experienced and think you have your technical routine down pat — watch out. Constant vigilance is necessary. Virtually every photographer I know shares this sentiment: just when you think you can relax is the time to stay alert. You make dumb mistakes.

Here's an example: On one shoot I was sloppy about double-checking to see that the shutter speed was set to synchronize with my strobe. I went from one indoor strobe-shooting location to another. I hadn't touched the shutter speed, so it must have been set the same. Right? Wrong. In the rush to reach the second location, possibly when the camera was put in the camera bag, the dial was hit and moved from synch up to 125th. I started the next shooting assuming that the shutter speed was still set on synch. A few half-black frames, edited the next day, brought me up short. A quick edit kept me from repeating the error. (Assumptions in photography, as in life, are dangerous. As a wise friend says: Never assume anything. But if you must assume, assume you're wrong.)

There is additional logic to speedy editing, it short circuits the fine art of procrastination. Film set aside to edit in "a week or two" may still be gathering dust the following Spring. Whether you have a pile of contact sheets to pore over or a mountain of slide boxes to handle — you can create a log jam in a hurry. It becomes a burden when it should be fun.

Edited film is the final photograph, so you have an investment in getting it edited quickly. In stock, unedited film is an investment without a profit. Unedited film is a tree in need of pruning — it can't flourish and bear fruit. (As overworked as the gardening metaphor may be, it is remarkably apt to the stock photography business.)

Now that you've seen the light. Let's select pictures.

You may have evolved your own system for editing. If it works well and you are exceedingly critical in the selection process, fine, stay with it. For another approach to editing, here's my system:

The first step in editing is to label each box of 35mm color (or black-and-white contact sheets). If you label your rolls in order as they're shot, some labs will transfer those roll numbers to the boxes of processed film, putting you one step ahead in the editing process. If they haven't been numbered while shooting and transferred to labels by the lab then I take a quick peek into each slide box to determine the subject and label it accordingly. Sample the beginning, middle, and end frames to be sure it's all the same scene. This way you can find the extra 10 frames of your hot air balloon pictures which are on a separate roll with the Albuquerque sunset-skyline pictures. For efficient editing you need to have an entire sequence together. It's a pain-in-the-neck to complete the editing of two rolls depicting a business executive at the computer, then carefully choose and put the selects in a plastic sheet — only to find (10 boxes and an hour later) another half-roll mixed in with the conference room scene. Going back over the same ground is wasteful and tiresome.

Selecting the photographs is the part that's fun, but it requires extraordinary discipline in order not to agonize too long over the first stage of editing. Make an instant decision about each slide and put it in one of four piles at the top of the light box (working flat on a table). Every photographer uses different names for those selection categories:

1st select	2nd select
first choice	acceptable
3rd select	**Rejects**
maybes	throwaways

The first selects are the perfect ones: razor-sharp focus, exposure that's right on the money, and spontaneous expressions and interaction. (There are exceptions. The intentional, successfully blurred motion or soft-focus picture is obviously going to be included in the first selects.)

The rejects are easy to spot: models who blinked, incorrect exposure, out-of-focus pictures.

The seconds and thirds can be a confusing middle ground. Just pick a pile for them and move on, you'll refine those groupings in a moment.

For me, a second is a technically perfect picture, suitable for reproduction and to keep on file, but not as compelling or interesting as the first selects. My thirds include the overflow if I have too many seconds — they are acceptable photographs, but perhaps I'm tired of the subject. They may be a bit flatter in expression or be taken from a less interesting angle, though in the case of landscapes often they are all equally good.

You can use the same system for black-and-white contacts by marking a symbol in grease pencil on each frame in the 1st select upper right corner. I use the following:

1st select	2nd select
star/asterisk	check mark
3rd select	**Rejects**
small dot	diagonal line across frame

Most of the editing principles here apply equally to color and black-and-white, but for this discussion, we'll concentrate on color because it predominates in today's stock.

Once you've gone quickly through all the boxes of slides on a given scene, and sorted them into these four categories, you can start fine-tuning. Examine the first choices again. Are there any that must be demoted to second-select? Did you miss a good expression that was relegated to the thirds? It can happen.

Arrange the firsts on the light box, placing all shots that are similar near each other (all the close-ups, all the profile angles, all the verticals). Then code each first select in some way on the slide mount: an asterisk in pencil or a color dot. This will serve to remind you months from now which you considered the best pictures when you did a critical editing. It will save having to scrutinize closely the whole edit once again. If there are some very good seconds, mark them also. The rejects go in the trash. Some interesting or amusing rejects can go into boxes to be sent to models (stamped with copyright notice and "no reproduction permission"). I keep an empty box with each model's name on it as I edit. Then it's quick and easy to toss some rejects into each box.

When I come to a very special photograph, in addition to an asterisk, I will put a "P" (portfolio), as a note that it may be worth including in my presentation to clients. But for now, it stays with the others to be filed and numbered. Pictures that are just floating around, outside the filing system, are in great jeopardy.

Dupes can be made at this stage. Many clients still say they prefer originals to dupes. Others are beginning to accept reproduction-quality duplicates. (See chapter 14.)

Duping is a convenient way to have multiples available of an especially marketable image. You can also dupe any photograph that is irreplaceable to protect the original from damage. Some photographs gain value through usage. If you see that happening, dupe that original — quickly!

While covering a story for a running magazine, an Atlanta photographer friend caught a perfect moment at the race's end. Hosed down with cooling water as they crossed the line, the exhausted finishers stood, back lighted in the spray, a symbolic statement about their endurance as athletes.

The picture was sold again a few times for editorial uses. Then suddenly it hit big. It was chosen for an advertising campaign by the agency for a major international sporting goods manufacturer, and used on billboards and in print ads worldwide. The fees were staggering.

The photographer had been sending out the original for reproduction purposes. He got dupes made just in the nick of time. After its last editorial usage he had noticed a tiny scratch on the outer edge of the transparency. Luckily he protected it in time to reap the rewards of the international campaign.

Once dupes are made, file pictures should be numbered, labeled, filed; then you can do everything else. This is the stage to pick complimentary prints for models from the third selects, or sometimes the seconds if you have enough. Of course, prints can be made from file pictures and later returned to file, but anything that separates pictures from their place in the file is a step sideways or backwards. Why put firsts at risk? Use your seconds or thirds, then there is less time pressure about getting them back to the file in a hurry.

Finally, there are sometimes pictures that don't make the cut, but which you can't bear to throw out because of some personal attachment — they may include friends, family, or a memory of an exotic trip. Put them in a snapshot file, labeled as such. Keep them separate. I put my snapshots in folders labeled chronologically by season or occasion: "Family Summer 90," or " Japan snapshots," (These may include pictures I took of my assistant in Tokyo struggling to load our equipment into the van or an obligatory shot taken of me with the Shinto priest we met in Matsumoto), and " Theo's school trip, Third grade." Naturally, the first-quality pictures from that "school trip" will go in the stock file. But I won't put the near-misses in the professional file. Theo's pictures are dear to my heart no matter what the quality, but emotional ties won't turn a reject into a select. Don't clutter your file with this sort of picture. Keep your professional life separate from your personal.

A word about editing on a projector: It can make sense to do a first edit using a projector if, like some travel photographers, you have hundreds of rolls to view after a trip. When I came back from China and Japan with 400 rolls of film, light box editing was out of the question. It would have taken months. For high volume, a first run-through on a projector is a speedy way to weed out the rejects. Then go to the light box for checking critical sharpness.

Preparing photographs for the file

All slides, contact sheets, black-and-white or color prints, even rejects or gifts must carry your name, copyright credit notice (Copyright word or symbol © ; year; your name. See chapter 14.). Some custom labs will make up special mounts with your name and the copyright symbol already on them; all you have to do is to add the copyright year. Talk to photographers in your area for the names of local labs. Several major labs in New York, Los Angeles, and Chicago offer this service. Otherwise, do it yourself with a rubber stamp you can have made at any stationary store or use a computer generated label.

Identification and captioning

The identification on a photograph includes four items:

- your name and copyright notice
- your photo file reference number
- a brief one- to two-word file category name
- model (or property) release number

This information is needed for your filing and for clients reference and logging purposes.

Caption information includes everything you can tell about a photograph, as concisely as possible. The journalist's "who, what, when, where, and why" is as handy a guide as any for writing captions. The information in a caption can make the difference in a sale. Since you may not be available to answer a client's question at the moment of an approval meeting, have it on the slide, where it can tip the scales in your direction.

Imagine that your vineyard photographs are being considered for a calendar to be produced by a major wine and spirits distributor. For the July page, the art director has narrowed the selection to two equally strong photographs, one from the Napa Valley in California and your scene of the Finger Lakes wine region in New York State. All of the pictures chosen for the other months are from California. For balance and for sales reasons, they would be likely to choose the Finger Lakes picture — they are adding distributors in that area. For lack of a detailed caption, labeled only "Vineyards, Domestic," your picture might lose out.

Photo file numbering systems

If you can't find it you can't sell it. The only reason for going through all the trouble of creating a filing category and numbering system is to enable yourself to find a picture surely and easily.

There are almost as many photo filing systems as there are photographers. To me, the most significant factor in any filing method is the use of a unique number for each picture. Some photographers don't agree. They feel that it's easy enough to search through a group of slide sheets in a file folder to find a specific picture. They argue that it's good enough just to get the picture back in a general location, the category folder. I consider that penny-wise, pound-foolish thinking. Since, you have to put numbers and labels on anyway, why not assign an individual photo number as well. There's very little more work to adding a number to the process.

The advantage of having a unique number — one that refers to a specific picture and no other — is that you will always know exactly where it is; it will be put back in the same place every time, and someone else can do the filing with a reasonable expectation of accuracy. This last point can be extremely important. If your stock photography is successful enough, you may find yourself relying on assistants sooner that you think. They must be able to work with whatever system you devise — so devise a foolproof one.

There are only a few places that a photograph can be at any time, and the first four are the most common:

1. In the file
2. With a client (or on the way)
3. In the "to be re-filed" drawer
4. In the "needs re-mounting" folder
5. Out for duping
6. In your portfolio

As a placeholder for any slide that is taken from the file, I put a 2x2" square of white cardboard into the pocket of the 20-pocket slide page I use for filing.

When a photo request comes in, put the date and client name on a group of cards before starting to pull pictures. For repeat clients I have a rubber stamp with their name. You can also use the consecutive numbering stamps, assigning a number to each consignment and noting the client's name next to the number in a log book. I prefer to use the client's name so I can see immediately who has what with just a quick look through the file. As each slide comes out of the file, a card goes in. You can see at a glance where every slide is.

A similar system works for black-and-white prints. Just use an 8x10" paper to replace the print that goes out.

The cards are easily ordered from any small printer. Ask for card stock cut in 2x2" squares (I use white, but colors are available.) My last order ran about $28.00 for 10,000 squares — enough to fill a shoe box and last a year. They are also useful for inserting notes to photo buyers in the submissions.

For this system to work to its full potential you need a unique photo number. There are a variety of numbering systems on the market that you can adapt to your use. Several of these are computer programs. Explore the possibilities and see what feels right for the type of shooting you do. Choose the one best adapted to the way your mind works.

First decide if you want to file by subject/ concept categories or with a numerical chronological system. There is no system that has a perfect spot for every picture. With any system you'll need to do some cross referencing. Since requests come in by subject or concept, that's the way I file. However, sometimes it means breaking up a story — or a shoot.

Here's what could happen. Let's say you've done a series of photographs in North Carolina including coverage of:

- Wildlife biologist at the Roosevelt Wildlife Refuge

- Pensive photo of woman by the pond, wildlife refuge

- Family walking along nature trail, wildlife refuge

- Hang gliding at Kill Devil Hill, Kitty Hawk, N.C.

- Old Salem Historical Site near Winston Salem, N.C.

- Winston Salem skyline, N.C.

- Textile Mills in Eden, N.C.

If you file chronologically, these photographs will be near each other in the file. They will go into separate folders for each main topic, but they will stay as a group in the file even though they are dissimilar topics. If, a year later, you photograph a naturalist working in a state park in Colorado, he will not join that North Carolina wildlife biologist but be separated by 12 months of other files.

If you file by subject and concept, however, the two naturalists will become neighbors in an occupations file. By the same logic, the hang gliding would go under sports or leisure; textile mills under industry; the woman at pond under mood-pensive; and the family under family.

When starting out, photographers tend to remember photographs by "story" — in other words chronologically. As time passes, the edges of those stories blur and it becomes more difficult to remember on which trip to North Carolina it was that you went to the textile mill. The confusion is compounded if you make subsequent trips to that or other mills. The other disadvantage to chronological filing is the difficulty an assistant will have in pulling pictures for submission — without your memory of the trips.

Subject filing
Since the requests come in by subject, that's the way I file and the method I suggest. My system breaks down as follows:

Major Category
Sub-Category: Subject or Concept
Slide number: Individual Photo number

You can use all numbers or a combination of letters and numbers. The combination works like this:

Major Category: Letter
Category: 3 digit number
Photo number: 2 digit number

To apply the system, here's what we might have from that North Carolina trip:

Major Category:	Industry	D-
Sub-category:	Textile: spinning	D-234-
Sub-category:	Textile: weaving loom	D-235-
Sub-category:	Textile: research lab	D-236-
Slide number:	Vertical spinning	D-234-12
Slide number:	Woman at loom	D-235-23
Slide number:	Scientist in lab	D-236-02

By using letters you have 26 major categories. If you need expansion, use double letters: BB, GG, for a total of 52 major categories. If that doesn't seem like enough, then use a two-digit number for major headings. This offers 99 major category possibilities. (If you need more categories than that it's time to clean house.)

For subjects within the major heading, you can have up to 999 folders, with as many plastic sheets as seem practical within a folder. Your individual slide numbers can go as high as three digits if needed.

With this system, if industry is category 56 then the unique number of the scientist in the lab, which was

D-236-02 becomes: 56-236-02

Keep a consecutive log as numbers are assigned. I use a three-ring binder. This log will stay in numerical order (and help remind you of the chronology). If you must use them, index cards will do, but I mistrust anything that can fall on the floor and get out of order. Since this is a permanent record, I want it to stay put. It would be good to wean yourself from index cards. Ideally you might think of going right to a database and keeping your master list in a computer (remembering of course to have backup disks and a print-out in case of emergencies). If you're just beginning your file system, then it's the moment to computerize. That's my advice to anyone starting out in the business.

For 35mm slides I file in 20-pocket sheets. Each sub-category is in a folder in a hanging Pendaflex file. Each folder will hold up to 10 plastic sheets comfortably. At 20 per,

that's 200 transparencies on a subject. Much more than that and you haven't edited tightly enough.

Chronological Filing

However, if it's more logical to you to stay with a chronological system and I haven't succeeded in dissuading you, then at least be thorough in your cross referencing.

One of the common numerical systems assigns the date of the shooting plus an individual number for each topic shot that day. The frame number becomes the individual photo number.

If you covered eight topics in one shooting day the number would be:

 10390- (October 3, 1990)
 -08 eighth topic, Winston Salem skyline
 -46 46th slide filed under that topic

To cut down some digits, you can simply use the month and year.

Editing Equipment

For accurate editing you will need a good quality magnifying loupe and a light box. Your eyes need tender treatment and your slides and contact sheets require critical editing. Don't use a magnifier with glass like a bottle-bottom. This is one place not to cut corners. There is an excellent loupe in the $115 range (the German-made Schneider Kreuznach 4x) which has an interchangeable base — opaque for viewing color and translucent for black-and-white contacts. This loupe has the added advantage of showing the full 35mm image, making editing much easier. There are a number of good mid-range loupes for $30 to $40. Any loupe of lesser quality will put unnecessary strain on your eyes.

There are many kinds of light boxes available, from top of-the-line, color-balanced precision instruments to fold-up viewers that are no more than plastic ridges covering a light bulb. The latter is clearly not suitable for editing professional work.

Keep two points in mind when choosing a light box:

1. Color balance of light source (5000 K fluorescent)

2. Even over-all lighting. Some people, including art directors, view slides on a graphic artist's tracing light box. This box presents a problem. The fluorescent light is not evenly distributed and creates a fall-off shadow down the center, making it difficult to edit exposures accurately.

Most camera stores and mail-order photo supply houses carry a range of suitable light boxes from about $55 for a desktop (10"x12") size, and $80 to $300 for medium to large light boxes.

It's quite easy to construct a light box. Just get two fluorescent tubes (5000 K) in whatever length you choose; the sockets and wiring; a piece of translucent plexiglass 1/8" thick, cut to size; 1/4" plywood; 1/8" molding and white cardboard, or flexible metal, painted white.

Design the box measurements to accommodate your tube length with tubes set equidistant in the space. When the tubes are set in the box, insert the painted metal or cardboard between the tubes, not touching, but curved up between them in the center, to act as a reflector. This will eliminate the fall-off shadow. The molding is set 1/8" (or whatever the depth of the plexiglass) below the edge of the box, to hold the glass in place.

Supplies

When researching in the files, the quickest way to view photographs is by use of the 20-pocket plastic sheets. By holding them in your lap or over a light source, you can skim-view at least eight plastic sheets in 15 seconds. (Yes, I've timed it.) That's 640 slides scanned in a minute. Imagine the time it would take to pick up that many individual slides from a drawer or from boxes — and to keep them in order. From my experience,

storing in slide boxes or individually, in metal storage boxes, becomes very cumbersome.

The supplies you'll need include: a copyright credit stamp, 20-pocket plastic slide sheets, file labels, file folders (letter size), and hanging Pendaflex folders (legal size). The letter-size folders (for sub-categories) fit nicely in the legal-size hanging folders, allowing breathing room and ease of access.

Archival plastic sheets (available at most photo supply dealers) should be used on all first select photographs. Archival products have become important to photographers concerned with the longevity of their work.

Some years back, PVC (polyvinyl chloride), commonly found in many brands of plastic slide pages, was identified as being dangerous to transparencies. Over time, the PVC will break down to form hydrochloric acid, emitting harmful fumes destructive to transparencies. The safer, archival type of plastic slide page is made of either polypropylene or polyethylene. The polypropylene sheets are a bit less flexible (which I prefer since they are easier to handle — they don't flop around in your hands quite so much) and usually provide a clearer viewing surface. Pages made of polyethylene are slightly more flexible, have a slightly milky quality and are prone to scratching. As with other slide pages they are available in top-or-side loading styles. There are many sources for archival materials, through your dealer or mail order companies. I have used Light Impressions in Rochester, N.Y. You can call for a catalog (1-800-828-6216).

The ideal environment for color transparencies includes storage in a dark place, away from heat (below 70 degrees), with low humidity, and dust free.

Used filing cabinets are available from office supply houses, and often the older ones are of better construction than the new. You'll be using these files often, so spare your fingers by getting legal-size cabinets. Photographs are heavy. Spare your shoulders by getting full-suspension file drawers. There are archival aspects to file cabinets as well:

the glue and varnish from wooden cabinets can give off vapors harmful to transparencies. Metal cabinets with a high-quality baked enamel are advised.

Systems — Forms and Files

Setting up the proper forms early on will ease the burden as your business grows. They will provide you consistency, a professional look, and in some cases, legal protection.

In addition to the forms, you will need a way to keep them and other information in order — the files.

Creating a file system is not so daunting as it may seem at first glance. It includes using the files and forms listed below, or variations of them. Just take the next two rainy days, put the phone on the answering machine, and do it. A little label typing and a lot of concentration will get you there quickly. Even if half of your folders are empty at first, the immense value of having a system in place can't be overemphasized. Make the time — now — it will save you much time and aggravation later on, when you have even less time to devise a proper system.

Don't make this mistake, which some years back, took me the better part of a summer, and the help of an intern, to rectify. I had allowed myself to develop haphazard systems early in my career — I was always too busy to stop and organize properly. Finally, when I was busier than ever, my system — or lack of it — became so unwieldy it was impossible to progress. Though belated, the investment of time to fix the problem increased my productivity dramatically. More important, it allowed me to turn over many tasks to assistants. Since there was a comprehensible system that anyone could use, it saved me from making constant explanations.

The rationalization "It's easier to do it myself than to explain it" is a cop-out from someone who hasn't put their system in order. Having been a world-class rationalizer, I know whereof I speak!

Following is a list of the possible forms and files needed in a stock photography business. Some forms, such as model releases, are essential no matter how you sell your stock. Others forms may be needed only if you are selling your own stock directly and not through an agency.

If you treat each stock assignment as an individual job, just as assignment photographers do, it will help with following up on all the details.

A blueprint for that is the stock job form in this chapter. This form was adapted from my assignment file. It was used to have a complete rundown of what needed doing for a stock shoot and beyond. It was devised primarily to show an assistant how to handle each project. But as a record of all the details for a shoot, it is a very useful document.

The forms and procedures listed in this chapter are a distillation of years of experience, of trial and error. Just take a few days, hide from the world, and set them up. Once you have these systems in place, you are ready. Really ready.

FORMS
1. Model release form
2. Property release form
3. Photographer's stock project sample
4. Form for job file "Stock Project"
5. Telephone request form
6. Delivery memo — terms & conditions
7. Invoice form
8. Stock category listings (photo file)
9. Stock category listings (promotion)
10. Photographic promotion mailers

FILES:
1. Job forms, in numerical order
2. Stock photo files
3. Client file, mailing list
4. File of model releases
5. Model file, sources
6. Location files (polaroids)
7. Clip file
8. Prop/supply source file
9. Assistants file (names & addresses)

STOCK JOB FORM

STOCK PROJECT TITLE _____

Stock Project #: _____ Date: _____

Description: _____

Date shot: _____

	Action Date	Completed On
Film edited:	_____	_____
Slides picked:	_____	_____
Labels (model address.):	_____	_____
Slides to prints:	_____	_____
Pick up prints:	_____	_____
Thank You letter:	_____	_____
Prints to models:	_____	_____
Model release filed w/polaroid:	_____	_____
Prop release filed w/polaroid:	_____	_____
Model file entry:	_____	_____
Selects edited (w/M.R.#):	_____	_____
Numbered by assistant:	_____	_____
Sent to agency:	_____	_____
File completed:	_____	_____

LOCATION Contact: _____

Address: _____

Tel: _____ Fax: _____

MODELS Name: _____

Address: _____

Tel: _____ Fax: _____

Running Your Own Stock Business

Now it's decision time. The question is: How will you market your photographs?

There is no money in stock without sales, so your next step is to get your pictures into the hands of stock buyers. There are several ways to do this:

- Representing yourself — handling all aspects of stock photo marketing

- Marketing through one stock photo agency on an exclusive basis

- Marketing through several agencies in the U.S. and abroad

- Representing yourself *and* using multiple agencies

This chapter will cover two areas: First, it will tell you what you need to know to make an informed decision on how to market your work. Second, it will give a complete presentation on the process of running your own stock photo business. Chapter 10 will provide advice on the marketing aspects of stock. If your decision is to look for representation by one or more stock agencies, chapter 11 will show you how to make that happen.

Maybe, like some photographers, you will just stumble into the selling of stock without having made a conscious decision to do so. It just happens — a few phone calls, a few requests, and you are selling stock. However, if you are to build a successful, long-term stock business after an initial (accidental) foray, you must be aware of the pitfalls you face and of the need for the professional planning detailed in this chapter.

Actually, there are some real benefits to selling your own stock, at least for a brief time early in your stock career. Handling your own work gives you the experience to understand what kind of time and skills are needed and helps you to gain an appreciation of what a good agency would do on your behalf.

Making the Decision on Representation

You need to know what you're getting into. Before making the decision to represent yourself, consider the following pros and cons of running your own stock business.

Reasons for selling your own stock:

Profit. You set your own prices and do your own negotiating. You receive 100 percent of the reproduction fee instead of the 50 percent commonly paid to the photographer by an agency. (Caveat: you will probably spend all of that 50 percent savings covering the costs of work that an agency would have handled; but if you have a spouse or partner working with you, at least it may keep the money in the family.) Spending decisions on that additional 50 percent are also in your hands. You will have greater control over costs — deciding, for example, how much is apportioned to marketing, how much to clerical staff, and so forth.

Productivity. You usually know your own photo files better than an agency can. You should be able to do a more accurate pull from the files, which could result in a higher yield of sales per request list. As important, when talking to a buyer, you are in a good position to suggest alternate photographic ideas to fill their request — photographs from your file that agency personnel might not remember. You won't get lost in the crowd, as sometimes happens in an agency. In your own file there is no internal competition.

Opportunity. You may have a lead-in to assignments. By having direct contact with the stock buyer, you may convert a stock request into an assignment. Sometimes a client requests a photograph that doesn't exist in your stock. However, if you suggest a creative shooting solution, you have a good chance to talk your way into a job that might not have existed.

Marketing. When handling your own sales you have direct personal contact with buyers. You can learn the specific needs of their market — and sometimes find out about their future projects. You can then plan your stock shooting with their needs in mind. This practice is simply taking advantage of mar-

ket information and should not be confused with the self-defeating "shooting on spec," which should be avoided.

Control over your images. You'll know exactly where your photograph (and credit) will appear. You make the decision, on the spot, about what products your work will advertise (cigarettes, liquor?) or what political or religious publication you will permit your pictures to appear in. Some agencies have the ability to restrict your work for certain usage — but that practice can be cumbersome even for the agencies that do it.

Control over the business. You run the whole shebang. It's your show in every detail. Some photographers find this complete control very appealing.

Here are some reasons for not selling your own stock and for going with an agency:

Loss of shooting time

Loss of shooting time

Loss of shooting time

Paperwork. There is a crushing load of frustrating detail-work which can diffuse your creative photographic energy.

Management. The organizing and overseeing of staff, equipment, shipping, and record-keeping involved in running a stock business will be an additional burden for you. The added attention to management can distract from the planning and shooting of new photography.

Overhead. Many photographers don't acknowledge the real costs of selling their own stock. There is a myth that you will have extra money if you sell directly to buyers since you receive 100 percent of the fee. The extra 50 percent you receive on the reproduction fee is not a bonus — the perceived extra

profit may go up in smoke when you calculate the actual added expenses (such as labeling, filing, shipping, and promotion) connected with marketing your work.

Limited marketing capacity. You can't be in touch with as wide a range of buyers as a photo agency can. Until you are very well-established, buyers are more likely to know an agency than they are to have heard of your files.

Limited access. You will miss out on the valuable market research that is shared with their photographers by many agencies.

Now then, once they are balanced, it looks as if the advantages are countered by equal disadvantages, so where have we gotten? It boils down to two questions:

First, what are your expectations for finding an agency? Is that route open to you at this stage in your career? The factors that influence those expectations for agency representation are covered in chapter 11.

Second, are you temperamentally suited to running a stock business? To answer the second question requires an honest, accurate assessment of your abilities and an understanding of how you enjoy spending your time. You may enjoy handling the business details yourself, some people do. On the other hand — you may enjoy the photography exclusively and work better without the clutter of extra paperwork.

What's needed

If the idea still appeals to you, take a look at what's needed to be successful in running your own stock business. Do you have the strengths listed below?

Keep in mind that being a photographer is a full-time occupation. Being a photo agent is a also a full-time job. Either you add a person to your staff or you divide yourself in half. Simplistic? No, it's really just that simple. If you decide to handle both functions, photographer and agent, understand that you will be spreading yourself thin.

Checklist of Qualities Needed

❑ A love of photography that transcends all the tedium and pressures of running your own stock business

❑ Organizational ability

❑ Tolerance for details

❑ Ability to sell yourself, i.e., market your photographs

❑ Ability to negotiate —and withstand buyer attempts at intimidation

❑ Determination

❑ Tenacity and follow-through

❑ Ability to juggle many tasks at once

❑ Ability to handle frustration

The final element needed is staff: a partner, a spouse, or an assistant.

Until your business is big enough to need (and support) two full-time people, your photo coordinator (described in chapter 6) might handle some stock marketing duties.

Facilities needed:

• Space. Additional work space will be needed for equipment and, if you are near major markets, a place for clients to work while selecting pictures.

• Equipment. In addition to the standard business equipment, such as a telephone answering machine, you will require more equipment than if you simply prepared photographs to be sent to a stock agency. You will need additional filing cabinets, an extra typewriter for the use of your assistant; and light boxes, loupes, and chairs for clients who visit the premises.

• Capacities. To compete effectively, you

will need a fax, a copy machine, a computer, and a modem for access to electronic networks.

- Access. Overnight courier services are essential so you can compete with agencies providing 24-hour service. (No matter how beautiful your remote mountaintop may be, it's a liability to your stock marketing if couriers won't guarantee 24-hour delivery service from your area.)

Psychology of stock

Evaluate your temperament, expectations, and goals. Do you enjoy keeping control, handling every detail? Are you willing to build a business for long-term growth? If so, then running your own business may make sense.

It's important, also, to understand that not everyone can get into the agency of their choice in the current competitive climate — another reason to consider marketing your own work.

On the other hand, is it your goal to spend most of your time on shooting and on thoughtful, creative photographic planning? If you are looking for a collaborative relationship with an agency — one where your expertise is in producing the pictures and theirs is handling the marketing — then it's worth the research to find the agency that will represent your work.

With all the energy and good will in the world, it is easy to become mired in the paperwork and to feel overwhelmed. By exploring your compatibility with the wide range of jobs involved in selling stock, you can pinpoint where you'll be most productive. Your tolerance for detail is a clue and frustration is the villain. Understanding your own temperament is the key to setting the realistic goals that bring success in running your own business.

As a final question, are you visual, energetic, creative, obsessive, compulsive, dedicated, hardworking, and disciplined? If so,

great. Then let's get started setting up your stock business.

Running the Business

The process of representing yourself is complex but can be handled if you approach it with order and organization and boundless energy. Where do you start? Assuming you are building a good collection of stock images, your next steps are to set up your files, forms, and systems, train staff, and plan your marketing — which is covered in chapter 10.

Setting up systems

To see why the systems and forms described are so important, just take a look at the complexity and variety of tasks involved in selling stock, many of which can happen simultaneously. For a quick overview of the process, see the box "25 Stages in a Stock Sale."

Each step of the process takes a relatively short time, but when your business takes off, many of these functions may happen simultaneously; so efficiency will be well rewarded.

It is essential that each step be handled accurately to avoid compounding problems later on. For example, if you didn't complete filling out a delivery memo with slide numbers, imagine the headache when trying to log in returns and match them to the delivery memo. If your records are messy and confused, you won't be able to blame a client for a delay — or a loss.

Imagine the sinking feeling in your stomach when you realize that an important transparency is missing — and you can't prove it!

So make it easy on yourself, understand these 25 stages, presented here in detail, and use your systems to your advantage:

1. *The Photo Request.* A request may come in the form of a written list, a telephone call, or from an electronic network. Occasionally, you'll stumble upon it in a casual conversation with a client, "Say, do you have any

pictures of..." Reach for a pencil and paper.

2. *Getting the information.* Call to clarify a written request list. Fill out a telephone request form as you speak. (See the sample in this chapter.) Using this form will help you remember the questions to ask. Above all, make sure you understand the underlying concept, the shape they need, and their deadline.

Ask the name of the project and, most important, the intended usage. Discuss the holding period they'll need. If you haven't worked with this client you should discuss fees and let them know your terms and conditions (on the back of your delivery memo). A full coverage of negotiating techniques is in chapter 12. Ask how they want the submission delivered. If they are in a rush, ask for their courier number (Federal Express, Purolator). Some photographers ask for credit references from new clients at this point.

3. *Researching the files.* Sometimes called the "pull." This is where you go into your neatly organized files and select the pictures. If a shape wasn't specified in the request, be sure to include horizontals and verticals.

Double-check for sharpness, expression, and exposure. Use a magnifying loupe on a light box. A marginal photo shouldn't be in the file after your editing process — but if it is, this is the stage to catch it. Also, in the event of a dispute over the return of damaged slides, you will be able to state with certainty that what you sent out was in perfect condition.

Send a variety of good *similars* of the same scene, three to four is a useful number. This makes an effective visual presentation and, if the picture is on the right topic, it will be tempting for them to pick one of the four. A one-picture submission may not make the same impact.

4. *Arranging the selection.* Organize your pull in a way that matches the request list. Insert notes to clarify any alternate ideas you're including. (For 35mm submissions, I use

25 Stages in a Stock Sale

1. The photo request
2. Getting the information
3. Researching the files
4. Arranging the selection
5. Protecting the images
6. Delivery memo
7. Invoicing the research fee
8. Packing the submission
9. Delivery to client
10. Filing the paperwork
11. Logging-in first returns
12. Filing first returns
13. Logging-in second returns
14. Filing second returns
15. Follow-up on submissions
16. Billing holding fee
17. Purchase order/billing request received
18. Price & usage negotiation (if not handled in #1)
19. Invoicing the client
20. Receipt of payment
21. Entry into bookkeeping systems
22. Logging-in final return of used photos
23. Cleaning and remounting of used photos
24. Re-filing final returns
25. Picking up the phone for the next request

two-inch squares of cardboard in the plastic sleeve pocket to mark spec numbers or to make comments.)

An orderly submission will increase your sales and gain good will with the buyer. If it is immediately clear how each of your slides matches the photo request it will be much easier for the client to organize their internal approval presentation.(See sample photo.) Some photographers arrange their submissions willy-nilly — with topics mixed. Imagine the appreciation of a harassed photo editor when, 30 minutes before a meeting, he

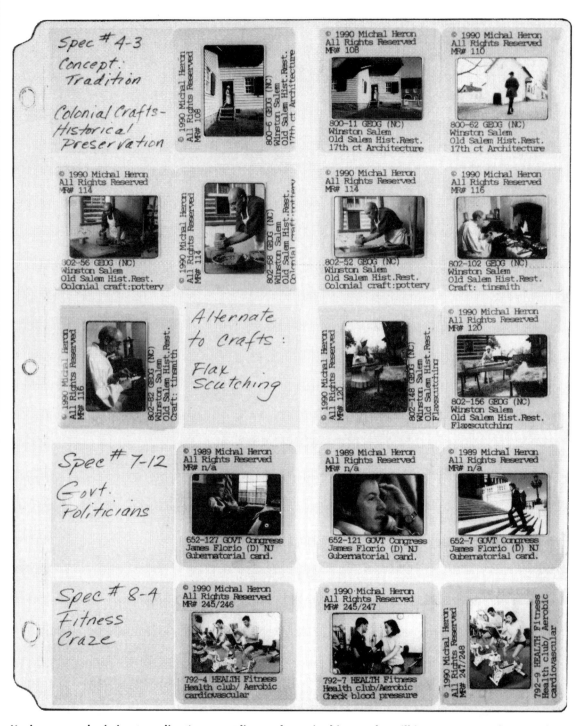

Keying your submission to a client's request list, as shown in this sample, will increase your sales. It makes it much easier for a busy photo buyer to organize a presentation for an approval session with an art director or client.

or she gets your 45 slides, all keyed to the request list. They can be placed in order and ready for an approval session in minutes.

Make it gorgeous. Make your submission as attractive a visual presentation as possible — within the order that matches their request. Arrange the slides so that the colors enhance each other. Before putting them in the slide pages, move them around on your light box as if you were designing a page.

For example, if a richly saturated color is next to a subtle, muted color photograph — though both are excellent in their own right, they may detract from each other.

Think of each submission sheet as a portfolio presentation. Take the time to make it dazzling. If the first impression of the page is stunning this few minutes will be well worth it. By creating the impact of a richly colored patchwork quilt you'll have predisposed a photo editor toward your work. Have compassion for the weary photo editor, who, week after week, views dreary-looking, haphazardly organized submissions. This is where you can have an edge. And the day you hear: "It's a pleasure just to glance at your pages..." will be the proof of that pudding.

I'll often spend an extra five minutes rearranging slides in a stock submission for greater visual impact. Same photography, better presentation. It's also more fun to make it look good.

5. *Protecting the images.* This is when you double-check all forms of protection, legal and physical. Be sure your copyright credit notice is on the photograph, © in a circle, year date, and name (see chapter 14), that the model release number is marked, and that the caption is full and accurate. If you are new to the business or dealing with an unknown client, you might want to include a name and address label on the photographs. When the slides get separated from the delivery memo there is no excuse for anyone not to be able to find you for billing or returns.

To protect the physical property of the transparency (it has a long earning life if well cared for), cover it with a protective plastic sleeving. On 35mm use a 2x2" Kimac sleeve, then insert in a 20-pocket plastic sheet. Even a submission of one or two 35 mm slides should be sent in the 8x10" plastic sheets for a very important reason: they are thus harder to lose. Single 35mm slides in their Kimac sleeves are slippery little devils and difficult to hold on to. Putting them in an 8x10" reduces the chance of loss.

6. *Delivery memo.* Using your delivery memo form (sample in chapter 14), fill it out completely. Assign a memo or consignment number. Enter this number and basic information about the delivery, in numerical order, in a log book of delivery memos. This provides a quick check on where everything is and how long a package has been held. Next, on the delivery memo, list the file number and a brief description of each photograph in the submission. Specify if transparencies are originals or dupes and the size of any black-and-white prints. Total the number included. Double-check your count.

You file your delivery memos alphabetically by client, with a copy, in a chronological follow-up file for keeping track of the holding period.

Some photographers (myself included) make two black-and-white photocopies of the submission, to have a more accurate record. One goes with the memo, one stays in your files. The great thing is that the black-and-white copy shows the file numbers and caption info as well as a rough of the image itself — a real boon in settling any confusion about what has been held or returned. (Since the light from a copier can damage a slide over a long period of time, it's smart to use a 1/4" plexiglass shield between the transparencies and the light source as protection.)

Finally, but most important, fill out the valuation provision for loss or damage to transparencies and black-and-white prints — that is the fee you would charge if your original transparencies were lost or damaged

by the client. (Make sure you understand about valuation of transparencies, read carefully the detailed coverage in chapter 14. It is critical to the long-term protection of your file.) Individual valuation is preferable to a blanket fee if there are different costs and replacement difficulty to be reflected — for example if a particular shot required extra expense for helicopter rentals or higher-than-normal model fees.

In order to make the task easier, you can categorize your photographs in terms of replacement value as one of the valuation factors. For example, develop a rule of thumb by calculating some typical photographic costs for the type of work you do in the categories below or create other categories to fit your file.

Then, when filling out the delivery memo, see which category is closest to the photographs being submitted.

Category A (Highest)
 Model fees (pro), prop costs

Category B (Highest)
 Unique moment, special equipment

Category C (Highest)
 Travel costs, foreign

Category D (Next highest)
 Travel costs, domestic

Category E (Next highest)
 Model fees (non-pro), props

Remember, too, that replacement value is only one measure of a photograph's value. As you'll see in chapter 14, many other factors come into play, such as the aesthetic or unique value of the photograph, the reputation of the photographer, and the sales history of the transparency. Established photographers quite commonly place $1500 to $2500 valuations on their transparencies, for very good reasons that are detailed in chapter 14. I urge you to study this information, and by understanding the complexities of valuing transparencies, be able to explain them to your clients.

Be aware that photographers who sue for lost transparency fees may have to prove the value in court. The damages claimed must bear some relation to the actual value of the photograph.

Sample log book:

 Consignment Number_____
 Client Name_____
 Shipped via _____
 Package #_____
 Date Out_____
 Date Due_____

7. Invoicing the research fee. This is the stage to make out your invoice for a research fee to be included in the submission. Many agencies and established photographers charge a research fee to help defray the cost of preparing photographs for submission and to discourage casual shopping. This fee can be deducted from any usage fee.

When you are at the stage of having office staff working in the files, you'll realize that charging a research fee makes economic sense. Your overhead must be covered. Until that time, if you choose not to charge a fee, at least let the client know that it is a common practice.

8. Packing the submission. First rule of packing: always double what you think is suitable protection! If you hesitate over this point, cast back in your memory to the condition of packages you've received from all delivery sources — some virtually in shreds. Rough handling is inevitable. Prepare for it.

For delivery, your photographs should be packed between a minimum of two pieces of unbent corrugated cardboard inside a cardboard mailing envelope. If you have a large submission (thicker than 1/2") repeat the process with a second set of larger cardboards and a final 11 x 14" envelope.

If you show respect for your work by protecting it with careful packaging, it increases the odds that the client will do the same.

Double-check that all your paperwork is in the package with the carefully protected photographs — and seal it. Even that sealing process is important, a double amount of strong packing tape is advisable. You can't overdo the protection.

9. *Delivery to client.* Except for the rare instance when you deliver a stock request in person, you'll use one of the following methods of delivery:

The U.S. Postal Service. Never send photos by first-class mail. You will have no proof of delivery or ability to track a lost package. Certified or registered mail is safer, as they provide return receipts. Overnight Express Mail from the post office is a reliable, economical method. They guarantee delivery on the next business day in most zip codes. You must take your package to the post office or to a drop box.

Overnight Courier Services. Federal Express, Airborne, Purolator, and the like have virtually taken over the delivery action in the stock photography business. Most publishers and ad agencies use them, even for returns, and will often request that you use their courier number. These couriers offer the convenience of door-to-door pickup and delivery — as late as 9:00 PM for some services — and offer a variety of delivery schedules, next day before 10:30 AM being the fastest.

The United Parcel Service (UPS) continues its standard package service and has added an overnight delivery service comparable to those of its competitors. My experience has been that UPS is a possibility for boxes or very large packages only. Photographer friends report that damage to packages handled by UPS is more common than with other carriers.

Messenger services (urban areas). Check with friends in your city for a reliable, bonded messenger service. Insurance of up to $100 per package is standard. Additional insurance is usually available.

Insurance: Every package you send should carry insurance. You should know that in the event you must file a damage or loss claim, no matter who the carrier is, you may run into difficulties collecting the amount you specified on your photographs. The U.S. Postal Service states that it will only cover the replacement cost of the photographic materials.

It is well worth the few extra dollars it costs, however, to use insurance to signify to the client the value you place on the photographs. Their value is in their earning ability. An original transparency, once lost, cannot continue to generate income.

The importance of insurance as a message to a client is made evident by this quote from a defendant in a lost transparency arbitration "...even the stock company did not place a high value on them [the transparencies] themselves because they didn't insure them or take any special steps to protect them." Fortunately, this case was won on the strength of the delivery memo, but you can see how important it is to close every loophole. Carrying insurance is a clear message to a judge or jury that you value your originals — and, should there be a dispute, one less argument in the client's favor.

Mark the exterior of the package PHOTOS DO NOT BEND. This will help to dispel the impression that the insured package contains negotiable valuables (no gold necklaces in here, folks) and dampen the enthusiasm of a prospective thief. Whether it ensures a gentler handling en route is open to speculation.

10. *Filing the paperwork.* Put everything in place or the paper will pile up mercilessly. Take your copy of the delivery memo, and if you haven't previously entered it in your consignment log book do it now. File the delivery memo by client name, with the receipt from the delivery service attached.

11. *Logging-in first returns.* Generally, a client will review your submission immediately, returning photographs they know they cannot use. They will hold a selection of

possibilities for further screening and approval.

Accuracy is critical at this stage. Check the count and check for damage.

Checking the count. Does the total number of photographs actually in the package tally with total listed in the client's return memo? (Be wary of future dealings with any client that doesn't include detailed paperwork with a photo return. It often indicates that they aren't any more careful in-house. It's only a matter of time before they lose a photograph.)

If the count is off and the photographs in the package don't match the total listed on their form, notify them immediately —in writing! It's good to call, as well, to alert them to the problem, but always follow up in writing.

Checking for damage. Look to see if the mounts are intact. Use a light box and a loupe to check for damage to the film, such as scratches, fingerprints, and dirt. Some scratches are hard to see at first glance but will fill up with dirt and show up eventually. The next step: hold the slide under a loupe, with a strong side light and over a dark surface. Certain scratches will pop out that aren't immediately visible on a light box.

If the mount has been sliced, as is necessary for reproducing it, how should you handle that with a client? With a pleasant, direct inquiry. "I notice in your return of xx date that the count agrees exactly but that one of the slide mounts has been cut. I haven't received a purchase order, but perhaps you reproduced it and haven't notified me yet. Would you check your records?"

Another approach is: " It appears that you must have needed to do a layout for presentation because the mount has been cut on photo # xx. Let's discuss your policy on layout fees. As I'm sure you know, it's a standard industry practice if a photo is used in a layout but not in final publication to pay a modest fee — it covers my costs for re-mounting as well as your use in the layout."

This practice is most prevalent in advertising, where an agency may use layouts to sell a presentation to their client.

Don't be afraid to ask a question. You have a right to know how they used your photograph. And to receive payment for that use. Making waves can be done nicely. You don't need to come on strong. A gentle nudge will usually suffice — just don't back off.

12. *Filing first returns.* Returning photographs to the file is a way to guarantee that they'll be ready for the next request. Have one spot in your office for all returns that are ready to be filed. You'll be amazed — and horrified — at how quickly your "to be filed" cabinet fills up if you don't return photos to the file immediately. Consider that one small return package is easy to file, seven or eight small return packages become a task to ponder. And there is a tendency in most of us — certainly in myself — to procrastinate.

13. *Logging-in second returns.* Now your photo submission has been through the second stage of client approvals and another return is made. By now what they are holding is likely to be used. Repeat the logging-in process.

14. *Filing second returns.* Repeat the filing process.

15. *Follow-up on submissions.* Send a follow-up note — a photocopy of the delivery form with a query will work. If you call, be brief and to the point. "Can you let me know your return schedule on project xx? I've had other requests for that material?" Or ask if they need an extension. This is a method of keeping track of your work but in a pleasant manner.

As you get to know a client you'll decide how much of an extension is reasonable to allow. With dependable clients I usually allow three to four weeks before I have my assistant follow up, though I *should* do it at two weeks. Advertising agencies generally need less review time than other buyers. They also

pass quickly on to other ad campaigns so it's important not too let too much time pass, or your work may become part of your client's "ancient history" file. In the revolving-door world of advertising it's good to keep close tabs.

Magazines may be planning an issue as much as four to five months in advance, but if you haven't been getting regular returns, look into the situation. Book publishers tend to need the longest review period — though today their schedules have become so accelerated that a photo research project that used to take 18 months might now be accomplished in four to five. Enforce your holding period or respond to a request for an extension but don't just let the time drift by. If you do, you may be out of luck when it comes time to track down your pictures.

16. *Billing holding fee (if applicable).* As returns come in, check them against the delivery dates and holding fee date that you have specified. Decide if a fee is in order. I am quite flexible in granting extensions if a regular client requests one. The fee is there to take care of serious offenders. Remember, they are keeping your originals out of circulation. A new client cannot use what another client is holding.

17. *Purchase order/billing request received.* Finally you know what they are using. Some clients automatically send you a purchase order or billing request letter. With others, you have to ask what's being used. If an amount is specified on the billing request, see if it agrees with the reproduction fee you discussed.

18. *Price and usage negotiation,* if not handled above in step 2. (The full discussion of this important skill is in the negotiating chapter.)

19. *Invoicing the client.* Make sure your invoice clearly spells out the specific limited rights granted following the guidelines in chapter 12. Always use an invoice number for easier record keeping. At this stage request a tear sheet. Get all the information about publication date so you can mark on your calendar to follow up later.

20. *Receipt of payment.* The check comes in. Examine it for fine print to see if the usage has been extended or any conditions added that were not part of your negotiation.

21. *Entry into your bookkeeping system.*

22. *Log in the final return of used photos.* As above, check the count. Check for damage even more scrupulously at this stage. Printers are not known to be particularly careful in handling art work. It's not unusual for chromes to have fingerprints, or be upside down or in the wrong mounts. Check the images as well as the photo numbers to see if they match.

23. *Cleaning and remounting of used photos.* Photographs that have been reproduced almost certainly require cleaning and remounting and new caption labels before return to the files.

24. *Re-filing final returns.*

25. *Picking up the phone for the next request*

This is what it's all about. The next question is: Do you want to handle it all yourself, or should you get some help — train an assistant so you can go back to shooting photographs?

Training Staff

Only you will know the right time to go from doing it all yourself to using an assistant. My advice is to get help sooner rather than later. If you assess the value of your time, you'll see that shooting new photographs or planning a marketing strategy is an infinitely better use of your time than stamping copyright

notices or typing delivery memos.

Identify the areas in which you want help and the degree of expertise needed for each task (see the levels listed below). Assign work as the experience and qualifications of an assistant warrant. Remember that accuracy is far more important than speed when working with photographs. Before being dazzled by the person who whizzes through filing tasks, wait a month until you find that everything is really in the right spot!

Office Work, Level A — clerical

Stamping edited photographs
Attaching captions/labels
Logging in returned photos
Cleaning/re-mounting slides
Returning photos to file
Writing delivery memos (for photos you've pulled)
Typing invoices (fees specified by you)
Packing submissions
Handling shipping/delivery of submissions
Qualities needed:
accuracy, neatness

Office Work, Level B —contact with clients

Respond to photo requests/call buyers, get usage info
Pull request from file
Organize photo submissions
Negotiate prices
Qualities needed:
understanding of photography, some experience and sophistication in business, good phone manner

Photography-related work, Level C

Editing processed film (selecting for sharpness, exposure, expressions)
Qualities needed:
photographic experience, good "eye," and/or training

During the training period and until you are sure a staff person is capable of a specific level of work, double-check everything. It will take some pressure off both of you and make for a more relaxed working environment.

Your staff should understand the extraordinary value of your photographs and the need for careful logging and protection. Make it clear that you value their thoroughness, because certain tedious clerical work is integral to the success of your business. Also, if you find someone competent, you can never show enough appreciation.

Finding staff is a process of research as well as trial and error. The right person might be found anywhere. The best assistant I ever found was a former actress who had worked as a free-lance mechanical paste-up artist and who was studying for an MA in education. We had complimentary needs at the right time. A person's experience may be less important than their qualities of thoroughness, accuracy, dependability, and that old standby, common sense. A sense of humor is a bonus.

If your business isn't ready to support two full-time staff people, you might use one person for two jobs. Use a photo coordinator who can help set up your stock shoots and work in the office as well.

In chapter 6 you saw sources for finding a photo coordinator. Many of those same sources could help you find an office staff person. Among those possible to fill this job are photography students or interns, theater people, and teachers.

For help with Level A, the most basic clerical work, some photographer friends of mine use high school students. Though there may be some exceptionally trustworthy teenagers out there, I have hesitated about putting that degree of responsibility upon such young, inexperienced people. College students, however, can work out well. Make contact with the placement office of your local college.

Also, see if any of the students in your area are in work-study programs, such as those conducted by Bennington College and several others. If you explain the qualities you need in an assistant, a placement counselor will

help screen for the right person. I have found dance students (they're disciplined), science majors (they're meticulous), and computer students (they're precise) to be excellent prospects for office work. Art or photography majors are often interested in the aesthetics of your business but may not be aware of the importance of detail work — or will merely tolerate it. Be aware that they may become dissatisfied quickly.

My greatest success so far has been with teachers — they often want to fill some of their vacation or after-school time.

It is very important to have your procedures written down. An outline of your system will help a new staff person understand your initial explanation and will serve as a guide to answer questions they may have later on. Though it's second nature to you, the information may appear to be overwhelming to an outsider. It's frustrating to believe that you explained to an assistant how captions should be attached to the slide mount — only to find it done wrong — with hours wasted, work to be re-done, and dispositions soured. In fairness to your staff, and to avoid frayed nerves, written procedures will assure that you have indeed conveyed the information clearly. The training of future staff will also be easier. By creating a cohesive structure, you have increased the likelihood of competence on everyone's part.

A well-trained staff can make it possible to run your stock business efficiently, leaving some energy for the primary goal: making wonderful pictures.

The Support System — Professional Photographic Organizations

Are other photographers having a problem similar to yours? Or are you the only one who feels frustrated? Where can you go to talk to someone?

You aren't alone. Much cheaper than therapy, the various professional photography organizations are there to help you.

Investigate them all and see which one is designed for your interests, professional level or goals.

The primary benefit is in associating with colleagues. You'll want to meet with other photographers to discuss similar problems and solutions. In addition, informative newsletters, meetings, and seminars on various photographic topics are offered. The important side benefit is that at these meetings you have a chance to learn how established professionals handle their businesses.

Most organizations have various levels of membership, from student or entry level to that of established professional.

The organizations most likely to be of interest are:

ASMP	American Society of Magazine Photographers
ASPP	American Society of Picture Professionals
APA	Advertising Photographers of America
PP of A	Professional Photographers of America

Having been an active member of ASMP, I'm a fervent supporter of that organization. ASMP has been protecting photographer's rights since the 1940's. It continues in that effort as well as in educating members — sharing valuable information and insights into the complexities of today's photographic world. There are 34 chapters throughout the country including Hawaii and Alaska. There must be one near you.

I can't encourage you strongly enough to join the professional organization that fits your needs. It's the one thing you can't get out of a book.

Expectations and goals
Your success in selling your own stock is in direct proportion to the commitment you bring. Stock is open to everyone. Not all will succeed. But anyone who brings dedication, quality and a long-term investment, has an excellent opportunity.

TELEPHONE STOCK REQUEST FORM

Request Date: _____ Photos needed by: _____

Name: _____ Tel: _____

Company: _____

Address: _____

For (Final Client): _____

PROJECT TITLE: _____

USE: ❏ Advertising FORMAT: ❏ Color

❏ Corporate ❏ BW

❏ Editorial ❏ Horizontal

❏ Other _____ ❏ Vertical

CONCEPT/SUBJECT:

USAGE/RIGHTS SHIPPING:

Use in: _____ Client Courier # _____

Size: _____ Date Sent: _____

How many copies: _____ Via: _____

Where (U.S.): _____

Other: _____

❏ English Language: ❏ Other Language: _____

PRICE: Our Quote: _____ Client Budget: _____

CHAPTER TEN

Marketing Your Stock

The wonderful photographs you've taken, carefully edited, and meticulously labeled are ready to go out into the world. How well they help you achieve your goal of a successful stock business depends on your ability to market your own work.

Marketing is as simple as finding out which buyers might need the type of photographs you have and letting buyers know you have photographs for them — a sort of match making.

Here are the steps in your marketing effort:

- Develop marketing strategy
- Develop marketing materials
- Find buyers
- Reach buyers
- Dealing with clients

Develop Marketing Strategy

What markets do you want to reach? Based on your analysis of your work (chapter 2), match the style of your stock with the potential markets you've identified in order to decide which ones to approach. Then go after them one at a time.

"Market" in stock photography terms refers to the type of intended use, not the topic or style of photography. What is the intended usage and who is the user? Who pays the reproduction fee and how will the photograph be reproduced? Will it be used to advertise a product or service, to promote a corporation, to illustrate written material in a magazine, or to embellish a calendar?

Travel photography can be used in any of these ways, for example. The same twilight scene of Singapore could advertise an airline, be used in an electronics company's annual report, appear in a magazine article about the Pacific Rim or, for the month of September in a calendar date book. Other types of photography have amazingly flexible uses as well. Imagine the ways a cozy family scene could be used: in a bank advertisement, in a corporate brochure for a manufacturer of heating units, in a magazine article about the stability of the family. The list is boundless.

Following are the major markets for stock photography and their requirements. We'll consider the fee ranges, competition, releases and discuss the likely contact in each market.

Advertising

Advertising is considered the highest-paying market as well as the most demanding market for stock photographs.

141

Fees: High to moderate. Sales will range from many thousands of dollars for an ad on the back cover of a national consumer magazine like the New Yorker or Life down to $400-500 for a quarter page ad in a low-circulation trade magazine.

Competition: fierce

Releases: Essential. To sell in this market you must have releases for everyone in a photograph and for certain recognizable property. The neighbor's dog you photographed and the porch of the charming Victorian house he was sitting on — both need a release. One of the main reasons for this, without worrying about all the legal technicalities, is that any ad agency buying stock will insist on such a release.

Contact: Most often your contact is the photo buyer of an advertising agency acting on behalf of its client. That client is usually a company offering a service or manufacturing a product, but can also be a governmental department or a utility. So the final user, your client's client, may produce dish soap, band aids, or kitchen equipment, provide telephone service, or be a branch of the armed forces. That client will make the final decision on what is presented by the ad agency. A few companies have their own in-house advertising departments and might conduct their own photo search.

It is more likely that the person you deal with will be one of the following: the ad agency art director, who sets the concept and makes the decision on what to put into layout for approval by the client; the ad agency art buyer, who most often does the photo research under the guidance of the art director, seldom has decision-making power, but translates the concept to the photographer or photo agency; or a photo researcher, usually free-lance, hired by the art director or the art buyer for a specific project. A researcher submits photographs but has no ability to make decisions.

Corporate

The corporate market is an interesting and growing market. Clients who formerly assigned most photography are now using stock on a more frequent basis in annual reports, brochures, house organs (company publications for in-house use), or slide shows.

Fees: Medium-high. Annual reports are the highest paying, while trade slide shows can be extremely low. (It is imperative that slide show use be monitored and that your invoice limit be specific.) Brochures can command a wide range of fees, depending on usage, which is very much open to negotiation.

Competition: keen

Releases: Required. It will be especially important to let corporate clients know if the workers or factory scenes in your photograph are from a competitor's facility. You may not always have to produce a copy of the release at the time of submission.

Contact: The corporate communications department or public relations office of a corporation will most often handle photography needs. You might deal with a designer in corporate communications, the corporate communications director, or the vice-president for corporate communications.

Editorial

The editorial market is the broadest market and includes magazines, newspapers, books, and television. Editorial usage is characterized as being informational or newsworthy. It is generally considered non-commercial usage, because the photographs are not used to advertise goods or services or to promote a commercial entity.

Fees: Average to low. A potential for a high volume of sales exists in this market.

Competition: normal

Releases: Releases are not usually required for interior editorial use when the photo is shown in an accurate context (i.e., the caption doesn't distort the meaning), and the usage would be considered to be newsworthy or to educate or inform. However, clients sometimes consider covers as a commercial use (even if this is not strictly true, legally). These clients will require releases. (See chapter 14 for more on releases and legal matters.)

Contact: Any of the following might be your contact at a magazine, newspaper, or book publisher: the art director, designer, picture editor, photo department staff, or free-lance photo researcher.

Advertorial
Advertorial is a hybrid market. Editorial in style and format, it is actually advertising. Most commonly used to advertise a country for tourism or business investment, advertorials are usually published as an insert to a newspaper or magazine. Though it may look like an editorial article, the word "advertisement" at the top of the page is your clue.

Fees: Buyers sometimes offer editorial rates for this usage, but most photographers negotiate to a middle range between editorial and advertising.

Competition: normal

Releases: Required. Remember it is advertising in sheep's clothing.

Contact: An advertising or a public relations agency.

Develop Marketing and Promotion Materials

Promotional materials are essential. They will serve two purposes: first, as an introduction — to let the buyer know who you are,

what range of topics you have on file, and the quality level and professional service you have to offer. Second, they are handy reference material for a client to keep on file for use in future projects.

Here's what you will need:

- Stock photo file subject listing. Your list should give a clear idea of the major categories or specialties of your stock photographs but needn't list every picture on file.

- Stock portfolio. This is a presentation of photographs for use when you have an in-person appointment to show your work. It can be in carousel form, suitable for showing in a slide projector, or arranged flat in cardboard mounts, for transparency viewing on a light box. Remember to include a balance of close-up and wide shots, verticals and horizontals in any presentation. And show only your best work.

- Letter or description of you, your work, and professional achievements.

- Telephone/Roladex card. An attractively printed card with your business name, address, and phone number can be a reasonably priced promotion piece.

- Business card (some include a photograph).

- CD-ROM disc of your photo portfolio.

- Photographic promotional pieces. These can be sent in mailings or left with clients you see in person. They can be postcard size or letter size — with three to ten photographs.

There are many companies in business to provide these printed promotional pieces to

photographers — they advertise in the photographic trade press. Photographer friends in your area may be able to recommend quality printers. Some photographers have been able to arrange a trade of services with printers — you get your mailers, they get to use your photographs to promote their services.

Finding Buyers

Mailing lists are available for sale for virtually all types of photo buyers — or you can build your own list from sources such as the *Photographer's Market,* published by Writer's Digest Books (see bibliography). Besides direct-mail promotion, there are marketing tools such as catalogs and electronic networks, which can be used to reach buyers.

Start your list of buyers to contact by pinpointing organizations and magazines who put out the kind of publications in which you would like to see your work.

Study the buyers' organizations in your area. Groups such as the art directors clubs or AIGA, the American Institute of Graphic Artists, 1059 Third Avenue, New York, NY 10036, which has chapters in 33 cities, often hold seminars, exhibits, and other functions at which you can meet art buyers.

There are catalog and source books in which you can buy advertising space. Publishers of these catalogs distribute them free to art buyers, who keep them for reference. Be cautious. Make sure you are not paying more than the going rates for catalog space. Research what various sources charge, then check with photographer colleagues to see how those rates compare with what they pay for space in their photo agency catalog. This will give you a range of prices. The cost of these pages must be balanced against the likely return . Photographers report that one successful catalog is Direct Stock, 10 East 21st Street, New York, NY 10010.

You can buy advertising space (or have a free listing) in *The Workbook Photography Portfolio* — one of a 4-volume set of books that serves the graphic arts industry and is pub-lished by Scott and Daughters Publishing, Inc., 940 North Highland Avenue, Los Angeles, CA 90038. Tel: (800) 547-2688. The same company publishes the *Stock Workbook,* a source book which advertises stock agencies.

Some photographers market through electronic bulletin systems. As a subscriber to these services, you have access (via computer or fax machine) to photo requests from a variety of buyers.

While the electronic networks can be a useful way to gain information about buyers and their needs, proceed with caution. Some photographers believe that buyers use networks to bargain hunt, knowing that hundreds of subscribers may respond. Photographer's have also started marketing via the Internet, taking pages on the World Wide Web. It remains to be seen how many hits (visits) to the page actually turn into photo sales. The Web may be best suited to major collections.

Know the company you keep. Ask clients what success they have on networks and the level of quality and service they receive. Above all, unless you know the client, call before submitting photographs. And do *not* send out unsolicited material.

Reaching Buyers

The essence of promotion is repetition and follow-up.

Keep your promotion manageable. It is better to target a small-to-medium size group of buyers and be able to contact them regularly than to hit thousands who never hear from you again.

Once your materials are prepared, send a mailing (800-1000 pieces) to carefully selected names. These names should include your assignment clients, the buyers within your area, and a limited mailing list from any of the source books you consult. From the mailing list, select the other names, based on how well you think your work fits what they do. There are a number of sources for stock photo buyers. Here are a few:

ASPP Directory
The American Society of Picture
Professionals
c/o H. Armstrong Roberts
4203 Locust Street
Philadelphia, PA 19104

Photographers Market
Writer's Digest Books
1507 Dana Avenue
Cincinnati, Ohio 45207

*Audio Visual Market Place and
Literary Market Place (LMP)*
R.R. Bowker Co.
245 West 17th Street
New York, NY 10011

*Standard Directory of Advertising
Agencies*
National Register Publishing Co.
3004 Glenview Road
Wilmette, IL 60091

Keep your list a manageable size so you can follow up. A phone call requesting an appointment to show your stock portfolio is the next step. Regular mailings should go out. Use the announcement of new additions to the file to highlight a second or third mailing. Also, send an announcement of a proposed shooting trip to an unusual locale — it will generate interest in your file and perhaps bring an assignment.

Once you have prepared your materials and conducted a few mailings, you should assess your responses to see which approach has brought the most business. You can keep track by asking callers how they learned of your files.

If you are new at promotion, once you've done a few mailings, you can fine-tune your marketing skills by getting a professional critique. There are seminars and portfolio reviews available at the trade shows and workshops around the country. You can get valuable feedback on your individual materials.

Contacting Clients

When dealing with photo buyers remember the following:

- Don't send out unsolicited material, ever. If you have heard of a client's need from another photographer or through an electronic stock listing, be sure to contact the client before sending any photographs. You can make sure the photographs are still needed. It will save you time and trouble if their deadline has passed. An additional benefit is that through personal contact you may learn of other photo requests. Most important, if they request that you send the material described in your phone conversation, you are in a stronger legal position in the event of loss or damage.

- Call! Even if you get a photo request list in the mail, always contact the client by phone. It can be invaluable to discuss a list directly with the buyer. You can clarify, eliminate, or add topics to be submitted — and dramatically increase your sales percentage. You will learn more about the present project, and possibly future projects as well, and you'll learn the purpose, the underlying concept, the shape needed — in fact, all the information listed on the telephone request form in chapter 9. You will avoid unpleasant surprises on both sides by discussing your terms and conditions with a new client. If your call is brief, professional, and to the point, you emerge in their mind as a careful, thinking photo source, and you should have learned enough to make the submission profitable.

Dealing with Clients

Make yourself easy to deal with. Your attitude should be as much of an asset as your photographs. Some clients tell me that they avoid calling individual photographers be-

cause it can be more trouble than it's worth. They prefer to work with photo agencies because they receive professional service and no nonsense.

How do photographers work against themselves? Self-indulgence in some photographers may be the root of the problem. They lose sight of the buyer's requirement for quick, courteous treatment and quality photographs. A common complaint is that, instead of concentrating on solving the buyer's problem, photographers use a photo request call as an opportunity to unburden themselves of a variety of attitudes ranging from pesty or belligerent to tiresome chattiness. No client wants to brace themselves for a tirade on the state of the industry and the rising cost of film or to endure a tedious account of your difficulties with the weather on a recent shoot. Your photographs would have to be the best in the industry to overcome the reluctance created by that approach.

There are moments when a buyer is interested in you as a person and may want to hear your stories from the front lines. Establish rapport, chat if they are interested. But don't assume they have all day for you. Let them take the lead. Listen to the signals. If you are respectful of the buyer's time, they won't hesitate to call you. Remember too, you can show pride in your work without resorting to braggadocio. Don't let your ego show through in adverse ways. Add to these problems a tendency by some photographers to be sloppy or late in preparing submissions, and you have an uphill road toward sales.

To assure a good reception and repeat calls from buyers, follow these guidelines:

Speed: Respond with your submission as quickly as possible. If you get there early, with the right photograph, they might not look farther. But if you come in at the tail-end of their deadline there might be many more contenders in competition with you. And to miss the deadline may be worse than not submitting — imagine the frustration when the photo buyer sees a better photograph of yours after he or she has finished the approval process and another picture is already in the layout.

Dependability: Do what you promise. Follow through with the photographs on the time schedule you discussed, or call and explain any delay or find out if they can give an extension of time. If you don't have anything to submit, let them know. Call or drop a note: "Sorry I wasn't able to provide exactly what you needed on the xx project. Hope I can help you the next time." Dead silence from a mail request leads them to believe just that, that you've died.

Quality: Do a tight edit for quality. Send only the very best, especially with a new client. If it's not on the mark don't send it.

The greatest compliment you can hear from a buyer is "Well, I know one thing, if you have it, it'll be good. You never send me anything mediocre." A client needs to depend on the level of quality they can expect from you.

I've heard photographers say: "I'll just send them a lot of stuff and they can weed out what they don't want." Now tell me, why would a buyer want to wade through a messy or mediocre submission?

Alternate photo ideas are another story. Good quality variations on the original request are welcome. Talk to the buyer. See if your suggestions fit their concept. When you can't reach them by phone, include a brief explanation with the alternate photograph you send: "The hot air balloon pictures are an alternate approach to your 'riding high' concept." It will let the buyer know that you were listening and didn't just send things willy-nilly, oblivious to their request.

Organize: The submission should be organized to match their request as closely as possible. Use their spec number or concept name.

Courtesy: In addition to being pleasant, be helpful. Suggest other sources for material you can't offer, such as a photographer friend or a catalog you've seen. This doesn't increase the competition — they would fill that request anyway. You emerge as a considerate professional.

Don't pester: It's necessary and important to follow up to keep track of your photos. If a client keeps your photographs out of circulation you can lose sales. But do your follow-up in writing or on the phone in a brief, specific, and professional way. You have established a holding time on your delivery memo or have discussed any extension they might need. So don't call every other day, that's being a nuisance.

Finally, distinguish yourself as a professional. That is the key to good marketing. If your promotional materials are of a high quality, if you make consistent contact, and you provide courteous, quality service, you will have repeat business. In addition you will build a stronger bargaining position. When it's time to take care of your needs — a good price and respect for your work — the ground work will be set.

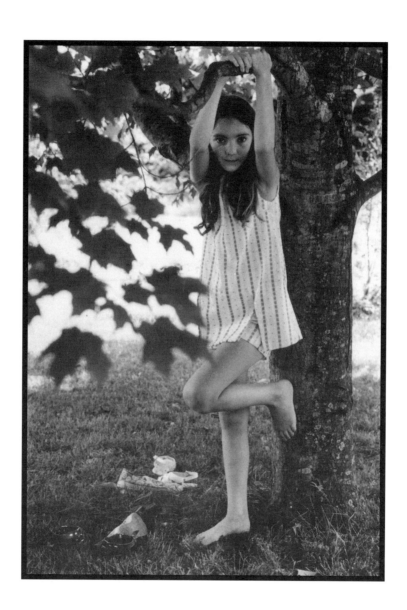

Finding a Stock Agency

If the way to Carnegie Hall is practice, practice, practice, then the way to finding an agency is research, research, and more research. There are occasional matches made in heaven when a photographer and the perfect agency for his or her work find each other on the first try — but it is the exception. It is currently more difficult to find agency representation than it was 5 or 10 years ago. Explore all possibilities: understand the function of a stock agency, assess what you have to offer, and search until you find the right match.

How Do Agencies Work?

A stock photo agency is a marketing arm for photographers and a photo source to buyers. An agency provides buyers with quick access to a wide variety of excellent images. For most photographers, agencies can open markets far beyond the scope of what might be achieved by individuals. Agencies license rights to photographs on your behalf, you provide the photographs that keep them in business. You are partners.

A stock agency functions much as you do when marketing your own work, but on a bigger scale.

An agency

- maintains a file of photographs.

- fills photo requests from buyers.

- negotiates fees with buyers.

- invoices buyers.

- provides sales reports and payment to photographers.

- provides marketing information to photographers (via newsletters and by maintaining files with tear sheets or polaroids of top-sellers).

- seeks photographers with new material to complement their files.

- edits photographers' submissions.

- catalogs, labels, and prepares photographs for filing.

- conducts regional, domestic, and worldwide marketing

- develops marketing tools, e.g., catalogs and compact disks of photographs representing a cross section of the agency photographers.

- Maintains computer systems.

Agencies negotiate the fees that accompany photographic usage. Agency fees are not higher than a photographer's, as some people suppose. The agency simply charges whatever fee is appropriate to a client's usage. In principle, they should be the same. Any differential between what an agency charges and what a photographer may charge for the same usage is simply a matter of negotiating skills — and agencies sometimes do a better job.

The veteran agencies — some of which have been in business 30 years or more — often have huge files, representing hundreds of photographers and millions of images. Later entries to the field often have a more specific marketing focus: some are specialists in sports, animals, or natural history, for example, others are considered to be regional agencies; still others can be characterized as having a boutique approach. And the most recent development is a shift by the newer agencies to a vigorous, high-powered marketing approach. There is a further trend toward mergers among agencies.

In the next 10 years we will see the emergence of a group of complex, high-profile agencies. To succeed in a crowded, competitive arena, today's stock agencies must be right up to the edge in every aspect of their business operation. They have to choose the best photographers, edit rigorously, market aggressively, and provide top-flight service to clients.

The success of stock has in turn put even more demands on the business. In the world of stock the educated client has become a choosy one. When your agency does well, you do well.

Your Decision

In deciding to pursue agency representation, consider what an agency can provide for you and assess the status of your photography. Are you ready to offer work to a specific agency? No aspect of stock is an instant bonanza. If you approach agency represen-

tation with realistic expectations, your chance for success will be greater. The more you contribute the more you will earn.

There was a time when any reasonably good photographer, and even a few who were not, could find an agency to take their work. That day is long past and it's not such a bad thing. Here's why: being accepted by an agency fostered an illusion that they would sell your stock and you would earn money. However, if it was an accept-any-and-everybody agency, your work may have ended up on the back shelf, crowded in with the scores of other photographs accepted, perhaps just for the sake of having lots of pictures on file. I'm not suggesting there was a conspiracy to accept photographs without the intention of marketing them. It's doubtful that any agency held such a cynical view. But during the evolution of the photo agency business, it was thought that diversity was the greatest asset an agency could offer a buyer. The premise was that a huge selection had value and that buyers had the time to wade through mountains of pictures. If some were mediocre, let it be on the buyer's head to pass those up. Some photographers got caught in that trend, did not earn much, and were soured by the experience.

That no longer works. Buyers are more sophisticated about what they want: they expect top quality and fast service. As for agencies, the cost of housing and handling photographs that don't produce any income is unsound economically.

While it's harder to get into an agency, getting in is a better deal these days. The good part is that, if they accept you, your chances of making money are better. They think you can make money for them or they wouldn't (and can't afford to) take you on. They don't want your unsaleable photographs clogging up the works. The corollary is that agencies want photographers who are constantly producing new work. A successful agency needs a supplier who supplies.

If you can demonstrate to an agency that you have and will continue to produce ac-

tively, you may win out over other photographers being considered. The in depth coverage resulting from your stock assignment shooting (chapter 5) and your plans for future stock production will underscore your seriousness of purpose.

An agency wants you to be producing income for them and that's exactly what you want. You don't want to have pictures lingering in the back of their files, never to see the light of day any more than they do.

How to Find an Agency

Where to Look for an Agency:

- Source books
- Photographer friends/colleagues
- Assignment clients
- Photo credits

The basic information is very easily available. An excellent source of information about stock agencies is the *ASMP Stock Photography Handbook,* 2nd Edition, published by the American Society of Magazine Photographers, 419 Park Avenue South, New York, NY 10016 ($29.98 plus postage and handling). Stock agency listings are arranged by geographic location, tell how many photographers are represented, how many photographs are on file, whether the agency has an exclusive contract, and other significant information. You will get a good initial profile on an agency from this reference book.

Another excellent source is PACA, the Picture Agency Council of America, which publishes a directory of its member agencies, including their specialties. To order a *PACA Directory,* send $2.00 for postage and handling to PACA, Marty Loken, President, c/o ALLSTOCK, 1530 Westlake Avenue N. Suite #600, Seattle, WA 98109 or to PACA, c/o H. Armstrong Roberts, 4203 Locust Street, Philadelphia, PA 19104.

A very thorough listing of agencies is found in *Photographer's Market* published by Writer's Digest Books, 1507 Dana Avenue, Cinncinati, Ohio 45207.

The *Stock Workbook,* published by Scott and Daughters Publishing Co, Inc. (800) 547-2688, is a catalog for buyers in which stock agencies can buy space. It lists over 200 hundred stock agencies. At a cost of about $98, you may want to refer to it in the library. Fred McDarrah's *Stock Photo Deskbook* has a wide listing of sources, including agencies and individual photographers. Available from The Photographic Arts Center Ltd. 163 Amsterdam Avenue, Suite #201, New York, NY 10023 (212) 838-8640.

These books give you the broad spectrum of what's available. Pare down the list to a manageable number that fit your specialty or geographic region.

Next, speak to your assignment photography clients. Find out if they use stock photography (if not, why not?) and what photo agencies they use most often. If they show any hesitation, ask for the first three or four they would think of calling. Then find out why. You should hear "quality, service, dependability...." But if the client responds with: "They give us such cheap prices," you have learned something important — that a particular agency will do almost anything to make a sale. That attitude is hardly to your benefit.

Talk to other photographers. This is where participation in organizations like ASMP is such a boon. Ask for their views on agencies. How does their agency handle the following:

- Turnaround time for photographs being edited for the file. Are they filed with reasonable speed or do they sit for six months, waiting to be labeled?

- How well do they share needs for new pictures?

- How well do they market?

- How well do they deal with foreign agencies?

- Is payment prompt?

- How detailed is their sales report?

- How accurate are their logging systems to clients — and returns of your submissions?

- What safeguards are available to the photographer? Are the books open to the photographer by appointment?

Finally, look at photo credits in editorial usage to see which agencies appear regularly.

There are many choices of agencies, well over one hundred. The *ASMP Stock Photography Handbook* lists 102 domestic agencies.

PACA, The Picture Agency Council of America publishes an annual directory of it's members.

Confine your search to the well-established agencies or those newer ones run by people experienced in the business.

Narrow the List

Based on what you've learned, match yourself with the right agency. If you shoot 35mm travel, you wouldn't want to end up in an agency known to buyers as specialists in 4x5 farm scenics. What about an agency's size? Do you want to be with a new agency where you could start small and grow with them? Or with a large organization with an established reputation?

How about exclusivity? Do you want to work to be accepted by a powerhouse agency that requires an exclusive contract? The argument for exclusivity from an agency standpoint is simple: they want to be free to negotiate deals for you worldwide without conflict. For example, if an advertising agency were offering a high fee for a two-year exclusive usage on one of your pictures and you have that picture with three different stock agencies, no one can guarantee the exclusivity, and you are out of luck.

Further, they wonder why they should share marketing information with you if the benefit of that information will go to several of their competitors.

However, exclusivity is a two-way street. Agencies requiring exclusivity will rarely offer you a contract unless they believe you have a lot to offer. And you must be sure they can deliver enough to make it worth putting all your eggs in one basket.

If you don't have the clout to command an exclusive contract at a major agency — or you do, but prefer a wider game — consider working on a non-exclusive basis. If you choose agencies in different areas or who hit a variety different markets, you can spread out your chances. Remember it does add considerably to the work to deal with more than one agency. A photographer friend of mine has work in over a dozen agencies — that's an extreme. It works for him. But I would probably go 'round the bend in handling that situation.

Another aspect of analyzing an agency is to look at their philosophy regarding internal competition. Recently two approaches have emerged in the newer agencies: What is called the "non-dilution effect" applies to an agency which limits the number of photographers it represents in order to reduce internal competition. They will protect you within your specialty. For example, if your specialty is underwater, they will not accept every other good underwater photographer who comes along. They believe this protection will foster your career and that in turn you will produce more for them. (Don't be dismayed at not gaining access to such an agency. Their style of operation makes competition fierce, and even very good photographers can have trouble cracking them.)

What has been termed the "mother lode" approach indicates that an agency believes it is an advantage to have many photographers with similar coverage in order to attract buyers. They believe that clients want broad coverage and would be happy to see the work of as many underwater photographers in one place as possible. It's a bit like the theory that car dealers benefit by having many showrooms on the same street.

When you get to the discussion stage with

an agency, ask their stand on this issue. There is validity to both points of view.

How to Approach an Agency

Send a letter. Explain that you are interested in learning about their acceptance procedures. Request submission guidelines. Many agencies today have a fact sheet they send out describing exactly how they wish photographers to contact them and submit work for consideration.

Don't call. Most agencies are busy trying to sell pictures. If they get 20 calls a day from prospective photographers who have 15 minutes each to spare on a conversation — that's five hours of their time not spent selling pictures.

If possible, visit an agency in person and by appointment. A visit will give you a sense of the professionalism and the picture handling methods of an agency. Be sure to check the logging and filing system. Is there a unique number for each picture? Can they tell the whereabouts of any picture at any time? How easily can they retrieve pictures from the file. If the filing and retrieval system works well, then you're less likely to face the unfortunate situation of having to remove your photographs from an agency.

If you start a relationship in a professional manner it has a much better chance of success. Though they need new material, an agency's primary responsibility is to sell the work they already have on file. Their responsibility doesn't extend to educating you, however much compassion they may have for your desire to learn about the business. You'll get a much better reception if they know that you've done your homework. It will augur well for a future relationship.

Follow their guidelines to the letter. Include promotional pieces, stock lists, printed samples, and biographical information, including areas of photography you are interested in pursuing. An agency is as interested in the person, the brain behind the camera, as they are in the photographs they see.

What do you have to offer?

Excellent photographs, a commitment to producing new work, and a wonderful attitude, in that order. But sometimes the order might be reversed. An extreme case brings home the point. A major stock agent recently confided that they had bought out of their contract with a high-earning photographer because of the difficulties in dealing with that person. The income generated wasn't worth the aggravation.

Let them know that you are reasonable and professional. How? By listening and following up in the manner they ask. Be courteous.

When presenting photographs, follow the agency guidelines for submission, but within those guidelines let them see how you think photographically. When organizing a sample submission, arrange the sheets to indicate that you have depth of coverage. For each topic or concept, show six to eight variations, including horizontals and verticals, close-ups, and wide shots (see the sample that follows). This shows an agency that you understand the variety they need.

Your presentation to the agency should be a very tight edit. Include only your highest-quality photographs or there won't be a second round of talks. This advice is the most common given out at seminars, in books, in agency guidelines — yet for all that, it still happens that a photographer will say, "Well, I'll show a lot and they can see what they like." An agency doesn't have the time to do your basic editing.

Editing is a photographer's stumbling block. Edit as if you're showing the work to the photographer friend you most respect or to your toughest client. If you have any doubts, take it out.

Concluding a Deal

Once you've gotten to this stage, you and the agency want it to work. It's contract time. Read the document carefully. Decide if there are any provisions you find difficult to live

Show your professionalism to a prospective stock agent by presenting your work with full captions, tightly edited including verticals as well as horizontals. Show enough coverage to let them see how you think photographically.

with. Agency contracts can run from as few as three years to an average of five to seven years. Three is a workable length for both sides to see how the relationship is working. Be wary of automatic renewal provisions.

In the *Stock Photography Handbook,* ASMP provides a sample photographer/ photo agency contract with explanations of provisions from the photographer's point of view. Take a look at it.

Next, have the contract reviewed by a lawyer who is knowledgeable in photographic matters. Your brother-in-law's real estate attorney won't be much help and can gum up the works by not understanding the standard practices in the photographic industry. (ASMP has available to members a legal referral system for locating photography lawyers.) The lawyer may explain the ramifications of clauses that you hadn't understood. This is not a time to be casual. You and your work will be tied up by this contract for a considerable time. Be aware of what it means.

Consult with stock photography colleagues to get their views on contract clauses of special importance to photographers. As marketing practices change, new contractual issues may emerge. Until recently, it wasn't necessary to know the contractual ramifications of being included in your agency's catalog or electronic marketing tools. Now it is. Contact with professional organizations will keep you informed of the latest concerns.

Here are some of the most important points you'll need to clarify with a prospective agency:

- Catalog sales costs: Who pays for them? What percentage does the photographer receive of sales of their photographs in a catalog? Do you have control over which and how many of your photographs are used in a catalog?

- Foreign sales escrow: Are these monies held aside or do they go into the general fund?

- Contract term: Is there an automatic renewal provision?

- Use of your images in agency advertising: Do you have right of approval?

- Deductions of expenses and fees for filing: Are they specified?

Decide which areas you want to negotiate. Remember that an important factor in this negotiation is your clout or lack of it. How much do they need or want your work and how much will you give up to be accepted? A clear contract, thoroughly understood, will clear the way for a productive agency relationship.

Working with an Agency

Now you are on the same side. You and your agency are partners. Sometimes what's right and what's good business coincide. That's the case with an agency relationship. It can be summed up as professionalism and the Golden Rule (and leave your paranoia at home).

Here's what you can do to make it work:

Professionalism: Continue to submit excellent, carefully edited and captioned photographs. Listen. Respond to the agency by shooting what they request. Help them help you by giving them the photographs they need.

New Material: Send new photos regularly, in batches of 200-400. Medium-sized batches, at regular intervals, will go through the editing process and into the file more quickly. Every two to three months is ideal timing.

Are big batches better? Your agency will be happy to receive new material any time they can get it, but swamping them with thousands of images at one time may clog up the system. Early January is a popular time to send new work to an agency, especially for

photographers who have spent the holiday vacation working on stock. Imagine how inundated an agency might be just after the first of the year.

Does an agency keep all the photos submitted? Generally not. They may file anywhere from 20 percent to 80 percent of your submission depending on how well you have edited. They keep what they think they can sell. It's that simple. You will help yourself by editing carefully according to your agencies' guidelines.

Respect: Agents are human. Treat them with courtesy. You are in a partnership which must be built on mutual respect. Why be in an intimate relationship on adversarial terms? Make it friendly. You should have fun, share experiences with your agent, get support and understanding. If you are tactless or insulting you can't expect an extra measure of help.

Integrity: Approach the relationship with openness and honesty. Live up to the spirit as well as the letter of your contract. In addition to excellence in photography, an agency will expect honorable dealings. One serious breach of integrity on the part of a photographer is misrepresentation on model releases or captions. This can put both you and the agency in serious jeopardy.

Here's what you should expect from a good agency:

- Vigorous sales efforts on your behalf.

- Excellent, courteous service to clients (they are *your* clients too).

- The highest standards in the care and custody of your photographs including meticulous handling and accurate logging.

- Marketing information: You should share in the research done by an agency of new trends, shifts in approaches, and changing picture needs.

- Support and guidance: You will expect specific advice and constructive criticism on your work, to target it even more specifically to the changing needs of the stock industry.

- Financial integrity: You have a right to know financial details that affect you. Instances of photographers' being cheated by agencies make for colorful stories but are actually not common. While you must be vigilant in protecting your interests, you should voice your concerns in a firm, but civil manner. Don't be afraid to follow through on unanswered questions.

The best protection is to research carefully into the reporting methods and financial practices of an agency before you sign with them. In most cases where irregularities on the part of an agency have come to light, member photographers could have seen the problem emerging.

How is that accomplished? With difficulty. The agency-photographer relationship is based on trust — on the belief that you are dealing with honorable people. Having made that assumption, some photographers are hesitant to question their agency on financial matters. This reluctance may contribute to the depth of the abuses that have occurred and to an air of uneasiness felt by many photographers.

Here are a few techniques to assure that you have made every effort to safeguard yourself:

- Sales report: Check to see that it is specific and detailed enough to be able to track any usage.

- Find out if the agency maintains a

file of original invoices in numerical sequence. If a discrepancy should arise, this file could confirm whether or not a payment was made.

- Find out if the agency designates a photographer liaison person or committee. Some agencies select a different photographer member each year to act as the ombudsman for all member photographers. The agency will explain financial practices to the satisfaction of that person, who is then available to inform other member photographers. The result is one person doing the in-depth work, instead of 20 or 50. It is more practical, from both the agency's and the photographer's perspectives. This is not yet a common practice, but it is an excellent idea, which ought to go a long way toward reducing mistrust.

Photographers and many agencies are working together to eliminate areas of confusion that have sometimes contributed to abuses — some of which have resulted from antiquated reporting and accounting systems left over from the days of mom-and-pop photo agencies.

Stock agency abuses are like air disasters — they're terrible, but happen much less frequently than most people fear. I believe that in spite of some problems that have occurred, the majority of photo agencies are run by people of integrity and commitment.

PACA (The Picture Agency Council of America) has recently amended its bylaws to include a grievance procedure. If your agency is a member of PACA this could be an avenue through which to address concerns.

You and your agency are better off if you have asked the hard questions satisfying yourself that accounting systems and procedures that protect you are in place. Then all of your energy and commitment can be put toward working together to sell photographs.

Plan for the Long Term

When your decision is made to go with a specific agency, commit yourself wholeheartedly. Contribute photographs regularly, listen to agency advice, and shoot what you do best within their requests. It will take at least two years, possibly three, to have a clear view of how well you and the agency are doing with your work.

One of the most serious errors a photographer can make is summed up in this statement made by one who decided to sit on the fence: "I'll just give them a few hundred pictures and see how well they do before I give them more." It doesn't work that way. If your commitment is half-baked your sales report will reflect that.

Stock is a game of numbers. The more pictures you have on file (well-edited by an agency that knows its market) the greater your chances for sales. When I contribute a significant amount of new work to my agency, I can virtually chart the increased income about 15 months later.

A fruitful agency relationship frees the photographer from much of the clerical burden involved in selling pictures, increases his or her income from stock, and, just as important, creates a partnership in which professional colleagues share in the excitement and rewards of producing and marketing excellent photographic work.

Negotiating Prices

Negotiating the price of a stock photograph is one of the most delicate and important tasks you face as a stock photographer. It may be as important as taking good photographs, in terms of succeeding at this business. Frankly, most photographers are not very good at negotiating, nor do they enjoy it. This unpleasant chore may account for some of the attraction of photo agencies — they handle the pricing.

An agency shields you from the buyer, avoiding uncomfortable or confusing confrontations about money. The agency takes the brunt of any withering remarks, such as, "You're going to charge what? We never pay anything near that amount!"

Getting off the hook on pricing is a good reason to work through an agency. But if that's not an option — if you want to run your own business or you feel you're not ready to go with an agency — you will have to face up to pricing. All is not lost.

Negotiating Attitudes

There is such a thing as a natural negotiator. Like sprinters they are born, not made. To them, negotiating is an exciting challenge. For the rest of us it takes time and training to learn the art. But with practice and the right techniques, anyone can become an effective negotiator — the goal is to become the best you can be.

Most photographers dislike negotiating. When it comes to selling our own work we are often our own worst enemies. Why? Attitudes about ourselves and our work are part of it.

Do you hold the following misconceptions about negotiating a fair price for your photographs:

- that you will be perceived as tough, pushy, arrogant, nervy, unseemly, materialistic, greedy?

- that you may lose this or future sales by appearing demanding?

- that if you lose this sale the buyer will never call you again?

- that it's beneath the dignity of a creative person to talk money?

Fear is the underlying problem here — fear of what the buyer will think of you, what you will think about yourself, and what the buyer will do. Have courage. If you're handling your business properly, it will not founder on the loss of one stock sale. (After all, no one will repossess the refrigerator because of one stock sale lost.)

A handful of brash and unpleasant photographers have made negotiating a dirty word. But equal damage to the climate for negotiating has been done by the scores of pushover photographers who have misled buyers into believing they can dictate stock photo prices, sometimes to a level below what it costs to produce a photo. Now you may think, or a buyer might sputter, "But that's all we can afford on our budget."

Try telling that to a TV salesman when you don't want to pay the ticket price. They'll likely tell you, very pleasantly, sorry, that's what it costs, come back when you can afford it.

I would like to put an end to the notion that it is reasonable or necessary to accept whatever you are offered — especially a bottom-of-the-barrel low price — for the use of a stock photograph. What I am saying is true for a beginner in the field just as much as it is for an established pro.

You do not have to tiptoe. You do not have to take what you get. You can state your price. You may choose to charge what the buyer has quoted. It may be a reasonable price. But you don't have to take it.

One danger in accepting any price just in order to break in is the difficulty you'll encounter in changing the buyer's perception later on about your value. How are you going to convince the buyer who got your photo for peanuts last year that it's worth more now? It's the same photo could be the same usage for the same buyer.

Assess each situation on an individual basis. Everyone recognizes that there is a difference between the price an advertiser can pay for a photograph that will sell a product and what a small literary magazine with a circulation of 1500 copies can pay. A beginner may choose to charge somewhat less for the experience and tear sheets that go with being published but not because they must accept the lesser terms. The concepts in which you think on the subject are important as a clue to how you view your power and rights in a negotiation: you *charge*, you

don't *accept*. You can *give* a lower price but you don't *take* a lower price. Look at the sample negotiating conversations later in this chapter — see how this can be handled in a subtle, diplomatic way.

As you'll see later, you must have an excellent reason for charging any lower-than-normal price, and that reason must be clearly expressed to the buyer, or you will be forever tagged as a cut-rate photographer.

But the myth persists that to arrive at a price a photographer must either be a doormat or a hostile, demanding negotiator. To assume that arrogance is a prerequisite for negotiating shows a complete misunderstanding of the negotiating process.

To negotiate means to try to come to an agreement. It doesn't mean to engage in an argument. One dictionary definition is "to try to reach an agreement or arrangement by discussion" and another, "to get over or through (an obstacle or difficulty) successfully." There isn't even a hint of belligerence in either definition. Negotiation is an honorable and civilized method of working things out.

How has the idea of negotiating become tainted? The culprits were those few photographers who were overly aggressive, the many whose timidity made that view acceptable, and those buyers who convinced us that we would not be able to sell our work if we dared to question what they offered.

What is rarely reported are the many successful, amicable negotiations that occur every day in the photography business. These transactions are what the stock photographer should emulate. Before we try to learn the techniques that made those transactions possible, however, a bit of behavior modification is necessary. It's a process of, as the chain-gang boss in "Cool Hand Luke" puts it, "getting your minds right."

To achieve a successful attitude about pricing, you need to convince yourself that:

- it is possible to explain, with dignity and courtesy, why you must charge a certain price.

- charging a fair price for your work is a way of showing respect for your photography.

- it is fair and reasonable to charge enough to earn a living.

- it is possible to turn a buyer down courteously, and have them call you again.

- buyers will respect the photographer who values his or her work.

- it is not reasonable for a buyer to expect to use photographs for whatever price they have decided to pay, no matter how low.

- you are not personally responsible for the survival of the client's project.

- perhaps a buyer shouldn't ask to use photographs if they cannot afford to pay a reasonable fee.

- a beginner's photograph isn't reproduced unless it has value to the user and that value is worth a fair price.

- dignity and self-confidence are not incompatible with creativity.

- a love of photography doesn't require us to subsidize everyone who asks.

I am taking a strong stand about this subject because I believe fervently that most photographers do themselves in — needlessly. With my clients I am exceedingly pleasant and accommodating. I will hold firm when they can't meet my bottom price — but in a cordial manner.

Why? Because it's a better negotiating tactic. But an even more important reason is that this is my world, these are my clients,

the people I talk to; this is how I spend many days — dealing with these people. Some have become friends. Why not make that time enjoyable. Being quarrelsome won't add any joy to the day or sell any more photographs.

Negotiating Tactics

Becoming a good negotiator takes practice, a knowledge of the business (so you can educate clients), and faith in yourself. Ignorance of the market and a lack of courage (guts, gumption) is what holds back most photographers.

The goal and measure of a successful negotiation is clarity, a fair price, and a return client. You need clarity so that you avoid the confusion and misunderstanding that breeds conflict, a fair price so you can stay in business, and a return client because that's how you continue to prosper. The ideal is that both you and your client are happy with the outcome of a negotiation.

You may say, "What's to negotiate? The buyer has a price and a budget in mind — that's what they'll pay — and I can simply take it or leave it." Wrong. Every time you discuss price it is a negotiation. The only question is whether it is successful for you.

There are four basic steps that take place in every negotiation, whether handled in 10 minutes or over a period of days, and they are crucial to the process:

Negotiating steps:

- Establishing rapport
- Gathering information
- Quoting the price
- Closing the deal

Establishing rapport is the first step in any contact with a photo buyer. Start with a friendly, welcoming tone. Find some common ground — the weather, the holidays, events in their area of the country. Next, express your interest in their project. You may think it's obvious that you are pleased they called. Not so. Say it. Make clear that you want to

know more about their company, their publication, and their particular request.

If you set the right tone they will relax, enjoy the exchange, and remember that it is a pleasure to work with you. Removing a little stress from their day will stand you in good stead.

Learn to read the mood of the client through voice inflection or body language. When a client is busy and not inclined to small talk, pick up the clue. Stay cordial, but respond in a quick, professional manner that is accommodating to their schedule. But don't let them rush you into a price quotation before you get the facts.

Gathering information is the next step and a critical one. Concentrate on usage? You must know where, how big, for how long, how many times, and for what purpose the picture will be used. Make clear that you can't quote without information. Explain that price depends on usage, size, and many other factors. It can depend on which of your photographs they are considering — one produced under normal conditions or one involving high model fees or travel expense. Go to your telephone order form (chapter 9) to make sure you've asked all the pertinent questions.

Quoting the price. Prices are sometimes discussed when the buyer is making the initial photo request. Other times, such a discussion occurs when they actually have your photographs in front of them, either under consideration or actually chosen for use — an ideal time because they are predisposed to your picture!

A buyer may call to ask your price range when they are updating their files or as the result of a promotional mailer you have sent. When this happens, I give a price range (a wide one) rather than a quotation, or I ask about their budget. I avoid getting locked into a hypothetical price because different photographs command different prices, based on very specific usage and on their differing production costs.

Quoting a price in the abstract takes away your flexibility in later negotiations. Don't worry that you are making it difficult for a client to use your work by not giving a firm price in advance. All the buyers I've worked with are confident of their ability to negotiate when they need a photograph. Also, once you have established a base of buyers, only send submissions to those buyers whom you consider to have a satisfactory price range. Weed out those who are too low or too much trouble.

Set a bottom price. It may be tempting to make a deal at all costs. However, saying "No, thank you" and walking away with your bottom price intact is one form of successful negotiation.

Talking price can be simple and straightforward. Sometimes a buyer will state the normal fee they pay for a usage and it will be well within your own and industry standards — done, finished. Or you may receive a billing request letter or purchase order stating their price. Again, if it is reasonable, the transaction becomes merely paperwork.

At other times it is less clear and you may have to take the initiative. If, after discussing the photo request, the buyer doesn't mention money, you should open the subject with "Let's talk for a moment about the reproduction fees." That will usually bring you to one of the two most common approaches to price— the buyer asks, "What do you charge?" or the buyer says, "This is what we pay." Some photographers state a price at this point — a foolish move. The buyer will occasionally have a higher budget than you anticipated, so you may have given away an extra 20 percent by jumping in. It does no harm and may do you much good to wait for more information about the buyer's budget or until you can research an area of pricing in which you may be inexperienced.

You don't need to rush a price quotation. Are you obliged to give an immediate answer on a price? Not at all! And don't fall for the old line "Just give me a ball park figure." That ball park could become your prison.

If you need time to think, get off the phone. Tell them you'll get back to them. Give it ten minutes while you think, or call a photographer friend. Use any ploy you must to get breathing room. If you can't think of anything else, there's always the old industry standby: "I'm in a meeting — let me get right back to you." Or the other common stalling technique: "I have another call; there's a messenger at the door."

But first, find out how long you can take to get back to them without jeopardizing a sale. Listen to the client's signals. If your comment, "I'll call you before the end of the day," provokes hesitation in the buyer's voice, counter with, "Look, let me see if I can cut this meeting short. Maybe I can have something for you in a few minutes." (Later we'll cover where to go for specific prices.)

If you don't have a clue about what a specific price should be, it's not necessary to broadcast that fact. Be a poker player. See what you can learn about their budget before you commit yourself. Draw them out. Don't ask what they can pay. That puts you in a yes or no situation (and by all means, avoid the great cardinal sin of asking the client what they *want* to pay. That figure is almost always lower than what they are actually able and willing to pay).

Without asking it directly, find out what they have budgeted before you answer the question "What do you charge?" Float a trial balloon. Quote a price range. (If they gasp, you've learned something useful.) You should quote a wide range so that their price is likely to fall somewhere within it. Also, you need room to maneuver. They may even blurt out their budget at that point. If they hedge, you can ask them to give a price range. Here's how I might answer the buyer's question: "What do you charge?"

Photographer: "Well, I have a range of fees depending on a lot of factors, including usage, which picture we're talking about, and so forth. In my experience, a fee for your use can range from $200 to $750, depending on the size you need, the intended circulation, and the number of pictures you are using from our file," (Note: you don't have to say "I've" charged $200 - $750. Your experience can be what you know of industry standards.)

Buyer: "We never pay more than $150." Now it's time for the good cop/bad cop technique. There are always four people in any negotiation: the buyer and his or her boss (the authority who approves the money) and the photographer and his or her boss. If you have a partner (or an accountant or a financial manager) you can use this technique.

You become the good cop: "I wish I could give it to you for that fee, but I may have to check with my partner — we've agreed on a rate schedule. Let me see what I can do."

Get off the phone. Make your decision, and call back with an answer. If you can't live with their budget, blame it on the bad cop — your partner, your business manager. If you do choose to work within their limits, take credit for it. Always give a reason and if you lower your price make sure you get something in return. Don't leave the impression that take-it-or-leave-it intimidation worked.

If you are a one-person operation, remember there are always two parts of you at work: the photographer half, who wants to see the work published, and the business manager half, who must make sure that your economic interests are protected. Make that clear to the caller. State a reason for holding your price or lowering it. See the sample approaches later in this chapter.

Try to educate the client (or show that you are educated about industry practices), as a basis for discussing your price. Until you get right down to a decision, keep the discussion open and fluid. Imply to the caller that there is always a possibility for agreement.

Closing the deal is an aspect that some photographers ignore. Once you have negotiated your way through the delicate matter of arriving at a price, make sure it is clearly understood by both parties. Ask the buyer if they will be sending a purchase order. If it

has been a complex negotiation, send your own follow-up memo confirming the prices quoted and extras, such as additional tear sheets, that were part of the agreement. (Note that the exact license of usage rights must be spelled out in your invoice.)

Negotiating Conversations

Having read and thoughtfully considered these principles of negotiation, you must now *believe.* Believe that you have the right and the ability to negotiate a fair price. Once you are a believer it's simply a matter of adapting negotiating methods and expressing them in your own style. There are many rhetorical devices that can be used in a negotiating conversation as you'll see below.

In picking your approach to negotiating, no matter what words you choose, remember to communicate the following:

- You want to help them, to work it out, to conclude a deal.

- You understand their problems.

- You hope they understand your situation.

- You are disappointed when you can't reach agreement.

- You hope that there will be another opportunity to help them out.

Your entire tone is accommodating. Firmness, polite firmness, must be shown when you have reached your bottom price. Regardless of how you really feel about the negotiation (and though you may be tempted to tell the caller to take a walk), you must project an earnest desire to solve their problem. In fact, you do want to conclude a deal, and you are disappointed when you can't answer their needs. Not only is an accommodating attitude smart negotiation but it usually has the additional merit of being true.

Here are some phrases from hypothetical negotiations. Find the ones that are comfortable for you, that adapt well to your situation, then translate them into your own language.

Deserving of special mention is one phrase that I use regularly. It is:

"As I'm sure you understand..."

It's especially useful when I'm sure they *don't* understand at all.

This phrase helps the inexperienced buyer to save face. You are attributing to them an education or awareness they may not have. But it prepares them to hear your information in a neutral environment.

The opposite tack: "Look, what you don't understand is..." can be dangerous. Nobody likes being lectured. At this point the buyer is almost required to respond defensively, perhaps with a counter-attack about what you don't understand " that "photographers are a dime a dozen and I can get this picture anywhere at my price." The negotiation is now almost irreparable. You can say: "So fine, get one of them." You will lose the sale and the client. Or you can back-peddle and take their price. Neither is satisfactory.

The "I'm sure you understand" phrase covers many bases. When the buyer really does understand the business, it serves as a gentle segue into the point you want to reinforce. In this instance you'll adjust the phrase and your inflection: "Look, Joe, I know you understand the situation as well as I do... But this type of photograph is... if I go much lower (note that the word *much* gives you a little room to maneuver), I won't be covering my costs. Let's see how..."

That brings us to the next most valuable phrase: "Let's see how we can work this out..." Often this is most effective when ended with a pause.

This phrase opens the door for adjustment on both sides. The buyer can enter the pause with an offer: "I could probably get them to go up to $xx but I'll have to check." Or you can pose some questions that are more suggestions than query.

"Let's see how we can make this work... (pause)... Are you planning to use more than one picture? Do you have other picture needs on this project? Are we speaking of any volume with these pictures? How about upcoming projects, do you know your needs in the next months?"

Once they pick up on one of those questions, your negotiation is still alive and you've steered clear of the take-it-or-leave-it waters.

Here are more variations from the photographer's perspective. Whenever possible refer to that vague entity "industry standards" or to some experience with a mystery client from the past. Give them some history:

"Well, in the past, I have sometimes given a small break when there was the possibility of extra tear sheets."

"What some other clients of mine have suggested is that they will pay my standard rates for the first ten photos. Above that we start discussing a small discount."

"If we had worked together before, it might be easier, but...Well, let me tell you how I've worked with some of my regular photo buyers. They pay my standard fee for most projects. Then when a special short print-run, lower-budget project comes along I am able to adjust for them. What other projects do you have coming up? Perhaps we can work out a guarantee of a certain number of pictures to be used between this and your next project."

What to say when they rush you:

"I'd like to give you a fast quote, but I have to trouble you for a bit more information — I want to be accurate about the rights you need. As you know, that affects the price."

Expressing concern over price:

"I'd like to be able to work with you on this but I have a little problem with your price."

"Well, that's a bit below my usual fee for this. I'd like to help you out and develop a relationship with you. Let's see...if you are able to use a volume of pictures, I might be able to..."

"I'm sorry, we just can't afford to go that low for usage of one photograph. I'm sure you'll understand — it's one of my expensive underwater shots. But if you decide to use several pictures, maybe we can give you a break on volume."

"As much as I'd like to help you out, I simply can't go much lower. It's because this particular picture is one of my xx collection — you know how expensive that can be — extra model fees, props..."

"Since it's going to be tough to come down much further, let's see what else we might work out."

"I'd like to help you out with this one — tell me the usage again — let's see if there's anything we can do..."

"I realize that you have a budget problem. I've got one too — I have to cover my costs on maintaining the file."

When you give a reason for adjusting your price:

"In this one case we're going to bend the rules a bit to help you out. The project sounds interesting and we'd like to work with you — but we'd need to have at least xx tear sheets. How do we arrange that?"

Educating them to the realities:

"I'm sure you're aware that the standard fee in the industry for this usage is $xxx and can be as high as $xxx. Now, understanding that you have a low budget I'll try to accommodate. I can go as low as $yyy — I'm not sure how much more I could do.

"As you know, most agencies will charge $xxx for this usage. And we have overhead and expenses to cover also."

When you have to enlighten them about your expenses:

"As I'm sure you know, costs for photographic materials have gone up xx% in recent years and photo prices have stayed relatively stagnant. I wish I could do more for you...."

"I'd really like to help you out, but one reason it's tough to go as low as you want is that I need to keep reinvesting in my stock. I hope that each time you come back to me, I'll have fresh new material for you. It's impossible for me to continue investing in new photography if I don't maintain a certain price level. I'm sure you understand."

"I certainly want to sell you rights to this picture. It doesn't do me any good sitting in the file... but, as I know you understand, the cost of assistants for labeling, captioning, file preparation, all of it, is getting higher and higher. I'm sure you've got the same problem with your staff...."

"You don't want to hear my business problems — and I wouldn't tire you with them if I could see my way clear to taking your price. As I'm sure you understand, my costs simply aren't covered in that price range. Let's see how we can resolve this."

(These approaches must avoid any hint of whining. References to your high costs must be unemotional and matter-of-fact, not bids for sympathy. One business person to another.)

When you have to say no:

"I'm afraid that is lower than I can afford to go. Thanks so much for calling. Sorry I couldn't help you out this time. Hope I'll be able to provide something for your next project. Do you have one of my updated stock lists? Let me send you one."

In order to get a feel for negotiating, some photographers role-play a buyer/seller situation with each other. It is a technique used by some agencies to train their new sales people. The buyer writes down a type of photographic usage, the top price the client's company is willing to pay and the low price that is their goal. The photographer writes down a bottom price and the highest price that seems even remotely possible for the usage.

They begin discussions. When an agreement is reached, the winner is the one who came closest to their goal price. It is a great technique for polishing the rough edges of negotiating.

Value of Photographs

Photographs have value to users only to the degree that they solve a visual problem for them — whether it's illustrating an article or advertising a product. The amount they will pay to reproduce a photograph depends on what they perceive as the value of that particular photo to their project.

The value of a photograph to you is much more complex. There are economic, aesthetic, and emotional components which sometimes cloud the pricing issue. Photographers may hesitate to charge enough for a photograph they especially like, not wanting to risk

having their price turned down. They may view a low price offer as a rejection of their photographic worth.

Take a cool-headed look at the value of your photographs. You can and should place greater value on some photographs than on others. Measure your photographs and price them based on their cost to you and their unique quality — not just on the client's intended use or ability to pay.

If you have a clear understanding of their value, you will be much more comfortable charging a price for your photographs that will keep you in business. The following are some more specific cost factors to consider when measuring the value of a particular picture to your file and calculating individual prices.

Expenses:

Normal costs:	shooting time, film, equipment, overhead
Extra costs:	model fees (non-pros) model fees (professionals) location fees props
Travel costs:	domestic, foreign, exotic (out-of-the way)
Extraordinary costs:	helicopters, plane, or balloon rentals, underwater fees
High risk:	extra insurance for shooting from air craft, bridges, high buildings, and rock climbing

Unique Quality:
 unable to be repeated

Uncommon:
 hard-to-find photographic topics

Freshness:
 new material, never-before published

I use these factors to decide how to price and mention them in discussions with clients when an explanation seems appropriate.

You can't expect that a client will always understand everything that goes into a good photograph. If you make it look effortless, they may not be ready to pay for the effort unless you make it clear.

You won't want to tell war stories to every client on every stock sale you negotiate. Just keep clear in your mind the cost, effort, and special vision that go into your photographs. An acute awareness of these factors will build your confidence when negotiating, and you'll be well prepared on occasions when it is appropriate to share the information with a client.

Premium pricing

Prompted by this understanding of the varying value of photographs, I devised a technique for myself that I call "premium pricing," to distinguish photographs of mine that are worth more than my typical rates.

It first occurred to me when I prepared a submission of several photographs on the same topic — a family group at dinner. I realized that the photographs themselves might look similar to the buyer, but I knew that considerable extra cost and effort had gone into one set — and it didn't feel right for them to be the same price. The set in question showed four generations of a Hispanic family — an especially handsome group that had required model releases, transportation for some models, meal costs, and a location fee. Further, the photographs were fresh, never-before-published material.

I decided to set them apart by stamping "premium price" on each slide mount in red and providing an explanation on the delivery memo that "premium" photographs carried an additional 25% above the standard reproduction fee for the usage.

Now, if the photographs have a similar look and the same value to the buyer why should they be willing to pay more? They might not. It can be their choice. They will be

alerted, forewarned. If they don't perceive any additional value to the premium photo they will choose another. But if they get the benefit of the freshness, extra costs, or effort in a premium photo, they will pay a fair price for it's use.

I went on to identify other types of photographs in my file that were difficult or expensive to get — ones I didn't feel right about letting go for the same price as all other photos. Photographs of various groups of American Indians have been a specialty of mine for a number of years. Photographs of Native Americans are difficult to get, require patience, travel time, and years of building up trust, to gain access to certain situations. These became premium photographs in my file. Other times a premium photo will be a brand new, never-before-published photograph. Depending on other elements, I may or may not remove it from "premium" status when it's no longer new. Freshness is only one measure. Some photographs have constant potential to increase in value through additional use. (Remember from chapter 8 the Atlanta photographer whose running photograph started in a magazine and progressed to a major ad campaign.)

Keeping the relative value of different photographs in mind while negotiating is a helpful and valid way to make your case for a fair price.

Finding Prices

This is all well and good but what should you charge? How does one know where to begin? What do other people charge?

Finally, what is a fair price? A fair price is one you are satisfied with, one that will cover costs and bring a profit. What I refer to as a standard price is a commonly quoted price for a particular usage — one that everybody is charging, photographers and agencies alike. Standard prices don't really exist except as a perception. All prices vary, but you can see similarities in ranges. These will emerge as you research past pricing trends in the industry. Following are some sources for pricing information:

- Published source material
- Your previous experience
- Professional associations
- Photographer colleagues
- Stock agencies

Publications. Reference material on pricing is available from several sources. One resource is the book *Pricing Photography* co-written by this author and David MacTavish, published by Allworth Press. In addition to comprehensive pricing charts, the book includes guidance on negotiating and calculating your business overhead. Available for the computer is *FotoQuote* a program to calculate prices. (see bibliography).

Another source of information is a book put out by Jim Pickerell, a photographer based in Washington, D.C., which contains his pricing list for many categories of usage. His "Negotiating Stock Photo Prices" is available through Pickerell Marketing, 110A Frederick Avenue, Rockville, MD 20850.

Your previous experience. In the process of selling stock you will have learned about pricing in some categories. Compile your own experience in a reference chart. Then add what you have learned from source books and combine this information to create your own price category chart.

For convenience, I suggest you use the comprehensive blank pricing forms designed by ASMP for members' use in building just this sort of price list. Space is provided for hundreds of categories in the major markets of Advertising, Corporate/Industrial, Editorial (books, magazines, and newspapers), as well as for greeting cards, puzzles, murals, and so forth. The spaces are designed to accommodate pricing by size, circulation, insertions, time limits. They include variations regarding cover, title page, re-use, and

translation rights. This excellent group of forms can save you a great deal of time in devising your own system for cataloging your prices. Just fill in the blanks as your sales experience increases. The forms are included with the purchase of the current *ASMP Stock Photography Handbook,* 2nd edition (blue cover) available from ASMP, 419 Park Avenue South, New York, New York 10016. A computer disk version is available for a separate charge. (Also of significant value in this edition is an economic study commissioned by ASMP and conducted by the Wharton Center for Applied Research. It is a comparative study of the rise in the Consumer Price Index, business costs, and the fees of editorial photographers from 1969 to 1987.)

Date your price chart. Revise it annually. At tax time each year, survey your invoices. Have your prices in each usage changed from previous years. Total the number of sales and divide your total stock income. What is the amount of your average sale? Do your prices reflect changes in the marketplace? Do they cover increased costs in your business, and increases in the cost of living? Are your prices falling behind? If so, your business may do the same.

Once you have created a price chart, throw it away. That's the advice of some stock agents. Sophisticated stock negotiators, such as those at major agencies, don't use any stock price list once they are versed in the price ranges within various categories. They negotiate each reproduction fee individually based on usage and on the importance of a project to a client. This is your long-range goal. Once you have enough experience with pricing, set aside the price list. It's a crutch.

Meanwhile, use your price list as a frame of reference, making sure to keep it flexible. If you only charge "by the list" you may be limiting yourself.

Professional associations. Access to industry information is one more excellent reason to belong to ASMP or a similar professional organization. As mentioned above, past publications of ASMP included the results of member pricing surveys. Membership in the organization will provide access to any future surveys on pricing, economic trends, industry information that the association conducts. No individual can research information to this depth by themselves. Membership in a professional organization is as important a tool as your camera.

Photographer colleagues are another possibility. Most photographers are generous. They share information on sources, supplies, techniques, and even pricing — if approached in the right way. A blunt question: "What do you charge for a brochure cover?" may make another photographer bristle, or at least hedge. "Well, it depends..." may well be the response, as it would be if a buyer asked you the same question. You'll get a lot farther if you try this approach: "I've got to quote for a usage I'm not familiar with — do you know the range most photographers use for...? Then follow with any details you have: " The circulation is xxx for in-company distribution. They'll be using the same picture on the cover plus a re-use inside at half-page. Do you know what's considered standard for that?" This gives your colleague a chance to tell you what they'd do under the guise of "standard." The answer might be: " From what I hear, most people treat that as a re-use and charge 75% ...but if it's a good client you might knock a little off."

This way your colleague can help you without putting his pricing out on the street — perhaps to have his pricing misquoted or used out-of-context. If you are not in touch with many photographers, I repeat my conviction in the value of professional organizations as a network. ASMP has 33 chapters including Alaska and Hawaii. Odds are you can find one nearby.

Stock agencies. It is unreasonable to expect a stock agency to be a price-answering bureau. They are obliged to sell photos for their member photographers. But certain agents

have mentioned their willingness to give (very occasional) guidance on pricing to individual photographers — if it doesn't get out of hand. You may meet stock agents at stock seminars at the various photographic conferences or workshops you attend. If you, or a colleague, have a relationship with an agency, it may be able to help on a complicated quote. Consider this a last ditch resource.

Once you have the basic information needed to negotiate and price your work from a position of strength, there are a few remaining concerns to handle, some points of view you may encounter, and some myths held by clients that need to be dispelled. Here are a few:

Myth # 1 — An individual photographer should charge lower rates than a stock agency.

The reasoning from a client goes like this: "If you sell through an agency you'll only get 50 percent so why are you charging me full price?" This argument doesn't wash. First, because the client is paying what the photograph is worth to them, for the usage in the specific publication or ad, at a specific circulation, page size, and so forth. It has an established value to the buyer's project regardless of its source — your files or an agency's.

Next, questioning your right to the additional 50 percent on the basis that your overhead may be lower is presumptuous and erroneous. When you provide photographs directly to a client you are bearing all the costs of captioning, labeling, filing, logging-in and out, remounting, and billing — just as an agency would. There is time involved — yours or an assistant's — as well as equipment. Though you may not be located in New York's photo district or on Wilshire Boulevard in Los Angeles, your overhead must be covered.

Why should a buyer consider it acceptable for a photo agency to recoup these costs and not an individual photographer? It doesn't make sense. It may be that photog-

raphers are accepting the buyer's point of view. Perhaps it is merely a client-negotiating technique to save their company some money. If you believe their argument, it's working. Keep in mind that you are running a stock business — and explain that to clients.

Myth # 2 — Bartering makes sense if I gain access to a good location for stock shooting.

This is the sharpest of double-edged swords. In the long run you may be taking a deep cut in your stock sales. Some photographers trade a portion of a shoot, turning over a certain number of actual transparencies, including all usage rights to those images, to a company that has provided the opportunity for photographing on their premises. This is a dangerous practice. You are sending the wrong message about your photography and its value when you trade off all rights to any photograph.

As we discussed in chapter 6, you can use complimentary prints, limited reproduction rights, and other means as a fair exchange with the administrators at an institution or location — without giving away all rights to some of the work for the privilege of shooting at their facility.

Be wary of turning over a segment of the shoot for nothing more than access to a location, or you could end up competing against yourself someday. Imagine that you did some barter photography in order to get permission to shoot stock photographs at the facility of a friendly small company in your city. Later that plant merges with the Octopus Corporation and your "freebee" photographs are swallowed up by the vast corporate photo file, for use without payment by every subsidiary of the corporation, to be given away free to outside photo buyers for public relations purposes, or even to be sold through a photo agency! And you don't receive a penny's share of those reproduction fees. The Copyright Act of 1976 gave photographers ownership of their work. But the law can't protect you from giving it away foolishly.

Myth # 3 — A beginner has to take what he or she can get and give away their work in order to be published.

Before answering that premise ask yourself if you are a professional and want to act like one? Remember that the minute you sell a photograph you are in the profession — even if it's not full-time. What you owe to the profession you are entering is respect for your own photographic work. One way of showing that respect is to require it from editors and art directors.

Should you make more concessions on fees than an established pro? Of course, that's the nature of breaking in. But do your price adjustment with a professional's cool appraisal, understanding that this is the reality of starting out. Avoid being apologetic, or gushing with gratitude, attitudes that characterize many beginners. A few years down the road it will be difficult to erase that image from a photo buyer's mind. Once a soft touch, always a soft touch.

A final thought before embarking on the negotiating trail: there are many photographers who are respected and appreciated by photo buyers as both successful negotiators and nice people. You can be one of them.

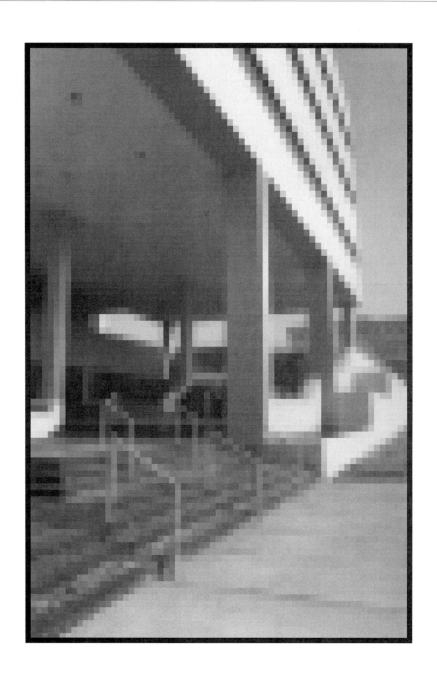

Computers and the Digital World

Sending a message faster is what digital technology is about. Primarily, digital is a delivery system — the computer delivers the message. In photography you, the photographer, still create the message, the means and speed of transfer are all that have changed.

In his fascinating book *Being Digital,* Nicholas Negroponte writes: "Computing is not about computers any more. It is about living," also "Digital is the instantaneous and inexpensive transfer of electronic data that moves at the speed of light. The information superhighway is about weightless bits traveling at the speed of light."

The photograph is your message. Digital technology is merely another way to deliver that visual message — one that you can alter, manipulate, improve on the way. The only limit is your imagination.

Your computer system can organize the bits of data that must be handled, it can access an incredible array of information on the Internet with the astonishing speed that's now available. Without it's help you can plod along the old, slow, haphazard way. One way or another, if you're in this business to stay, you must manage information, and visual messages must be created and delivered.

Your choice is simply what one of what means to use, traditional or digital. Digital technology opens an exciting world and one that is changing as fast as we speak. Ride the wave, it's thrilling, and once you get wet, much less daunting than you assumed.

What You Need

Most of you have at least a basic computer system (or your kids do) in the household, but is it up to the task of running a photo business?

If you are a digital person, fluent in techno-jargon and using cutting edge software and equipment, then you can skip this chapter. Otherwise it's time to evaluate the computer and software you are currently using and take a good look at the additional capabilities which are out there. It may be time to jettison the old equipment, prices are down and capabilities are up. It all depends on what you choose to have your computer do.

Uses of Your Computer System

For stock photographers the most common areas of use for the computer are:
- Running the business
- Network communication
- CD-ROM
- Digital imaging (photo manipulation)

The big dividing line is imaging. Decide if you want to use your computer only to run the business side of your stock photography (including access to the Internet, CD-ROM products, and the like), or if you also want the capacity to do digital imaging. This will guide your subsequent research and a series of decisions.

How do you know if you want to get into imaging? Try it. Try it, just to see if you like it. Take a course in imaging — they are offered at many colleges, photography, and art schools across the country. An experiment with digital imaging is the easiest way to determine if it's for you. More on imaging below.

Running Your Business

In today's world, it's hard to imagine handling the details of a stock business without at least a basic computer system (see box). If you aren't yet computerized, consider that if you use it for nothing more than handling paperwork connected with the stock business, that a computer will pay for itself in a few months due to the time and tedium it eliminates and the accuracy it contributes. Most photographers use computer generated delivery memos (with terms and conditions on the back). Office procedures and information for your assistant and photo coordinator can be updated regularly and easily.

Labeling

To market stock in today's competitive arena, neat, legible captions are critical to sales. Slide mounts with handscrawled information look unprofessional to the new breed of photo buyer.

Preparing stock photos for your file or for your agency is simplified enormously by the use of computer caption and labeling systems. Say you've come back from a complicated shoot at a textile industry research lab with detailed caption information. With computer captioning you can easily change one or two lines without having to type the same information repeatedly. Some programs offer the capability of five lines on a label 7/16 of an inch wide. The samples in this chapter are prepared for labels that wrap around the 35mm slide mount. Information on the left appears on the front of the slide. Many of the available computer programs advance the file numbers automatically. Imagine the ease of handling detailed travel captions.

Some photographers keep a laptop computer next to the light table, writing captions as they edit. An assistant can then print up the labels, stick them onto the slides, and file them straightaway. The beauty here is that you are contributing the brainwork — your memory of the shoot, the information that only you can provide — and delegating the part that is easily turned over to others. The photographer can make filing category decisions at this point as well.

A model release at hand is money in the bank. Keeping your model release information in the computer allows you to place it easily on the slide mount when preparing photos for your agency.

Using a computer for subject category listings and cross referencing of your photo files is an area that has stirred debate. There is some question about the usefulness of entering your entire stock inventory photograph by photograph, into a computer program. Certainly there is abundant software to handle this type of filing and searching. But is the ease of retrieval significantly greater than by doing it from your visual memory and a basic category listing? (Though an assistant or your heirs might find it valuable.) Is there enough improvement to warrant the investment of time it will take to enter all that information into the computer?

Other photographers — especially those who intend to market through CD-ROM — see great value in a stock photo filing system that allows you to choose five to fifty

cross-reference keyword "qualifiers." Some programs have the function of assigning a file number to an individual photograph each time you write a caption, so that the picture is automatically in the system and becomes part of the file. You can choose the photo's cross-reference words then, or add to them later. This is a great system because you build the stock inventory file without having to devote separate time to it.

Accounting and billing systems (as well as estimating, for those who shoot assignments) are available to handle almost any degree of photography business management, from the most rudimentary to the most sophisticated needs. You can see the range of business applications in the software listings elsewhere in this chapter.

Network Communication

Consider the value of information to your business and your family. There's no reason to be stuck on a gravel side-road when the information superhighway is so easily accessible.

In order to stay current, most photographers are "online" with one or more of the electronic networks. With a modem to connect your computer to the telephone line, and a fee for your online time and telephone charges, you have access to an astounding array of information and services. Just a few are: electronic mail (e-mail), chat rooms, interest groups, encyclopedia, travel, and so very much more. The information you can find on the Internet is invaluable when used for researching the trends needed to plan your stock shoots.

Look into the networks such as Compuserve, Prodigy, and America Online among others. Also investigate the World Wide Web, perhaps the fastest growing area in cyberspace. Check with friends or research in computer magazines for the network to fit your style. Networks have varying fee structures and terms for their services, but they all offer instantaneous communication and immediate access to an overwhelming variety of information.

Digital Imaging

For photographers, the most exciting development of the decade is the ability to manipulate images in the computer, an ability fast becoming commonplace. Digital imaging requires a significant investment in equipment and in the time to become proficient. Even if you eventually decide not to make the commitment needed to develop expertise in the field, every stock photographer, every single one, should take at least one basic course in imaging.

As we said earlier. Try before you buy. It's the only way to know. For some, imaging opens a door to creative outlets they never dreamed were possible in an explosion of possibilities. Many find the happiest combination is to keep shooting in the real world with a final image in mind that can only result from merging in the digital world. Others acknowledge the obvious fascination but find the hours spent in front of the computer tedious in contrast with the delight of being out in the light and air creating new photos. Until you are sure which person you are, agonizing over equipment is wasted energy.

Another great value to taking an imaging course is that you can understand and be articulate about imaging with a client or your stock agent — essential in the current tough climate of stock. Your stock agent may be using a digital delivery system, or may suggest digital retouching changes to one of your images. The concepts and language of imaging is part of the lexicon of publishers, graphic designers, and the pre-press production departments of printing companies. Without an understanding of the digital world you will be living in isolation.

Stock Uses for Digital Imaging

Retouching is a major use of digital imaging for stock. It's easy to remove a blemish that

makes stock less saleable — blemishes such as ads or logos, unsightly wires, trash on a sidewalk. Another common use of digital retouching is to add background to enhance the shape of a photo. The ability to add (clone) more sky on the top or grass in the foreground might save a sale.

But, the most exciting aspect of imaging is the ability to create new, unimagined photos. Merge several photos, distort them, alter color, change perspective. Make a real-looking scene more perfect than you could shoot it. Or an create an impossible universe from your imagination.

Basics of Digital Imaging

Here, in brief, are five stages in the process of digital imaging:

- The idea
- Image capture — on conventional film (your photo)
- Image capture — digital scan (of your photo)
- Manipulate
- Output

The idea. As with traditional photography you start with your imagination. A photograph can come from your response to a beautiful scene or from a complex concept you have intellectually visualized.

One aspect of *image capture* is the translation of an idea into a tangible form on film — taking the picture. In computer terms, the next step of image capture is turning the continuous tone photographic image into digital form, usually done by scanning. A scanner offers the ability to convert a film image into a digital image. Scanners do this by converting the continuous tone film into pixels (picture elements) which are little square dots. Photos can be scanned to offer varying levels of quality or resolution based on the number of DPI (dots per inch). Often a low-resolution (low-res) scan is made to be used for positioning in a layout or as a work print, then a high-resolution (hi-res) scan is made for reproduction purposes.

Manipulation. Once the image is scanned and the digital files for that photograph are in the computer's memory, it's time to work on it. Manipulation or image management is the most thrilling and sometimes frustrating part of the process. And it also requires a lot of memory in the computer (be alert to that when planning equipment).

Output. When you have finished the image manipulation what you have in the computer is a *latent image* much like exposed but unprocessed film. To bring it to life outside the computer is called "output." You can output in many ways: as a black-and-white digital proof on a laser printer, a low-res color laser print, a hi-res continuous tone photo quality print, or with another step, also as a transparency.

CD-ROM. A photo CD is another way of bringing a continuous tone photographic image into the digital world. Currently it is being used by some stock houses and photographers as a marketing tool — delivering images on approval to clients. The debate about security — can the images be made safe from piracy — continues. CD-ROMs may not be here for the long term, but now some photographers are using it for archiving and portfolio purposes as well. For information on the Kodak Photo CD system contact your Kodak rep for *The Kodak Guide To Imaging.* See page 10 for a discussion of clip art CD's.

Using a Consultant

A computer consultant who is knowledgeable in photography is an invaluable aid in selecting and setting up your system. That is unless you love poring over software manuals and learning about computers instead of spending your time taking photographs. You may find, as I did, that the fee you pay a consultant can save weeks of work

COMPUTERS AND THE DIGITAL WORLD

(and frustration) trying to do what you aren't good at and don't enjoy. Consider the investment in a consultant's time as part of the cost of the system. Budget the money with your purchase price for equipment and software.

A consultant will inform you on software and equipment purchasing and guide you through discussions of chips, motherboards, bus architecture, expansion ability, hard drive, RAM needed, types of monitors and keyboards, and much more. Your task is to analyze your needs first, so a consultant knows how to guide you.

You could rely on a helpful friend or colleague, preferably a photographer. But you may be loathe to use as much of his or her time as you really need unless you are paying a fee.

What Do You Need

Unless you are enthralled by the research, now is the moment you need your consultant to guide you. You must specify what you want to accomplish with your computer — imaging or business use only.

Investigating software is usually the first step, if you don't own a computer now, or if your are thinking of changing systems.

Choosing Software

A number of programs related to photography and stock management are listed in this chapter. The descriptions are written by the companies. This is not a complete list. The listing of a program is not to be considered an endorsement, nor the omission of any program a reflection on the quality of the program. New programs come out regularly, others are updated. This is a starting point.

If the key to success is the right program what happens if you choose wrong? Ask software vendors about their return policies in case you and a program aren't a happy combination. Some will allow you a time period to evaluate if they haven't provided a demo

disk in the first place.

Remember that the program is intellectual property protected under copyright. If you return a program that isn't right for you, it is unethical and illegal to retain a copy for use without payment. That's piracy. And it's just as offensive as when a client reuses your photograph without payment. The software creator's rights must be respected just as your rights in your photograph are zealously defended.

For your success with a program, the quality (or cost) of the support you get from the software company is critical. When evaluating the program, check on the type and amount of help you can receive without payment from their tech support system.

Choosing a System

Despite partisans on each side, there is no final answer to the great debate over which platform to choose, PC or Mac; or if any real distinction exists between platforms any more; or whether you first choose the software that suits and select the appropriate equipment afterwards.

It seems as if each month a new microprocessor chip is announced, faster than the last. The one sure thing is that anything written here about systems will be out of date when you read it.

But more than ever before, you can't really go wrong as all systems have excellent capabilities to offer.

In the deep, dark past a few years ago, your basic choice was between a PC DOS system made by IBM, plus their clones (using a pentium chip made by Intel) or a Macintosh system made by Apple (with a chip by Motorola), no clones available. That changed when a consortium including Apple, IBM, and Motorola created the Power PC.

The Power PC used a breakthrough chip which was designed to bring together all the advantages of both systems with incredible speed. And some argue that it did just that and is still the only row to hoe. Others com-

plained that available software wasn't fast enough to keep up to the speed of the chip. In the blink of an eye a new generation of software emerged solving the problem by providing native code power versions of the software.

In terms of the pocketbook, and in a break for the consumer, Apple clones were authorized and came onto the market, running 10-15 percent cheaper than the original Mac.

To many experts observing the "chip" wars, the competitors are neck in neck, month by month, one leapfrogging ahead of the other. Keep in mind, it's axiomatic that, no matter what computer you buy today, there will always be a faster one tomorrow.

The match to watch is between the Power PC (PowerMac) chip and the Intel Pentium chip. When you know exactly what capabilities you need and are ready to buy, do your final research with the help of your consultant who's likely to be following the scene closely.

Resources

If however you are enthralled by doing your own research on equipment there is a full array of computer magazines on the stands. *Wired* magazine gives perspective on the life in cyberspace.

There are consultants in every area of the country. One especially helpful person is David Claunch of Claunch Consulting, based in Austin, Texas (512) 472-4314, FAX (512) 472-4457. He works most often with clients in Texas, but fee arrangements can be made for telephone consulting. Photographer and software developer, Jim Cook of Denver (303) 791-3370 always gives much appreciated advice. His photography programs *Hindsight* and *Insight* are listed in this chapter.

Expectations

Computers, especially those used for digital imaging, aren't like a Hassleblad camera, they won't last forever. They become outdated quickly and need to be replaced as newer faster versions are developed. Computer systems used solely for running the

business have a longer lifetime.

Beyond the equipment are the capabilities. What you can do with what you get. This is the joyful aspect of the digital world. For a stock photographer, being digital is essential, it opens the doors to tomorrow's stock.

What the Computer Can Do for Your Stock Business

❏ Basic office paperwork:
 Stock photo delivery memos
 Invoices for
 reproduction fees
 research fees
 holding fees
 Permission request letters to location
 sources
 Follow-up letters: thank you letters
 to models, thank you letters, or
 location permission
 Office procedures lists
 List of photo coordinator's duties
 General correspondence

❏ Photo files:
 Stock photos:
 caption labels
 identification labels
 Photo files: subject listing,
 cross reference
 Bar code (for logging out photos)

❏ Files of:
 model names and addresses
 location names and addresses
 prop and equipment sources
 assistants' names and addresses
 client names and addresses

❏ Digital imaging: retouching, creating images

❏ Promotion:
 Client mailing list
 Potential clients
 Stock photo category listings
 Promotion mailings

❏ Accounting-business management

❏ Files of insurance policies,
 tax information etc.

❏ Connect with electronic networks

LISTING OF SOFTWARE

Silent Partner

Business

Windows & Macintosh

Silent Partner is an integrated accounting package designed for commercial photographers. Includes full breadth of bookkeeping — A/P, G/L, A/R, etc. as well as client estimating, billing, contact management, prior year comparisons, ad hoc writing. Silent Partner contains over 100 reports reflecting all aspects of your business. The system is feature rich and includes many options that can be targeted to your specific needs.

The Medi Group Ltd.
180 Black Rock Rd., Oaks, PA 19456

Phone: (610) 666-1955
Fax: (610) 666-5911

THE BOSS

Business & Stock

DOS

An integrated single- or multi-user database for A to Z studio management. Features client/prospect/vendor tracking. APA/ASMP-style estimates/invoices, complete accounting (checking, A/P, A/R, G/L), time management, list/label production, equipment inventory, and 84 built-in reports. Integrated stock cataloging/captioning, delivery memo, and sales/cost analysis modules also available. Designed or maximum speed and minimum disk usage. Runs on DOS-based IBM-compatible PCs (XT to 486 Pentium) and networks, under Windows, and on Macs under SoftPC. Complete computer systems, custom programming and consulting services are also available. Sixty-day money back guarantee. For a brochure and dealer list contact BOSS Development.

BOSS Development
310 Mockingbird Lane, Suite E, South Pasadena, CA 91030

Phone: (818) 799-3400
Fax: (818) 799-3403

The ViewFinder

Business & Stock

DOS & Windows

Prepares estimates, delivery memos; transforms them into Invoices while updating accounts receivable and a "research" JobFile. Stock module included w/research and label-printing capability; can query images into delivery memos. AR includes statements, aging report. JobFile gathers groups of jobs done for client, agency, art director, and more. Client DataBase inserts names/addresses into documents; produces lists, mailing labels and MailMerge file for use with word processor. Accounts payable include check-printing. Asset inventory and more. Working demo available for $25 refundable deposit. Demo data saved if program is purchased. Unlimited, free tech support via phone. FAX or Compuserve.

Retail Merchandise Systems
8122 S.W. 83rd St., Miami, FL 33143

Phone: (305) 271-8941 • Fax: (305) 274-6220
Compuserve CIS ID#73767,3655

Full Spectrum

Business & Stock

Macintosh

Full Spectrum is a complete photography business and stock management software program, featuring fully integrated client and contact tracking, job costing, estimating, stock usage history, scheduling, accounting, and much more. *Photo District News* says "It's a business package that means business every step of the way, with considerable depth in each of its capabilities." Full Spectrum is a powerful yet user-friendly relational database, which provides smoother data entry and retrieval, total linkage between all areas of the program, and the flexibility to meet the needs of all photography businesses. All forms and labels can be totally customized.

Parhelion
PO Box 107, Cornish Flat, NH 03746

Phone: (603) 675-2966
Fax: (603) 675-2966

InView & StockView

Business & Stock

Macintosh

Inview & StockView, by James Cook, remain the fastest, most comprehensive photo business software available for the Macintosh. No other software is required for you get everything necessary to manage your daily business and stock photo files in one seamlessly integrated package. InView handles contact data, marketing, correspondence, estimating, job costing, invoicing, collections, scheduling, to-do lists, phone dialing, payables, check writing, equipment files, and more. StockView handles captioning, cross referencing, file searching, digital photo filing, submissions, and more. Both have customizable ASMP style forms too, so you can personalize virtually everything you print. Also available separately.

HindSight
PO Box 4242, Highlands Ranch, CO 80126

Phone: (303) 791-3770
Fax: (303) 791-3770

LISTING OF SOFTWARE

Grip 32
Business &
Stock

Windows

Grip 32 is a 32-bit studio management system for Windows '95, Windows NT, and Windows 3.11. It is network-ready right out of the box. Clients, contacts, scheduling, invoicing, double-entry accounting, mailing lists and labels, stock picture management, extensive Photo CD controls, customizable printing templates, modem and graphics support, equipment manager, report generator, and much more. New for '95 -- import existing BOSS data. On line, context-sensitive help. Unlimited free technical support. Demo disk available.

Grip Software
420 N. 5th St., #707, Minneapolis, MN 55401

Phone: (612) 332-8414
Fax: (612) 332-0052

MacStock Express 3.5
Business &
Stock

*Windows &
Macintosh*

Complete stock photography management which runs in single or multiuser modes with features including: word processing, automatic mail merge, delivery memos, invoicing, tracking, and statistics of all kinds. Forms for terms and conditions, production shoots, terms of delivery, jobs/estimates/bids, sales reports, etc. Adapts to various numbering systems, imports scanned images, thumbnails or documents created in any application, creates documents from photo searches, bar-code compatibility, on-line help, self-customization, label printing for slides, prints, envelopes, etc. Files for clients, photographers, models, photos, jobs, shoots, sales, photos held, invoices, letters, etc. Also available: demo and three "feature limited" versions which can be upgraded by purchasing passwords.

Photo Agora
Hidden Meadow Farm, Keezletown, VA 22832

Phone: (540) 269-8283
Fax: (540) 269-8283

PI/E
Business &
Stock

*Windows &
Macintosh*

PI/E, Pro Invoice/Estimate Powerful studio management software for the professional photographer. PI/E provides the forms and reports for creating and producing the job from the first estimate to scheduling, casting calls, location searches, delivery memos, letters and faxes, production call sheets, production advances, model and location releases, job changes and, after the shoot, the final invoice and past due statements. Codes charges for film and processing, addresses digital photography and tracks sales, clients, crew and equipment. Manages stock images with user's codes, imports Photo CD, invoices and tracks stock sales, prints labels and sends stock delivery memos with terms and conditions. Comprehensive user's guide and on-screen help. Free technical support. Mac/Windows.

RLW Concepts
5940 Highridge Rd., Calabasas, CA 91302

Phone: (818) 887-1509
Fax: (818) 887-4601

StrucSure
Business &
Stock

*Windows &
Macintosh*

StrucSure is The Photographer's Management Software; Filmmaker Pro-based for Macintosh and Windows. 100% customizable, StrucSure includes ten modules; clients, vendors, estimates, projects, job expenses, prop search and location finder, equipment inventory, stock library and portfolio manager. Modules are cross-linked, to minimize repetitive data entry. Version 3.1 adds a system-wide control panel and improved scripting to automate complex reports including statements and sales tax returns. FileMaker Pro sold separately. A member of the Claris Solutions Alliance, StrucSure is committed to providing powerful, customizable solutions for the photographer that are easy to use.

StrucSure Software Company
PO Box 11633, Saint Louis, MO 63105

Phone: (314) 993-7577
Fax: (314) 863-8018

Darkstar
Specialized

DOS

Darkstar solves exposure and filtration problems in the photographic darkroom. It works with color as well as black-and-white, and positives (slides) as well as negatives. It also provides b-&-w film processing data that can eliminate the need for temperature control. The program is menu driven, and offers eleven different categories of problems it will solve. By eliminating waste of expensive printing materials Darkstar can quickly pay for itself.

F/22 Press
PO Box 141, Leonia, NJ 07605

Phone: (201) 568-6250

LISTING OF SOFTWARE

FFilit/FFindit
Specialized

DOS

Programs fall under the family name of FotoFindr. FFilit copies data from FFindr entries, including the Descriptor Dictionary, to diskette and periodic distribution to photo buyers. FFindit is copied to diskette for free distribution to photo buyers. FFindit gives the buyer the ability to study your library electronically through access to your FFilit disk. The buyer can view the Descriptor Dictionary, search on a Descriptor, and word or phrase within a Descriptor, up to three Descriptors joined by "and" or up to three Descriptors joined by "or". For users of FFindr only.

Franklin Service Systems
PO Box 202, Roxbury, CT 06783

Phone: (203) 354-8893
Fax: (203) 350-9249

Labeler
Specialized

DOS

Stores of up to 150 characters in database files for retrieval by searching on any word, phrase or character string in the caption. Print captions to three standard sizes of pin feed labels small enough to fit on the base of 35mm slides or exhibition mounts. Create slide presentations, including title and sequence number, for label printing. Upgradable to FFoto and/or FFindr.

Franklin Service Systems
PO Box 202, Roxbury, CT 06783

Phone: (203) 354-8893
Fax: (203) 350-9249

Timestar
Specialized

DOS

Timestar turns any computer into a powerful sequence timer. It allows the user to program as many as 15 sequenced events. Programs can be stored to disk for reuse. Each event can be as long as 99 minutes and 59 seconds. Audible warning can be selected before the end of each timed period. Automatic or manual starting of periods is provided. Screen data includes; name of period being times, its position in the sequence, the number of periods in the sequence, the number of minutes and seconds remaining in the period being timed.

F/22 Press
PO Box 141, Leonia, NJ 07065

Phone: (201) 568-6250

fotoQuote
Specialized

*DOS,
Windows &
Macintosh*

fotoQuote is the new, user friendly software package that simplifies your job of pricing and selling your stock photos. Written by Cradoc Bagshaw, fotoQuote has over 1500 prices (based on actual sales records of stock agencies and photographers) in over 50 categories. To help you get your asking price, fotoquote includes a coach section written by Vince Streano, former ASMP president. He takes you step by step through your negotiation — from your initial phone call to closing the sale. The ASMP Legal Action Fund receives a $20.00 donation for every order received directly from ASMP members.

The Cradoc Corp
PO Box 10899, Bainbridge Island, WA 98110

Phone: (206) 679-4030
Fax: (206) 842-1381

FFindr
Stock Only

DOS

Cross indexes photographs with user created Descriptor Dictionary of up to 9,999 words or Phrases. Limits Descriptor entry for any single photograph to size of Dictionary. Search on a Descriptor, a syllable within a Descriptor, up to three Descriptors joined by "and" or three Descriptors joined by "or." Creates invoices, maintains ledger, tracks earnings. Captions can be printed using Labeler. Available without invoicing, ledger, and earnings as FFoto.

Franklin Service Systems
PO Box 202, Roxbury, CT 06783

Phone: (203) 354-8893
Fax: (203) 350-9249

LISTING OF SOFTWARE

FotoFind

Stock Only

DOS

For over ten years (July 1984) FotoFind has been helping photographers to organize. Labeling combined with superior find capabilities allows quick retrieval of thousands of photographs. The functional $10 demo disk is worth $20 off the purchase price. Conversions from other programs available.

Process Technologies, Inc.
PO Box 19129, Johnston, RI 02919

Phone: (800) 443-9922
Fax: (800) 751-3541

The CRADOC CaptionWriter

Stock Only

DOS,
Windows &
Macintosh

Since its introduction in 1984, The CRADOC CaptionWriter has been the world's best selling slide labeling software. Designed by an ASMP photographer with the guiding philosophy that a photographer makes their money by shooting and not by "playing computer", The CRADOC CaptionWriter is particularly easy to use and remarkably fast. Features include the ability to print up to five lines of information on slide labels; sequential numbering; ASCII database capabilities; and the ability to print the copyright symbol. As a major photographer said, "It's the most valuable computer program we have for photography."

Perfect Niche Software, Inc
6962 E. First Ave., Suite 103, Scottsdale, AZ 85251

Phone: (602) 945-2001
Fax: (602) 949-1707

The Photo Management System

Stock Only

DOS,
Windows &
Macintosh

The Photo Management System is the easiest way to organize collections of photographic related items. Whether you work with slides, prints, x-rays, or other collections, The Photo Management System makes the job of organizing, tracking, and locating images easy. The Photo Management System works either as a stand-alone database program for the visual arts, or in conjunction with the CRADOC Caption Writer. Features include: the use of a single database file; the ability to sort, filter, or tag records; easy Import and Export of records; and reports which let you create a delivery memo, invoice, or listing of select images.

Perfect Niche Software, Inc
6962 E. First Ave., Suite 103, Scottsdale, AZ 85251

Phone: (602) 945-2001
Fax: (602) 949-1707

Copyright, Releases, and Business Forms

Why do I have to get bogged down in legalese and paperwork? I'm a photographer, not a bureaucrat. This is our common lament. However, thinking that paperwork can be avoided is a misguided notion as well as seriously out-of-date.

Taking care of the legal formalities is a necessary part of your photographic business, which, if handled properly, will allow a smoother running of your business — and more time and creative energy for your photography. This chapter presents the basics of copyright and what you need to know about invasion of privacy and the importance of model releases; it gives sample forms to clarify your business dealings and help to avoid misunderstandings; and it offers some thoughts on where to turn for legal help if things go sour.

Copyright

Many photographers avoid the subject of copyright, fearing that it's beyond their comprehension, or worse, that it doesn't matter.

Understanding copyright is good business, more important, knowing about copyright is a way of showing respect for your photographs, just as using archival sleeves shows regard for the fragile nature of the materials in them. Your photography is your creation. For most photographers it is the tangible result of a life's work with economic, artistic, and sometimes historic value. It can be a legacy and an annuity — and deserves respect.

It is important to understand that you cannot copyright an idea, only the tangible expression of an idea — the photograph.

The copyright is actually composed of a bundle of rights which can be separated and portioned off for different purposes — and licensed to a variety of clients for a wide range of reproduction fees.

It's good to remember that while we casually refer to the "selling" of stock pictures, or to the income from "stock sales," those terms are misleading, however convenient and commonly used. The correct terminology is that you "license" rights for specific usage, usage which is then spelled out in your in-

voice to a client. The same photograph has a virtually unlimited number of uses over its lifetime.

In stock photography, the picture, the actual physical property of the photograph (transparency or print) is merely on loan and the fee paid is not for the "sale" of anything, it is for usage permission only, that is, reproduction rights.

Background of copyright

The Statute of Anne, enacted in 1710 by the British Parliament, is considered the first real copyright law. The drafters of the United States Constitution recognized the importance of protecting "authors" — which means all creators — by giving Congress the power "to promote the Progress of Science and the useful Arts, by securing for limited Times to Authors and Inventors the exclusive Right to their respective Writings and Discoveries." Since 1790, when Congress enacted the first copyright legislation, to the present day, the law has been changed and expanded many times.

The underlying principles of copyright, embodied in our Constitution, are to encourage and promote the artistic and intellectual life of the society through the fostering of the individual creator. We must continue to cherish and protect those rights so carefully handed down by our enlightened forefathers.

Copyright overview

This section will answer the most often asked questions and serve as a basic introduction to this complex and fascinating subject. There are important variations and exceptions which you can learn about in specialized books listed in the bibliography or by consulting your lawyer.

In general, the following discussion will center on copyright information applicable to the free-lance photographer. It may not apply if you are employed as a photographer by someone else, in most cases your employer will own the copyright to any work done "on the job."

1. Who owns the copyright?

You, the photographer, own the copyright in your photograph from the moment of creation (the second the aperture closes). The exceptions are:

- If you are an employee
- If you have signed a work-for-hire contract

This ownership of the copyright from "the moment of creation" was legislated by Congress in the Copyright Act of 1976 (which took effect January 1, 1978).

2. How long does copyright last?

The term of copyright is the photographer's lifetime plus fifty years. Because this is such a long period of time, the law gives creators the opportunity to terminate transfers of rights after 35 years (but work-for-hire agreements cannot be terminated).

There are also exceptions to the term, such as works published anonymously or under a pseudonym or as work for hire. All of these have a term of 75 years from the date of first publication.

Copyright for works created prior to January 1, 1978 have a different duration — 28 years plus a renewable term of 47 years. The second term requires renewal during the 28th year of the initial term.

3. What are the rights of the copyright owner?

The copyright owner has the exclusive right to control the reproduction of the image; to control the first sale of any copies (such as fine art prints) of the image; to resell that print; to control use of the image in derivative works (such as when an artist uses your photographs as the basis of an illustration) and to control displays of the image (subject to the fact that someone who has purchased a physical copy, such as a fine art print, has the right to display it to people who are present at the location where the display is taking place, as in a home, gallery, or museum).

4. I've heard I shouldn't sign work for hire. What is it?

Work for hire means the client, not the photographer, owns the copyright as if the client had, in fact, shot the photographs — because under work for hire the copyright vests in the client from the moment of creation. There is not even a copyright transfer to the client in a work for hire. This means that in the eyes of the law the client was the photographer.

5. How can work for hire happen?

Employees, such as most staff photographers, do work for hire in the traditional employer-employee relationship.

Free-lance photographers are never employees. (For this discussion we are concerned with work for hire as it applies to photographs taken on assignment. It can never apply to stock photographs taken on your own time.)

The only way work for hire can come into being for a free-lance photographer is if there is a contract that is: (1) written, (2) states that the work being done on an assignment is work for hire, (3) is signed by both the photographer and the client, and (4) the assignment itself must fall into one of a limited number of categories, the most likely to apply to photographers being: (a) as a contribution to a collective work such as a magazine, (b) as part of an instructional text, (c) as part of a supplementary work (which is a work intended to supplement a larger work), or (d) as part of an audio-visual work or motion picture.

If the work you do on an assignment does not fall into one of the categories specified in the law then it is not work for hire no matter what contract a client may ask you to sign.

In 1989, a unanimous ruling in favor of the creator by the United States Supreme Court *(Community for Creative Non-Violence v. Reid)* was a victory for the creative community. The high court's decision resolved a conflict that had existed in the courts regarding the definition of employee in a work-for-hire relationship. The court did not accept the argument that actual "supervision and control" or the right to "supervise and control" was sufficient to make a free lancer into an employee for copyright purposes. The result, and the impact of the *Reid* case, is that work for hire can happen only under the conditions stated in the law. There must be a written contract and the work must fall into one of the categories specified.

6. What is a "lifetime" work-for-hire contract?

An even more outrageous and damaging abuse is the lifetime, or blanket, work-for-hire contract. This contract, which says that all future assignments shall be done as work for hire, should *never* be signed. In effect, this lifetime contract doesn't allow you to change your mind after having done one work-for-hire assignment for a particular client. It does not meet the ethical and economical standards that should prevail in the industry.

The best protection is not to sign any work-for-hire contract — but in the rare instance that you consider doing so, read the contract carefully to make sure that it is binding only on the current job.

7. What are the results of work for hire?

The results of work for hire are:

- loss of authorship, in that the client becomes the creator,
- loss of creative control,
- loss of residual income,
- loss of bargaining power,
- a complete absence of employee benefits of any kind,
- no right to authorship credit since, legally, you never created the work.

8. What do these results of work for hire mean to me?

The simple answer is that if you have signed a work-for-hire contract for an assignment you can forget about any stock use from those photographs. But there are other equally horrifying ramifications: In a legal

paradox that's difficult for photographers to fathom, the client actually becomes the creator under work for hire. The photographer no longer exists. You can't even use the photograph in your portfolio without permission! Once you sign a work-for-hire document, the client owns the copyright and all the usage rights to the photograph in perpetuity. They are the creator under the law.

They can use the photograph again and again without payment; they can alter it, re-sell it, put it in a stock agency. You could find yourself competing against your own work — running face-to-face with your own outtakes that a work-for-hire assignment client has placed in a stock agency.

In addition, by signing, you are giving up your independent free-lance status without gaining the employee's benefits of hospitalization, paid vacation, sick leave, pension, etc.

It's easy to see why a furor has been raging among photographers who oppose and refuse to sign work-for-hire contracts. It's also why photographic organizations like ASMP have been leading the fight to limit or eliminate work for hire.

Many readers of this book, who are shooting primarily for stock, will not have to confront the problem of work for hire. But for those who are doing assignments and may be faced with work-for-hire contracts, know one thing: you don't have to sign. If you do, you are slowly poisoning the well of your own stock.

9. How to negotiate out of work for hire.
There are several ways to approach the client who requests work for hire on a photographic assignment. First, find out what rights are really needed. The art director rarely needs more than limited rights for specific usage on a project. In many cases, the decision to use a work-for-hire contract arises from a corporate level decision. My approach, in discussions with a client, is to run through a list of the rights and time-limit protections they may need, come to an agreement, and license those specific rights in my invoice.

Advising the client that fees are based on usage rights transferred may create an understanding on the client's part that work for hire should carry a substantially greater fee than the limited rights transfer of a standard assignment.

Another approach, since most clients ask for work for hire when, in fact, they want to avoid competition (i.e., they don't want to see their assignment photographs turn up in a competitor's publication) is to offer to put a non-competition provision in the contract. The language of the non-compete clause you suggest should describe the current assignment use as closely as possible, so as to narrow the scope of the restriction. You may suggest language (in an editorial usage) such as "Photographer shall not permit any use of the photograph in another book on fresh water fishing," for example. Or, in the case of advertising, you may specify the product or service that would be competitive: "Photographer shall not permit any use of this photograph for a competing detergent."

In this event, make sure you both agree on what would constitute competing use. Of course, you should be careful not to completely devalue the usefulness of the photographs and your own rights in the images and thereby eliminate their residual value by too broad a non-competition agreement.

Most important, I have found that many companies offer a work-for-hire contract to those photographers who will sign it, but they are willing to negotiate variations for those who won't sign. And this isn't true just for photographers with clout. Sometimes, the contracts are sent out as a formality — a corporate convenience. I've received boilerplate work-for-hire contracts from an accounting department after an art director and I have concluded a separate agreement, only to be told when I call to question: " Oh, that doesn't apply to you. Toss it out."

10. What is copyright notice?
Copyright notice is the statement of copyright ownership in a photograph.

A significant value of copyright notice is symbolic — it warns the public or any potential user not to use the image without permission of the copyright owner. It also has the practical value of letting a potential user know whom they should contact in the event that they want to reproduce the image.

Also, the use of a notice will benefit you in the event of a lawsuit by eliminating the defense that the user was an "innocent infringer" (they didn't know they couldn't use it). This defense is dangerous because it can reduce the damages you can recover.

11. What is the correct form of copyright notice?

A proper copyright notice has three elements:

1. The word copyright, or the abbreviation copr., or the symbol ©

2. The year date

3. The name of the copyright holder (you)

Examples:

> © 1991 Pat Photographer
> or
> Copyright Pat Photographer 1991
> or
> Copr. 1991 by Pat Photographer

12. What year date should be used?
The year of first publication (Roman numerals, as used by some stock photographers, are acceptable).

13. What year date is correct for unpublished photographs?
The date to be used in a copyright notice for unpublished photographs is the year of creation. You may wonder whether using the year of creation may not shorten the term of copyright. However, since the copyright term is measured by the life of the photographer plus fifty years, it will be the same no matter what date appears on the photograph. When a work has been unpublished and is then published, the year of first publication should be put in the copyright notice.

14. When do you use a copyright notice?
A copyright notice should be on *all* photographs leaving your studio (prints or transparencies) and should be required as a part of your photo credit accompanying all publication. (You'll notice this stipulation on the back of the sample delivery and invoice forms in this chapter.)

15. Do you need a copyright notice?
A significant change regarding copyright notice came about on March 1, 1989, when the United States became a signatory to the Berne International Copyright Convention. By adhering to this convention and making certain changes in the Federal copyright laws, the United States gave notice that the formality of a copyright notice is no longer required to maintain copyright protection for works published after March 1, 1989. That is, copyright will not be lost simply because a work is published without copyright notice after March 1, 1989. Likewise, copyright will not be lost because a work is published without a year date.

On the other hand there are certain important benefits under the copyright law to having a correct copyright notice accompany your photograph. In the event of a lawsuit for copyright infringement, there may be a reduction in damages owing to the "innocent infringer" defense mentioned above. These benefits are further detailed in the sources listed in the bibliography.

If you wonder what happened if you omitted copyright notice prior to March 1, 1989 several simple rules will explain this. First of all, for photographs first published before January 1, 1978, the effect of publishing without notice was generally the complete loss of copyright, that is, the copyright went into the public domain, where the work could

be freely copied by anyone.

For photographs published between January 1, 1978, and March 1, 1989, if the copyright notice were omitted, the same loss of copyright could have occurred, certain provisions that came into play that could save the copyright.

16. What is copyright infringement?

Infringement occurs when your photograph is used (published) without your permission or that of your authorized agent (such as a stock agency).

17. How do you handle a copyright infringement?

First, consult a lawyer expert in photographic and copyright matters. You may not have to go to court, there are sometimes quick, amicable solutions. But knowing about an infringement and doing nothing could jeopardize your right to sue.

18. How do you find out about an infringement?

By being alert and by being lucky. You may notice a usage that you didn't authorize. Often a friend will recognize your photograph and bring it to your attention. But there may very well be infringements that you never see.

19. Is it necessary to register each photograph with the Copyright Office?

There is no requirement to register photographs with the Copyright Office whether photographs are published or unpublished — your copyright ownership is not jeopardized by lack of registration. However there are certain benefits to registering photographs. Further, they can be registered in groups, to make things less complicated and save fees.

20. What are the benefits of registration?

If you have registered prior to an infringement's occurring, the benefits of registration include certain presumptions in a lawsuit and certain rights to damages and legal fees that might not otherwise exist for you.

21. How do I register?

The Copyright Office provides Form VA for works of visual art. The application fee is $20. With the form and fee you have to provide copies of the images being registered (generally one copy of unpublished work and two copies of published work). The form, the fee, and the deposit copies of the photographs must all be sent together for the registration to be valid. Registration, by the way, will take effect on the date that these three items are received by the Copyright Office, even if the Copyright Office takes some time to mail the certificate of registration back to you.

Bulk registration is available for unpublished work. Photographs can be registered in bulk by supplying a single 35mm slide taken of a plastic sheet of 20 photographs, a contact sheet, microfilm, or microfiche of your work. ASMP is currently working with the registrar of copyrights in an effort to create depositless registration for photographers. This could mean that an identification list with unique photo numbers will be accepted in place of copies of the photos.

Check with the copyright office for applications and information at their hotline number (202) 707-9100.

A final piece of advice, don't think that this is just a fantasy or something that happens only to other people or that fears of infringement are ungrounded. In fact, there have been a rash of infringements. The typical story is that after the infringement has taken place, the photographer is offered merely the fee that he or she would have gotten in the first place had the infringer come to the photographer for that photograph. This is completely unacceptable. To strengthen your position, use copyright notice and, at least, register your most important works.

The best way to deter infringement is to use a copyright notice.

22. Why do some photographers continue to omit copyright notice — or not require a copyright notice as credit?

One can only guess that they don't understand the copyright laws or realize the serious implications of not using a notice. Some are intimidated by the buyers and concerned that they may lose sales by insisting on copyright notices. They don't realize how easy it is to explain this standard professional practice to buyers, and that it is their right!

I am appalled at the number of photographers who send pictures to a client without a copyright notice — or, for that matter, without a name stamp or even without any kind of identification on the picture. I've learned about this from clients of mine who have made remarks about their puzzlement at such cavalier business practices.

It's pretty tough to be aggrieved at the mishandling of your work if you haven't shown the proper respect for it in the first place.

Valuation: What a Photograph Is Worth

Is a lost or damaged photograph worth $1500?

The answer is yes, though not always, and sometimes more than $1500. But let's go back a few steps.

Photographs must be protected, since their value contributes to your financial and artistic life for only as long as they are in good condition.

The first step is to protect your photographs while they are in your studio and en route to a client by using careful packing and bonded couriers. Some photographers protect valuable originals by submitting reproduction-quality duplicates to clients. While the quality of dupes has improved over the years, I still find the very term "repro-quality dupe" a contradiction in terms. It can *never* be the same quality as an original. Furthermore, many clients still insist on originals for reproduction purposes.

Good paperwork is the next line of defense. Using forms similar to those you will find later in the chapter will help show buyers that you have respect for your work and will require respect of them.

Especially important are the loss or damage provisions. You will have to specify the value of each photograph or group of photographs, in the submission, unless you use the $1500 stipulated damages provision on the back of your form, which will cover every picture in the submission.

If you use the stipulated damage figure, make sure that it actually applies to every transparency in the submission. Don't overlook the photographs that are worth more — that you may want to value higher than $1500 because of their special qualities. It's smart to check each submission and value photographs individually whenever possible. Remember, you may have to prove the value if there is a dispute.

Finally, know the law regarding loss or damage fees for photographs. Understanding the legal background of this pervasive and troublesome problem will help when you are placing value on your photographs on the delivery memo and will aid in explaining the valuation to a client.

Origin of the "$1500" fee

Where did the $1500 stipulated damage figure come from? From the courts. It was not initiated by photographers or photography organizations, as some suppose. Since the early 1970's the courts and arbitrations have upheld loss or damage claims, many of them in the area of $1500. Documentation of these cases is available to your lawyer through ASMP, in the event you need the information to go to court in a loss or damage claim.

Why should you charge for loss or damage?

There is no way to earn money in stock without having stock photographs to license. Each loss of an original transparency diminishes your earning power and the integrity of your file.

Oddly, I have heard the point of view expressed to beginners in the field that charging a loss or damage fee is an effort to penalize a client and that it is done only by the top pros. This is absurd. The notion that it is a penalty to make clients accept their responsibilities shows a basic misunderstanding of the business and the law. Each photograph is your valuable property and deserves respectful treatment. Further, the courts prevent us from *penalizing* by not awarding damages they consider excessive. Clients are amply protected. But you are the only one who can stand up for your work.

The loss or damage of an original photograph can be a devastating occurrence to a photographer. Many photographs are irreplaceable. The fee paid for a lost or damaged original transparency is intended to compensate, at least partially, for that loss.

Opinions expressed by the courts in recent years regarding lost transparencies show an increasing understanding of the photography business and the factors that contribute to the value of a photograph. One judge summed up those factors as including:

- technical excellence
- the selective eye of the photographer
- prestige and earning level
- uniqueness of the subject matter
- established sales or use prices
- group value of individual images
- frequency of acceptance by users

If the courts recognize this value to photographs, why do you suppose some photographers do not? Perhaps because they do not keep sight of the real value of their work.

Determining value

As mentioned above, valuation must be assessed. There is no automatic $1500 check out there waiting any time a photograph is lost. This is why professionals must set up a system for valuing photography.

There is a range of valuation you can establish. For example, a photograph of a girl in Mongolia learning traditional methods of archery is easily defensible when valued at $2000 as would be a complex setup of a three generation family using professional models on location in a park. A rare opportunity to photograph in a submarine or another location with extremely difficult access would be valued higher still. However, a good but standard shot of a cornflower in a field would be likely to have a lower value.

Reasons for a different evaluation aren't always immediately obvious. A series of released photographs of professional models involved in sports activities on a Caribbean island beach would be valued way above a similar picture that is a grab shot of an unreleased model wind-surfing in Florida.

Determining value is complicated but there are techniques to help. Create some categories for your own photographs which take into consideration the different kinds of work you do, reflecting replacement costs as well the factors listed above. Assign a loss or damage fee to these categories and refer to them when filling out the valuation for particular photographs on the delivery memo.

If you do a lot of setup shooting for stock you'll find that many of them will be over the $1500 value.

Possible categories:

A Setups — local (with professional models)
B Setups — local (with amateur models)
C Setups — national (with professional models)
D Setups — national (with amateur models)
E Setups — international
 (with professional models)
F Setups — international
 (with amateur models)
G Scenics/Location — local
H Scenics/Location — national
I Scenics/Location — international
J Unique situation — weather/lighting
K Unique situation — people interaction
L Unique situation — difficult access/permission
M Extra fees/Risk — helicopter, underwater

Your professional models sporting in the sun on Martinique will be in category E, while the wind surfer is in category H. Add or refine categories depending on the type of shooting you do. Assign values based on the costs in each category for transportation, props, model fees, and exceptional expenses, such as location fees or helicopter rentals.

Cost to produce is by no means the only factor to consider. A brilliant photograph with low production expense, which has sold well, or is likely to sell well based on the photographer's track record, may have a loss value equal to a high-expense one. It's very important to add the following to your equation in valuing a lost transparency:

Artistic value
Portfolio sample
Income — history of sales of that photograph
Income — projected sales over the life of the image

In a recent court decision, the judge evaluated lost transparencies based on groupings rather than using a flat per photo value, underscoring the importance of establishing value by category.

All of this will help, not just in court, but before that when discussing a loss settlement with a client. A clear expression of these factors may avoid the need for going to court.

When a loss occurs

Since in most cases no fee will be an appropriate recompense, make it clear to a client that you prefer that they find the photographs. I always suggest they take some more time to look before billing them a loss fee. If they aren't familiar with industry practices, remind them of your delivery memo terms and about the kinds of loss fees that are common in the industry and that courts have upheld. (This may terrify them into looking harder and you may get the desired result of pictures returned.)

Keep one thing in mind — lost transpar-

ency fees aren't a good deal. You almost always lose in some way. It's always better to have your photograph back than to get a fee. Also, no matter how justified your position, a dispute over lost pictures may sour a client relationship, so do everything possible to have them find the pictures and avoid billing for loss or damage.

When the die is cast and you must send them a bill, prepare yourself first. Make copies of your paperwork. Send a letter along with the invoice explaining the terms on your delivery memo, the damages that you stipulated, and why these particular pictures are expensive (or impossible) to replace. Finally, explain industry practices citing some articles from the ASMP *Bulletin* or the trade press on court decisions regarding lost transparency valuations which will show an uninformed client that you are not making a rash claim.

State also that you are giving them this complete background information in order to have a quick and amicable settlement. A full explanatory letter makes it easier for the art director to state your position to those in management approving the invoice. On several occasions I've had photo buyers thank me for giving them the ammunition needed to present my case, and the lost transparency invoices were paid promptly.

If this fails, then it's time for your lawyer, who will advise you on the costs of a suit and the strength of your case — largely dependent on good paperwork!

Valuing dupes

A duplicate transparency is a second generation, one made as a photographic copy of an original piece of film, and does not have the same value as an original. There is, however, a much greater value to a dupe than simply the lab cost of making it. Remember that the cost of labeling, captioning, and preparing for file must be considered in valuing dupes. Some photographers value dupes at $200.

Similars, extra originals taken at the same time and sometimes erroneously called "in-

camera dupes," are originals and are valued as such. Courts have recognized the need for the client to have a group of photographs for selection purposes. An original's value is not diminished because you have some similar out takes.

Black-and-white or color prints are valued, as with dupes, taking into consideration not just the cost of producing the prints, but all the attendant labor of captioning and labeling them.

As with statistics on airline accidents, it's amazing there aren't more losses, considering the amount of travel done by a stock photograph in the course of its life. One reason may be the care and respect clients show to transparencies, a result of court decisions and awards that reinforce the industry standard of $1500 for loss or damage. You can be sure that they wouldn't pay for staff time in logging photographs in and out if there weren't a risk to be avoided.

Model Releases and Invasion of Privacy

An area in which photographers should exercise most caution — where they are most likely to put themselves at risk — is in the area of the law known as invasion of privacy. Individual citizens have rights of privacy, that is the right to live free from unwanted publicity. This right to privacy overlaps with another right held by all individuals, but, for this discussion, of particular interest to creators. This is the right to free expression under the First Amendment of the Constitution.

Which rights take precedence, and when, is complicated and sometimes requires a decision by the courts. Photographers can avoid most of these problems associated with the risks of invasion of privacy by obtaining proper model releases and by observing certain cautions, as we'll see below.

When you need releases
From a business standpoint, model releases

increase the value of your stock dramatically, so you should make every effort to obtain them. It is also very important to understand your vulnerability in not having releases for stock photographs in terms of the legal protection they can provide. It is not always clear legally when a model release is required but the following guidelines will help.

1. If the use of the photograph is commercial, for purposes of trade or advertising, a release is needed for any recognizable person (and, in some cases, property).

2. In a non-commercial situation where the use can be considered newsworthy or a matter of public interest, a release is generally not needed. In photographic terms, that generally means editorial usage: books, newspapers, or magazines. However, many photographs could have commercial application down the line, and you would be wise to have a release available.

The exception here occurs (even within an otherwise protected use, such as editorial) if the person is portrayed in a false light to the public. This most often takes place when a true photograph (one which has not been altered) is connected with a caption which makes it untrue. For example, a caption describing the family-destroying effects of crack is connected with the photograph of a mother and child, when, in fact, neither of these actual people has ever had any relationship with crack. Even though the usage is editorial it is not in the public interest to say false things about particular people. Even a signed model release would not provide protection from this extreme and defamatory usage unless the release specified the models' consent to portrayal as crack users.

Also know that if the depiction puts the subject of the photograph in a demeaning light then you may also be open to a claim for libel.

3. Physical intrusion, such as trespassing or obtaining entry by fraud to take photographs,

can also be invasion of privacy.

4. There are a different set of rules connected with celebrities. A celebrity used in photographs for commercial purposes of advertising or trade is protected under the laws of privacy as is any other individual, but this leads us into another interesting, and somewhat murky, area of the law. What has been termed the right of publicity is the right that well-known people have in the value that has come to exist in their names and images.

And while the rights of privacy exist only for living persons, in some states the rights of publicity to the persona of a deceased celebrity exist as property rights, which descend to the heirs.

Photographers should be aware that the rights to license the images of certain famous people who are deceased are often held by special agencies set up for the purpose of controlling the commercial and artistic exploitation of the celebrity's persona — such as John Wayne, W.C. Fields, Babe Ruth, Albert Einstein, and others. There are laws in several states which recognize these rights of publicity. It isn't yet known whether a model release obtained while the celebrity was alive will be valid after death. This area of the law is in flux. If you specialize in celebrity photography be sure to consult your lawyer and watch closely the developments reported by ASMP.

5. Property Releases. Property does not have rights of privacy or publicity. However a property owner may have the right to prohibit commercial exploitation (use for trade or advertising) of his or her identifiable property.

A house, a pet, a piece of jewelry or sculpture are some items of property that may require a release for advertising use. A horse running in a field, silhouetted against the setting sun might not need a release — unless that field is on a Kentucky horse farm and the horse were a famous brood mare. Then a release would be advisable.

A property release may not always be required legally, but such releases are a necessity if your stock is to have maximum value — which means being available for advertising users.

Certainly, you should obtain property releases when shooting interiors, especially since the release can also serve as a contact with the owner. But releases can add value to exterior photographs, especially of buildings, since clients will prefer a photo with a property release to a photo without one.

In any case a release should be signed when the property is photographed, and some payment, even if very small, should be made to the owner.

What is the final word on releases? Simply put, you as a stock photographer should always obtain a model (or property) release for any subject appearing in any image that you create. Since advertising is the most lucrative market, clearly you, and your stock agency, will want to have your images available to sell in that marketplace. Make the effort.

Business Forms

Nuisance though it is, paperwork is more than just a good idea — it's essential.

The most important reason for having a good "paper trail" is that it protects you with models, with clients over questions of usage, payment, or holding fees; in disputes over lost transparencies — in every way imaginable.

Further, you can create an impression of professionalism by using clear, thorough agreements, presented on nicely designed forms.

Don't let the concern that you'll alienate a client keep you from using detailed paperwork. Photo buyers are already used to receiving forms from photo agencies. Why should they expect less from you? And why should you expect less from yourself? An experienced photo buyer will appreciate the clarity of good paperwork — and will take you seriously if that's how you run your business.

You can, and should, make any changes in these sample forms that work well in your business. However, when deciding on the terms and conditions for your forms or the wording for your model releases, be sure to work with a lawyer. This is not the time to be casual.

ASMP publishes sample forms and model releases in its *Stock Photography Handbook,* as well as in its White Paper titled "Photographer's Forms: Get It in Writing." Both are valuable resources that can be ordered from the ASMP national office: Suite 502, 14 Washington Road, Princeton Junction, NJ 08550.

Releases

The releases included in this chapter are a model release for both adults and minors and a property release. These releases have been adapted from *Business and Legal Forms for Photographers* by Tad Crawford (Allworth Press) and appear here by permission of the author.

The model release which follows is similar to the one that I use. Some photographers use a scaled-down release, sometimes called a pocket release, which will fit on a 3 x 5" card (a sample of this is also in the ASMP book). It is very convenient and not so formidable to a model, but doesn't offer as much protection as you might want. When possible, especially if you work with professional models or plan to sell to advertising clients, use the strongest possible release.

In addition to the language that protects you legally, I add an introductory paragraph to soften the harsh tone of the legal language. I find it helps to put non-professional models at ease and seems to make the release easier to get signed. Such an introduction might read as follows:

Dear Friend (or Parent):
Thank you for your cooperation in allowing me to photograph you (or your child) for use in my stock photography project. Would you please sign the form below to show that you give me and the user, my stock photo client, permission to use these pictures.

Or, if you are short of space, you can put the friendly introduction on the back of the release along with an explanation of your project and a definition of stock as existing photography. The definition might read, "Stock photographs are existing photography. These photographs may be placed in my stock photography file or that of my agent to be used for publication." Vary the introductory language according to your own prose style and the particular project.

The release shown here adapts for use with an adult or child model. Or you can make two versions, one for adults and another for the parent (or guardian) of a minor. If you work with children a lot, you might want to have the separate version for minors.

Once you add any introductory words that you may want to this release (or a release you find in the ASMP book), have it printed or photocopied on your letterhead. This adds a professional look. Be sure to have your name in the space for the photographer's name so the release will be valid. Also, it is wise to give something of value (even a small amount of money such as a dollar or complimentary copies of the photographs) to make the release as binding as possible on the model or the property owner. Some releases do not mention giving money, but simply say, "For valuable consideration received..." Be certain, in fact, that you give something of value to the model and keep a record of what you gave as consideration.

Stock Picture Delivery Memo

A stock picture delivery memo and an invoice complete the forms in this chapter. Each has a front with spaces for the photographer to complete and a back which contains the terms and conditions for the form. The backs of the forms also have a small number of spaces to be filled in. These two forms have

been adapted from *Business and Legal Forms for Photographers* by Tad Crawford (Allworth Press) and appear here by permission of the author.

You can design your memo with or without lines. I prefer mine without so it's easier to use a typewriter or computer. I've tried to use the simplest, cleanest form possible so that I have space to write. You can vary it any way that works well for you. Just be sure to keep the legal protection of the terms and conditions.

Invoice Form — Licensing Rights

You can design the front of your invoice any way that is convenient as long as you include all the information needed for a complete invoice. Some photographers use an almost plain letterhead. However you design the face of your forms, be certain to have the terms and conditions on the back. To make your design task easier, forms for photographers are available on computer disk from Allworth Press.

When you write an invoice for the use of one of your stock pictures, you are doing what is termed "granting a license of rights." You grant the user, upon payment of the agreed-upon fee, permission to use your photograph in very specific and limited ways. A well-written license will clearly limit the usage to only what the user needs and has paid for, specifying the limitations of size, time, number of copies, and a number of other factors. It will exclude all other uses.

If you are dealing with governments or governmental institutions, be sure to require that they agree to be sued in the event a dispute arises. This is because sovereign immunity may protect governments and their institutions (such as state-owned universities) from claims under copyright and other laws. However, this immunity can be waived by an agreement to allow lawsuits to be brought. This additional provision should be added to both the stock picture delivery memo and the stock photography invoice.

As mentioned in earlier chapters, you can refer to the ASMP *Stock Photography Handbook* for a comprehensive listing of the categories of pricing and license of rights specifications for every imaginable stock usage and to the book *Pricing Photography*, published by Allworth Press, for comprehensive pricing and negotiating information. Also, remember that the amount paid as the repro fee is what determines the extent of the rights granted. So the greater the usage rights required by the client, the higher the fee.

When you need a lawyer
In the unlikely and unhappy event that you need to resolve a dispute through the courts or arbitration, by all means get the right lawyer — one who is knowledgeable in the law as it pertains to the photography business.

ASMP maintains a referral list of lawyers in various parts of the country who are experienced in handling legal matters for photographers.

The beauties of paperwork.
All the reasons for using careful documentation and good paperwork have been spelled out and can be summed up very simply: paper protects you.

MODEL RELEASE

In consideration of _____ Dollars ($_____), and other valuable consideration, receipt of which is acknowledged, I, _____(print Model's name) do hereby give _____(the Photographer), his or her assigns, licensees, successors in interest, legal representatives, and heirs the irrevocable right to use my name (or any fictional name), picture, portrait, or photograph in all forms and in all media and in all manners, without any restriction as to changes or alterations (including but not limited to composite or distorted representations) for advertising, trade, promotion, exhibition, or any other lawful purposes, and I waive any right to inspect or approve the photograph(s) or finished version(s) incorporating the photograph(s), including written copy that may be created and appear in connection therewith. I agree that the Photographer owns the copyright in these photographs and I hereby waive any claims I may have based on any usage of the photographs or works derived therefrom, including but not limited to claims for either invasion of privacy or libel. I am of full age* and competent to sign this release. I agree that this release shall be binding on me, my legal representatives, heirs, and assigns. I have read this release and am fully familiar with its contents.

Witness: _____ Signed: _____
 Model

Address: _____ Address: _____

 Date: _____, 19 _____

Consent (if applicable)

I am the parent or guardian of the minor named above and have the legal authority to execute the above release. I approve the foregoing and waive any rights in the premises.

Witness: _____ Signed: _____
 Parent or Guardian

Address: _____ Address: _____

 Date: _____, 19 _____

* Delete this sentence if the subject is a minor. The parent or guardian must then sign the consent.

PROPERTY RELEASE

In consideration of the sum of _____Dollars ($_____) and other valuable consideration, receipt of which is hereby acknowledged, I, _____, residing at _____, do, irrevocably authorize _____(the Photographer), his or her assigns, licensees, successors in interest, legal representatives, and heirs to copyright, publish, and use in all forms and media and in all manners for advertising, trade, promotion, exhibition, or any other lawful purpose, images of the following property:

_____,

which I own and have full and sole authority to license for such uses, regardless of whether said use is composite or distorted in character or form, whether said use is made in conjunction with my own name or with a fictitious name, or whether said use is made in color, black-and-white, or otherwise, or other derivative works are made through any medium.

I waive any right that I may have to inspect or approve the photograph(s) or finished version(s) incorporating the photographs, including written copy that may be used in connection therewith.

I am of full age and have every right to contract in my own name with respect to the foregoing matters. I agree that this release shall be binding on me, my legal representatives, heirs, and assigns. I have read the above authorization and release prior to its execution and I am fully cognizant of its contents.

Witness:_____ Signed:_____

Address:_____ Address:_____

Date: _____, 19_____

(Photographer's Letterhead)

STOCK PICTURE DELIVERY MEMO

_____ Delivery Memo No.: _____

_____ Purchase Order No.: _____

Per Request of: _____ Telephone: _____

Photo Return Due: _____ Extension Granted:_____

Value*	Quantity	Format/ Size	Original or Dupe	Description/File Number	BW/Color
_____	_____	_____	_____	_____	_____
_____	_____	_____	_____	_____	_____
_____	_____	_____	_____	_____	_____
_____	_____	_____	_____	_____	_____
_____	_____	_____	_____	_____	_____
_____	_____	_____	_____	_____	_____
_____	_____	_____	_____	_____	_____
_____	_____	_____	_____	_____	_____

* Value is in case of loss, theft, or damage. A reproduction fee for specified usage will be negotiated.

Total Color_____ Total Black and White_____

Please count all photographs and confirm that the count is accurate by returning one signed copy of this form. If objection is not immediately made by return mail, the Client shall be considered to accept the count shown on this form as accurate and that the photographs are of a quality suitable for reproduction. If the recipient of the photographs is not the Client, the recipient by accepting this Delivery Memo and the photographs warrants that the recipient has the authority to receive the photographs on behalf of the Client.

Acknowledged and Accepted_____ Date:_____

SUBJECT TO ALL TERMS AND CONDITIONS ABOVE AND ON REVERSE SIDE

Terms and Conditions

1. **Purpose and Definition.** Photographer hereby agrees to entrust the Photographs listed on the front of this form to the Client for the purpose of review and examination only and no other purpose. "Photographs" are defined to include transparencies, prints, negatives, digitized encodations, and any other form in which the images submitted can be stored, incorporated, represented, projected, or perceived, including forms and processes not presently in existence but which may come into being in the future.

2. **Ownership and Copyright.** Copyright and all reproduction rights in the Photographs, as well as the ownership of the physical Photographs themselves, are the property of and reserved to the Photographer. Client acknowledges that the Photographs shall be held in confidence and agrees not to project, copy, store, or modify directly or indirectly any of the Photographs submitted (whether such modification is of the Photograph itself or involves combining the Photograph with other images or graphic or written elements, including but not limited to comping for clients) without the express permission of the Photographer, nor will Client permit any third party to do any of the foregoing. Reproduction shall be allowed only upon Photographer's written permission specifying usage and fees. In the event of the licensing of any usage rights by Client, payment shall be made within thirty (30) days of the date of the Invoice and time shall be of the essence with respect to payment.

3. **Acceptance.** Client accepts the listing and values set forth for the Photographs as accurate if not objected to in writing by return mail immediately after receipt of the Photographs. Any terms on this form not objected to in writing within 10 days shall be deemed accepted.

4. **Loss, Theft, or Damage.** Client agrees to assume full responsibility and be strictly liable as an insurer for loss, theft, or damage to the Photographs and to insure the Photographs fully from the time of shipment from the Photographer to the Client until the time of return receipt by the Photographer. Client further agrees to return all of the Photographs at its own expense by registered mail or bonded courier which provides proof of receipt. Reimbursement for loss, theft, or damage to any Photograph(s) shall be in the amount of the value entered for that Photograph(s) on the front of this form. Both Client and Photographer agree that the specified values represent the fair and reasonable value of the Photographs. Unless the value for an original transparency is specified otherwise on the front of this form, both parties agree that each original transparency has a fair and reasonable value of $1,500 (Fifteen Hundred Dollars). Client agrees to reimburse Photographer for these fair and reasonable values in the event of loss, theft, or damage.

5. **Holding Fees.** The Photographs are to be returned to the Photographer within fourteen (14) days after delivery to the Client. Each Photograph held beyond fourteen (14) days from delivery shall incur a weekly holding fee of $5 (Five Dollars) if it is color and $1 (One Dollar) if it is black and white. These holding fees shall be paid to the Photographer when billed.

6. **Arbitration.** Client and Photographer agree to submit all disputes hereunder in excess of $_____ to arbitration before _____ at the following location_____ under the rules of the American Arbitration Association. The arbitrator's award shall be final and judgment may be entered on it in any court having jurisdiction thereof.

7. **Copyright Notice.** Copyright notice in the name of the Photographer shall be adjacent to the Photograph(s) when reproduced unless otherwise agreed by both parties and stated in the Invoice. If such copyright notice, which also serves as authorship credit, is required hereunder but is omitted, the Client shall pay as liquidated damages triple the usage fee agreed to between the parties instead of the agreed upon usage fee.

8. **Tearsheets.** Client shall provide Photographer with two (2) copies of tearsheets of any authorized usage.

9. **Releases.** Client agrees to indemnify and hold harmless the Photographer against any and all claims, costs, and expenses, including attorney's fees, arising when no model or property release has been provided to the Client by the Photographer or when the uses exceed the uses allowed pursuant to such a release.

10. **Miscellany.** This Agreement shall be binding upon the parties hereto, their heirs, successors, assigns, and personal representatives. This Agreement constitutes the full understanding between the parties hereto. Its terms may only be modified by a written instrument signed by both parties. A waiver of a breach of any of the provisions of this Agreement shall not be construed as a continuing waiver of other breaches of the same or other provisions hereof. This Agreement shall be governed by the laws of the State of _____.

(Photographer's Letterhead)

STOCK PHOTOGRAPHY INVOICE

To: _____ Date : _____

_____ Invoice No.: _____

_____ SS/EIN No.: _____

_____ Purchase Order No.: _____

Per Request of: _____ Telephone: _____

The following nonexclusive rights are granted:

For use in:_____

For the product, project, or publication named:_____

In the following territory:_____

For the following time period or number of uses:_____

Other limitations:_____

Photo ID#	Description	Color/BW	Size/Placement	Fee
_____	_____	_____	_____	____
_____	_____	_____	_____	____
_____	_____	_____	_____	____
_____	_____	_____	_____	____
_____	_____	_____	_____	____
_____	_____			

Total Repro Fee _____

Research Fee _____

Holding Fee _____

Check should be made payable to: Sales Tax _____

_____ **TOTAL** _____

SUBJECT TO ALL TERMS AND CONDITIONS ON REVERSE SIDE

Terms and Conditions

1. Delivery and Definition. Photographer has delivered to the Client those Photographs listed on the front of this form. "Photographs" are defined to include transparencies, prints, negatives, digitized encodations, and any other form in which the images submitted can be stored, incorporated, represented, projected, or perceived, including forms and processes not presently in existence but which may come into being in the future.

2. Grant of Rights. Upon receipt of full payment, Photographer shall license to the Client the rights set forth on the front of this form for the listed Photographs.

3. Reservation of Rights. All rights not expressly granted are reserved to the Photographer. Without limiting the foregoing, no advertising or promotional usage whatsoever may be made of any Photographs unless such advertising or promotional usage is expressly permitted on the front of this form. Limitations on usage shown on the front of this form include but are not limited to size, placement, and whether usage is in black and white or color.

4. Fee. Client shall pay the fee shown on the front of this form for the usage rights granted. Client shall also pay sales tax, if required.

5. Payment. Payment is due to the Photographer within thirty days of the date of this Invoice. Overdue payments shall be subject to interest charges of _____ percent monthly. Time is of the essence with respect to payment.

6. Copyright Notice. Copyright notice in the name of the Photographer shall be adjacent to the Photograph(s) when reproduced unless otherwise agreed by both parties and stated in this Invoice. If such copyright notice, which also serves as authorship credit, is required hereunder but is omitted, the Client shall pay as liquidated damages triple the usage fee agreed to between the parties instead of the agreed upon usage fee. Copyright credit must be as shown on the Photograph(s) unless specified to the contrary by the Photographer.

7. Alterations. Client shall not make alterations, additions, or deletions to the Photographs, including but not limited to the making of derivative or composite images by the use of computers or other means, without the express, written consent of the Photographer. This prohibition shall include processes not presently in existence but which may come into being in the future.

8. Loss, Theft, or Damage. The ownership of the Photographs shall remain with the Photographer. Client agrees to assume full responsibility and be strictly liable as an insurer for loss, theft, or damage to the Photographs and to insure the Photographs fully from the time of shipment from the Photographer to the Client until the time of return receipt by the Photographer. Client further agrees to return all of the Photographs at its own expense by registered mail or bonded courier which provides proof of receipt. Reimbursement for loss, theft, or damage to any Photograph(s) shall be in the amount of the value entered for that Photograph(s) on the front of this form. Both Client and Photographer agree that the specified values represent the fair and reasonable value of the Photographs. Unless the value for an original transparency is specified otherwise on the front of this form, both parties agree that each original transparency has a fair and reasonable value of $1,500 (Fifteen Hundred Dollars). Client agrees to reimburse Photographer for these fair and reasonable values in the event of loss, theft, or damage.

9. Tearsheets. Client shall provide Photographer with two (2) copies of tearsheets of any authorized usage.

10. Releases. Client agrees to indemnify and hold harmless the Photographer against any and all claims, costs, and expenses, including attorney's fees, arising when no model or property release has been provided to the Client by the Photographer or when the uses exceed the uses allowed pursuant to such a release.

11. Arbitration. All disputes shall be submitted to binding arbitration before _____ in the following location _____ and settled in accordance with the rules of the American Arbitration Association. Judgment upon the arbitration award may be entered in any court having jurisdiction thereof. Disputes in which the amount at issue is less than $_____ shall not be subject to this arbitration provision.

12. Assignment. Neither party shall transfer or assign any rights or obligations hereunder without the consent of the other party, except that the Photographer shall have the right to assign monies due.

13. Miscellany. This Agreement shall be binding upon the parties hereto, their heirs, successors, assigns, and personal representatives. This Agreement constitutes the full understanding between the parties hereto. Its terms may only be modified by a written instrument signed by both parties. A waiver of a breach of any of the provisions of this Agreement shall not be construed as a continuing waiver of other breaches of the same or other provisions hereof. This Agreement shall be governed by the laws of the State of _____

BIBLIOGRAPHY

ASMP—The American Society of Magazine Photographers. *ASMP Professional Business Practices in Photography,* Fourth Edition. New York: ASMP, 1986. current: "The Business Bible"

ASMP—The American Society of Magazine Photographers. *ASMP Stock Photography Handbook.* Second Edition. New York: ASMP, 1990.

ASMP—The American Society of Magazine Photographers. *Valuation of Lost Transparencies,* Michael D. Remer, 1992.

A.G. Editions. *The Guilfoyle Report:* A Quarterly Forum for Nature Photographers, New York: quarterly.

Bagshaw, Cradoc, *FotoQuote* (pricing software), The Cradoc Corporation, PO Box 10899, Bainbridge Island, WA.

Crawford, Tad. *Legal Guide For The Visual Artist,* Third Edition. New York: Allworth Press, 1995.

Gordon, Elliott and Barbara. *How To Sell Your Photographs and Illustrations.* New York: Allworth Press, 1989.

Grotta, Daniel and Grotta, Sally Wiener *Digital Imaging for Visual Artists* New York: Windcrest/McGraw Hill, 1995.

Haas, Ken. *The Location Photographer's Handbook.* New York: Van Nostrand Reinhold, 1989.

Heron, Michal. *Stock Photo Forms* (32 pages) New York: Allworth Press, 1991.

Heron, Michal and MacTavish, David *Pricing Photography* New York: Allworth Press, 1992.

Negroponte, Nicholas. *Being Digital.* New York: Knopf. 1995

McCartney, Susan. *Travel Photography.* New York: Allworth Press, 1992.

McCartney, Susan. *Nature Photography.* New York: Allworth Press, 1994.

Photo District News. Monthly newspaper for professional photographers. New York: Visions Unlimited Corporation.

Photographers Market 1996. Cincinnati: Writer's Digest Books, 1996.

Pickerell, James H. *Negotiating Stock Photo Prices* 2nd Edition. 110A Frederick Avenue, Rockville, MD 20850

Pickerell, James H. *Taking Stock.* Monthly newsletter. 110A Frederick Avenue, Rockville, MD 20850

Piscopo, Maria. *Photographer's Guide To Marketing and Self-Promotion.* New York: Allworth Press, 1995.

Purcell, Ann and Carl. Stock Photography: *The Complete Guide.* Cinncinati: Writer's Digest Books, 1995.

Seed, Brian. *The Stock Photo Report.* Monthly newsletter for professionals. 708-677-7887.

Solomon, Jack. *The Signs of Our Time:* Semiotics. New York: St. Martin's Press, 1988.

INDEX

invoicing the research fee, 134
log in the final return of used
 pictures, 137
logging-in second returns, 136
packing the submission, 134-35
photo request, 130-31
price and usage negotiation, 137
protecting the images, 133
purchase order/billing request
 received, 137
receipt of payment, 137
researching the files, 131
Shape, 21
Shoots
 organizing, 39
 preparing. *See* Preparing the shoot
Sleeves, kimac, 133
Slide sheets, 124
Slides, protecting, 133
Snapshots, file, for, 120
Software. *See* Computers and software
Specialization, 40
Staff
 finding, 138
 training, 137-39
Stock photo assignments. *See*
 assignments, stock photo
Stock Photo Deskbook (McDarrah), 151
Stock photography
 changing perception of, 14
 current trends in, 14-15
 definition of, 12
 expectation of photographers
 concerning, 15-16
 history of, 13-14
 sources of, 12
Stock photography agencies. *See*
 Agencies, stock photography
Stock Workbook, 151
Storyboard, creating a, 100-02
Strobe lighting, 39, 40
Students, as office staff, 138-39
Style, 17-24
 analyzing your, 18-20
 definition of, 17
 elements of, 21-24
 past assumptions about, 17

tips on, 22
Subject filing, 122-23
Subject listing, 143
Subjects, 41, 42
Submissions. *See also* Selling your own
 stock
 arranging your, 131, 133
 delivery memos for, 133-34
 delivery of, 135
 held beyond your specified time,
 follow-up on, 136-37
 packing, 134-35
 quality of, 146
 speed of, 146
Symbols, 26-28

T

Technical excellence, 35
Thank-you letters to models, 103, 110
Themes, 85
Toddlers, working with, 113-14
Trademarks, 100
Training staff, 137-39
Tungsten lights, 30

U

United Parcel Service (UPS), 135

V

Valuation of photographs, 133-34, 166-67
See also Negotiating prices
 dupes, 191-92
 loss or damage and, 189-92
Vertical photographs, 21

W

Wardrobe, 88, 96, 112
 letters to models concerning, 108-09
Work for hire, 185-86
Work-study programs, 138-39
Workbook Photography Portfolio, The, 144

ALLWORTH BOOKS

Allworth Press publishes quality books to help individuals and small businesses. Titles include:

Legal Guide for the Visual Artist, Third Edition by Tad Crawford
(softcover, 8 1/2 x 11, 256 pages, $19.95)

The Law (in Plain English)® for Photographers by Leonard D. DuBoff (softcover, 6 x 9, 208 pages, $18.95)

Business and Legal Forms for Photographers by Tad Crawford
(softcover, 8 1/2 x 11, 192 pages, $18.95)

Pricing Photography by Michal Heron and David MacTavish
(softcover, 11 x 8 1/2, 128 pages, $19.95)

Licensing Art and Design, Revised Edition by Caryn R. Leland
(softcover, 6 x 9, 128 pages, $16.95)

Electronic Design and Publishing: Business Practices, Second Edition by Liane Sebastian
(softcover, 6 3/4 x 10, 200 pages, $19.95)

Mastering Black-and-White Photography by Bernhard J Suess
(softcover, 6 3/4 x 10, 240 pages, $18.95)

Nature and Wildlife Photography: A Practical Guide to How to Shoot and Sell by Susan McCartney (softcover, 6 3/4 x 10, 256 pages, $18.95)

Travel Photography: A Complete Guide to How to Shoot and Sell by Susan McCartney
(softcover, 6 3/4 x 10, 384 pages, $22.95)

Wedding Photography and Video by Chuck Delaney
(softcover, 6 x 9, 144 pages, $10.95)

Overexposure: Health Hazards in Photography by Susan D. Shaw and Monona Rossol
(softcover, 6 3/4 x 10, 320 pages, $18.95)

Stock Photo Forms by Michal Heron
(softcover, 8 3/4 x 11, 32 pages, $8.95)

The Photographer's Organizer by Michal Heron
(softcover, 8 1/2 x 11, 32 pages, $8.95)

How to Sell Photographs and Illustrations by Elliott and Barbara Gordon (softcover, 8 x 10, 128 pages, $16.95)

The Photographer's Assistant by John Kieffer
(softcover, 6 3/4 x 10, 208 pages, $16.95)

Please write to request our free catalog. If you wish to order a book, send your check or money order to Allworth Press, 10 East 23rd Street, Suite 400, New York, NY 10010. Include $5 for shipping and handling for the first book ordered and $1 for each additional book. Ten dollars plus $1 for each additional book if ordering from Canada. New York State residents must add sales tax.

If you wish to see our catalog on the World Wide Web, you can find us at Millennium Production's Art and Technology Web site:

http://www.arts-online.com/allworth/home.html
or at http://interport.net/~allworth